ART&DESIGN

ACADEMY GROUP LTD
42 LEINSTER GARDENS, LONDON W2 3AN
TEL: 0171-402 2141 FAX: 0171-723 9540

EDITOR: Nicola Kearton
ART EDITOR: Andrea Bettella
PRODUCTION TEAM: Alex Young, Rachel Bean
DESIGNER: Mario Bettella

SUBSCRIPTION OFFICES:
UK:JOHN WILEY & SONS LTD
JOURNALS ADMINISTRATION DEPARTMENT
1 OLDLANDS WAY, BOGNOR REGIS
WEST SUSSEX, PO22 9SA, UK
TEL: 01243 843272; FAX: 01243 843232
E-MAIL: cs journals@wiley.co.uk

USA AND CANADA: JOHN WILEY & SONS, INC
JOURNALS ADMINISTRATION DEPARTMENT
695 THIRD AVENUE
NEW YORK, NY 10158, USA
TEL: 212 850 6645 FAX: 212 850 6021
E-MAIL: subinfo@jwiley.com

ALL OTHER COUNTRIES:
VCH VERLAGSGESELLSCHAFT MBH
POSTFACH 101161
69451 WEINHEIM, GERMANY
TEL: 00 49 6201 606 148 FAX: 00 49 6201 606 117

Subscription rates for 1997 (incl p&p): Annual subscription price: UK only £68.00, World DM195 for regular subscribers. Student rate: UK only £53.00, World DM156 incl postage and handling charges. Individual issues: £19.95/DM45.00 (plus £2.30/DM5 for p&p, per issue ordered).
For the USA and Canada: Art & Design is published six times per year (Jan/Feb; Mar/Apr; May/Jun; Jul/Aug; Sept/Oct; and Nov/Dec) by Academy Group Ltd, 42 Leinster Gardens, London W2 3AN, England and distributed by John Wiley & Sons, Inc, Journals Administration Department, 695 Third Avenue, New York, NY 10158, USA. Annual subscription price; US $142.00 including postage and handling charges; special student rates available at $105.00, single issue $29.95. Periodicals postage paid at Jamaica, NY 11431. Air freight and mailing in the USA by Publications Expediting Services Inc, 200 Meacham Ave, Elmont, NY 11003: Send address changes to: 'title', c/o Publications Expediting Services Inc, 200 Meacham Ave, Elmont, NY 11003.

Printed in Italy. All prices are subject to change without notice. [ISSN: 0267-3991]
The full text of Art & Design is also available in the electronic versions of the Art Index.

CONTENTS

ART &

Books reviewed by Steven Gartside • 'Material Culture', Hayward Gallery, London • Academy Highlights

ART & DESIGN **PROFILE** *No 55*

SCULPTURE

CONTEMPORARY FORM AND THEORY

Guest-edited by Andrew Benjamin

2 Andrew Benjamin *Introduction*

4 Saul Ostrow *Piecing the Pieces Together Again: Phenomenal Objects, Pictorial Events*

18 John Lechte *Eleven Theses on Sculpture*

22 Stan Allen *Minimalism: Architecture and Sculpture*

30 David Batchelor *Chromaphobia: Ancient and Modern, and a Few Notable Exceptions*

38 Charles Harrison *On Colour and Abstract Art:* **David Batchelor** *'s Recent Work*

42 David Moos *Which World: The Sculpture of* **Harald Klingelhöller**

50 Michael Newman *Three Ends of Art: Approaching* **Didier Vermeiren** *'s Sculpture*

56 Andrew Benjamin *The Activity of Space: The Sculpture of* **Christine Boshier**

60 Jean-Luc Nancy *Held, Held Back: The Sculpture of* **Lucille Bertrand**

64 Rebecca Comay *Memory Block:* **Rachel Whiteread** *'s Proposal for a Holocaust Memorial in Vienna*

76 Jesse Reiser *Latent Tectonics in the Work of* **Tony Cragg**

84 Andrew Benjamin *Sites of Tension:* **Serge Spitzer** *'s Work in the Kennedyplatz, Essen*

reviews

MATERIAL CULTURE

The Object in British Art of the 1980s and 90s

Hayward Gallery, London
3rd April – 18th May, 1997

Gathering together key works by 45 British artists, this exhibition sets out to breathe life into a recurring theme in British art since the 1960s: that of the object. Sculpture has always been the most internationally visible British art form since the war with the well-funded shadows of Moore and Caro and their heirs never far absent. *Material Culture* is not an attempt to produce a theory of generation but a lively and useful filter through which to look at the enormous variety of art being produced in Britain today. As the organisers Michael Archer and Greg Hilty affirm, the object is precise enough to constitute a valid theme, but broad enough to encompass a representative selection of work in a way that 'painting' or 'sculpture' could not. Work by veterans John Latham and Richard Hamilton appears alongside that of 80s exports Cragg, Deacon and Kapoor, with a predominance of work by younger artists who emerged in the 90s such as Sarah Lucas, Damien Hurst, Cathy de Monchaux and Anya Gallaccio. Even so this does not give rise to a demonstration of linear development but more a shared sensibility.

It is no accident that many of the names one picks out of this considerable list are female. Perhaps the do-it-yourself mentality of artists in the 1990s forced, due to lack of funding, to develop outside traditionally male-dominated institutions favoured the emergence of women artists. Perhaps the witty attack on the sculpture of permanence, monumentality, unwieldy and expensive materials ideally suits women.

Ideas which could seem tired reappear energised in the context of this exhibition: the slippage of meaning attached to an object robbed of its function, as with Gavin Turk's gleaming post-minimal skip, or Mona Hatoum's colander straight from a designer kitchen, but with its holes blocked by nails; the narratives created by Susan Hiller's painstaking collections; the subtle indication of absence provided by the dusty outlines of skeletal parts laid on Christine Borland's glass shelves. The object is defined by its opposite: the imagination.
Nicola Kearton

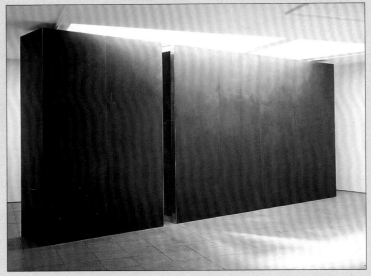

Shirazeh Houshiary, Isthmus, *1992, copper and aluminium, 2 parts: 340x220x90 cm and 340x500x90 cm*

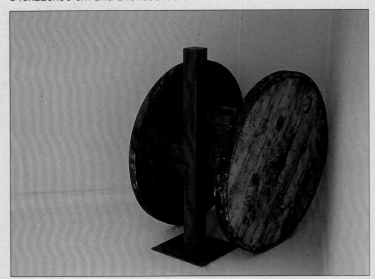

Lucia Nogueira, Full Stop, *1993, wood, cable trim, steel post, 101x55x89.5 cm*

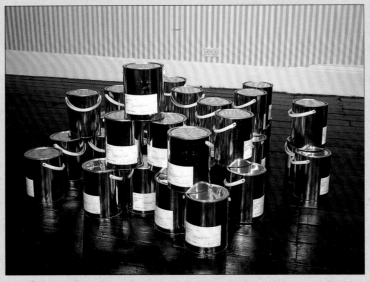

Douglas Gordon/Simon Patterson, Framework for colour co-ordination for building purposes, *1992-97, paint and cans, dimensions variable*

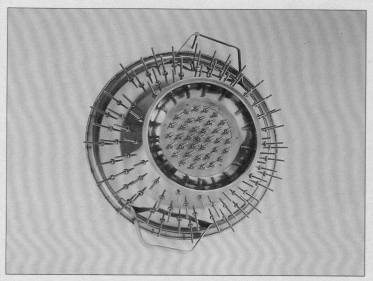

Mona Hatoum, No Way II, *1996, stainless steel, 27.3x22.2x12.7 cm*

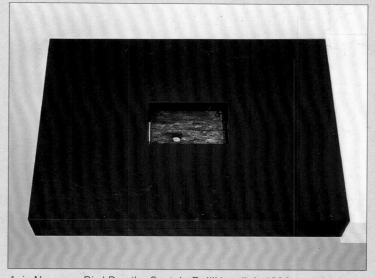

Avis Newman, Bird Box 'La Scatola Dell'Uccello', *1992, wood, glass and steel, 98x73x13.5 cm*

Alison Wilding, Echo, *1995, stainless steel and polished brass, 104x296x135 cm, detail*

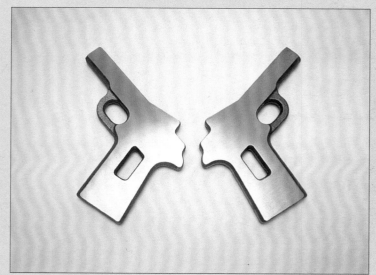

Cornelia Parker, Embryo Firearms, *1995, Colt 45 guns in the earliest stage of production, each 15.2x15.2x2.5 cm (2 guns)*

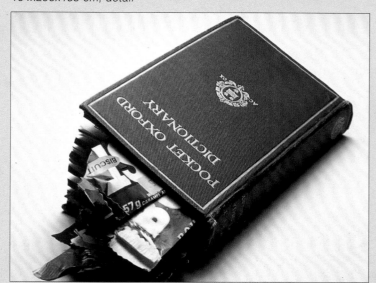

Richard Wentworth, Tract (from Boost to Wham), *1993, book with paper and plastic, 8.5x24.5x10 cm*

Richard Deacon, Art for Other People No 2, *1983, marble, wood, vinyl and resin, 43x158x33 cm*

RICHARD WILSON: JAMMING GEARS, Serpentine Gallery, London, 1996, PB, £19, 55pp

In much of Richard Wilson's work there is a play of opposites, contrasts of interior and exterior space, the temporary with the permanent, reality against artifice. This play of opposites is present in *Jamming Gears*. Although only 55 pages in length, this is a big book, it uses sizable images of the work surrounded by generous amounts of white space. The sponsors of the exhibition are also on an impressively large scale: Selfridges, *The Guardian*, Henry Moore Foundation, Andy Warhol Foundation, Channel Four. These elements provide an indication of intentions and of the position Wilson's work now holds. However, the size of the book plays well against its limited yet carefully formed and concise content.

The book/catalogue was produced for the exhibition of the same name at the Serpentine in August-September 1996. Although this forms the primary concern, the images and essay by Andrew Wilson range across work made over the last eight years. Part of this range is necessary because of the nature of the work produced for the Serpentine. *Jamming Gears* is not so much a series of individual pieces for the gallery but a reaction and interaction with the site itself. It is here that the context of Wilson's earlier work provides a useful indication of his methods.

It was the exhibition of *Jamming Gears* that closed the Serpentine. If you invite an artist to dig up your gallery you have to choose your moment carefully. As it was about to close for refurbishment, the time obviously seemed appropriate. Yet, the impact of finding holes in the gallery, windows removed and two fork lift trucks sitting in the space is lessened by the fact that this is work waiting to happen. The challenge to the space, with the addition and removal of structural elements, is tempered by the knowledge of its impending fate. Once this lessening of the impact is taken on board, the result is nevertheless interesting – structures working with and against structures.

Much of this relationship between structure and object is based in familiarity. Partly through the use of mass-produced items – the cabin, the greenhouse, the plastic swim-ming pool. Their familiarity is part of the key to how the pieces work. Through their treatment in space – and the additions and subtractions that are made – perceptions are challenged. The familiar becomes unfamiliar by placing and then a further displacement takes effect.

Jamming Gears is dominated by three cabins or site huts, temporary structures designed to provide refuge, challenge the permanence of the gallery space. It is these temporary structures that penetrate the perceived solidity of the gallery. A corner of one of the cabins cuts through the windows into the park outside, the missing section appears at the back of the cabin. Another of the cabins is upturned and hung over a pit dug into the gallery floor. Holes have been drilled into the walls and floor; the contents of these holes, still in their complete circles then appears in the sides of the hut. In the pieces that have been removed and the gaps that remain, the layers of varied substructure of gallery and soil can be seen. Like museum cases of geological surveys these circles are samples of the building's structure, and the limited layers on which it stands.

Wilson's work has never really concerned itself with the individual object, the pieces tend to be big, but one is also conscious of the space around them. Their size draws attention to the type of space in which they find themselves.

Building metaphors are almost inevitable with Wilson's work, and it is from building rather than architecture that the parallels are drawn. Constructions are taken more from the flat-packed variety than the search for individual architectural form. The surfaces of the work come ready applied, the shapes pre-empt the destination of the gallery. Wilson changes perception by redefining context, much of the material that he uses is designed and shaped by its purpose. Through their place in the gallery and the experiments Wilson inflicts upon them, these objects become impotent reminders of intention.

TONY CRAGG, by Germano Celant, Thames & Hudson, London, HB, £38.00, 351pp

The way that a book is structured often provides indications towards how an artist wishes to be seen. After a short opening essay by Germano Celant, there is a concentration on the work itself. The predominantly colour images, placed chronologically in single and double page spreads, are interspersed with occasional statement taken from interviews and essays by Cragg.

In a quotation that appears towards the end of the book, Cragg comments, 'A picture, an image or form cannot be expressed with a thousand words – not even a million'. It is an odd, though not necessarily inappropriate quote to end this most recent monograph of Cragg's work. It fits the books structure and presentation. All Cragg's comments tend to refer not to individual works, but the process, reasoning and materials out of which they are formed. The materials Cragg uses are central to an understanding of the work. This is not in any way a precious sensitivity towards a manipulation of materiality to the production of meaning. As Cragg himself has noted, with much of the work one has to overcome the sheer banality of both the material and the reference to its earlier function. Much of the work of the 1970s and early 1980s makes use of the detritus of everyday existence. The excesses of societies involved in overproduction and consumption based on ephemerality provide an abundance of material. The variations of colour, texture and condition are extensive. The abandoned functionality of a discarded plastic bottle is provided with a high art status just by virtue of place.

In the early work there is little attempt to transform objects beyond the place and order that Cragg applies. A work such as *Spectrum* (1974) consists entirely of found plastic objects. They are spread over the gallery floor in colour order, ranging from red through orange, yellow and green to blue. There is no attempt to combine other than through colour order. The rectangle that the work forms could, perhaps, be seen as a reforming of the picture frame on the gallery floor. Yet, this does not really take us any further. Their limited method of presentation forces a focus on the earlier significance of the individual pieces. Man-made materials deprived of function, are forced to be seen as what they originally represented or in the abstract terms of what they have become.

With Cragg's later work of the mid-1980s and onwards – and this is

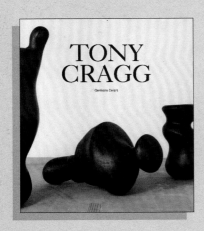

the work that dominates the book – forms and the uses of material become more complex. The relationship between natural and man-made materials is often obscured by surface texture. There is an uncertainty with many works as to what they are made of. This is perhaps the point at which the work becomes much more challenging. Distinctions are less objective as they are based on visuality rather than the materiality – which is disguised – of the object that they present. The functional is either replaced or flawed. Glass containers appear inverted or with holes, machine parts are produced in glazed ceramics, a bicycle is covered in bottles.

In *Spill* (1988) four glass containers of varying shapes stand upright on a black table top. A fifth container lies on its side and spills its contents across the surface of the table. It appears as though this has just occurred, yet the piece is static, the flow of material on the table is still, clear and solid.

As Cragg's work has progressed, his use of materials and the forms that they take sets deliberate obstructions against easy meaning. The material property of the work has become infinitely interchangeable. A stable imagery of form has been abandoned for a more free form approach. The freedom encapsulated in the work requires from the viewer an equivalent response that is enhanced through knowledge and an awareness of the range from which the work comes.

BOOK WORKS: A Partial History and Sourcebook, Jane Rolo and Ian Hunt (eds), PB, £13.50, 160pp
With the placing together of the words 'art' and 'book' an immediate problem arises in the terminology. Artists' books, book art, book works and book objects are all terms that regularly occur, yet none really have any precise meaning. The more one looks though, the less important the problem seems as the sheer diversity of the work available unfolds. In fact, many works challenge the idea of 'reading' itself, they become books that go beyond words – and in many cases books that go beyond books.

In line with the complexity of the subject area the activities of Book Works have been equally varied. Part of their aim is to 'question contexts for books in contemporary art prac-

tice'. As well as producing books of a more conventional type – in form if not in content – there is also work on installations, performances and exhibitions. All Book Works projects have a strong collaborative base, participants have included artists and writers – Douglas Gordon, Susan Hiller, Joseph Kosuth, Cornelia Parker amongst others.

With this partial history of Book Works there is an instant draw to the book itself. It has a pleasing size and feel with fine reproductions, but it is the structure and layout that are of the greatest importance. The writings of the commissioners and the commissioned provide a thorough guide to the work carried out over the last ten years. The collaborative nature of the projects seems to come through to the work itself. Outside the production of the work is the relationship to the audience. As the book is not simply presented as a book, so the demands on the audience are increased as to how to 'read'. The works extend over and beyond concerns with a single text. Use of text is of course familiar from the conceptual work of the 1960s where notions of the individual art object are questioned. In many of the Book Works projects text becomes contextualised by the site on which it is made available.

This can be seen most clearly perhaps, in the Reading Room project (1994) which involved a range of artists and writers on the theme of books, reading and knowledge. The purpose of the commissions was for the participants to 'create their own versions of a reading room, both as physical sites and conceptual spaces in which dialogues might take place'. The sites were varied from gallery to museum to library.

The work produced by Douglas Gordon was an installation, a room painted blue – including ceiling, radiators and floor. It is empty except for a cassette deck, amplifier and loudspeakers. In the ambient blue light 30 songs from the 1966 'Pop 50' play. Gordon adapts the notion of reading as sound, and sound as knowledge. The significance of 1966 lies in Gordon's birth – these are sounds heard from the womb. Hearing denied meaning.

The published Book Works projects are impressively varied. With Joseph Kosuth it is a response to text and the library, relating to

the two installations carried out for the Reading Room project in Oxford. Cornelia Parker's work treats the book as object, with the presentation of items crushed between heavy sheets of paper. Each of the works produced extends the possibilities of the book with that of contemporary art practice.

BOOKS IN BRIEF

CARL ANDRE AND THE SCULPTURAL IMAGINATION, Ian Cole (ed), Museum of Modern Art Papers, Oxford, PB, £11.50, 67pp
This collection is based on the symposium arising out of the 1996 exhibition of Andre's work at MOMA Oxford. With essays by Michael Newman, Eva Meyer-Hermann, David Batchelor, Paul Wood, Briony Fer, Mark Pimlott and Alex Potts, the publication provides a range of approaches for a detailed assessment of Andre's practice. The position of the institution and the actual siting of work are themes that consistently emerge in the book. This is parallel to a placing of the work in the wider context and the development out of the changes in artistic practice in the 1960s.

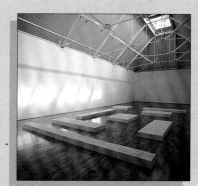

THE SCULPTURE OF STEPHEN COX, Stephen Bann, Henry Moore Foundation/Lund Humphries, HB, £40, 144pp
The title of this book is a literal translation of its contents, with the latter section consisting of a kind of concise catalogue of all Cox's work. There is an essay by Stephen Bann, and interviews from 1985 and 1994, but it is the catalogue section that is most fascinating. Page after page maps out Cox's work from 1969-1994, each page containing nine black and white photographs carefully laid out in chronological order. In this way Cox's work is seen as a development, early post-minimalism giving way to the introduction of different histories and cultures.

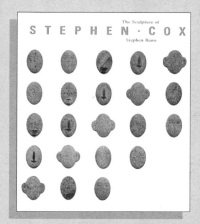

SCULPTURE: FROM ANTIQUITY TO THE PRESENT, Taschen, 4 vols, HB, £99.95, 1212pp
The range of this publication is vast, covering sculptural work from the eighth-century BC to work of the last few years. Its scope does not permit the documenting of detailed shifts in individual periods, but as an outline text containing over 2,000 images it is very useful in reference.

This selection of books has been reviewed by **Steven Gartside** *who teaches art history at Manchester Metropolitan University and is completing his PhD*

Art & Design *highlights*

SCI/FI AESTHETICS
Guest-Edited by Rachel Armstrong

A&D PROFILE 56

Asserting that science fiction is the integration of art and science, this issue of *Art & Design* seeks to answer the question 'What will it be like to be human in the future?' Examining the work of contemporary artists such as Orlan, Stelarc, the Chapmans, Moriko Mori, Peter Gabriel, Kathy Acker, it also includes a wide variety of writings with pieces by scientists, doctors, fiction writers. The focus is on the human body as a metaphor to reflect our hopes, fears and anxieties about our ability to survive and evolve in an increasingly information-overloaded and technologised world.

Dr Rachel Armstrong is a multi-media and science fiction specialist based in London who has written extensively on art/science/technology issues.

PB 0-471-97855-8 £19.95 $29.95
305x250 mm, 96 pages
Illustrated throughout, mainly in colour
September 1997

Further information can be obtained from:
(UK only) Academy Group Ltd, 42 Leinster Gardens, London W2 3AN. Tel: 0171 402 2141 Fax: 0171 723 9540

(USA and Canada) National Book Network, 4720 Boston Way, Lanham, Maryland 20706, USA
Tel: (301) 459 3366 Fax: (301) 459 2118

(Rest of World) VCH, Postfach 101161, 69451 Weinheim, Federal Republic of Germany
Tel: +49 6201 606 144 Fax: +49 6201 606 184

A THING OF BEAUTY IS . . .
Guest-Edited by Michael Petry

A&D PROFILE 54

Perhaps the worst thing that can be said of modern art is that it is beautiful. This dismisses the work as mere fluff, art that is candy, art that is not really art. This profile explores beauty as a cultural construct looking both at its more positive historical associations and how it functions today in relation to artworks in the global media age. With contributions from over 40 different artists and writers, *A Thing of Beauty is . . .* will ask if anything can be allowed to be beautiful again, and if so, what does it mean for art in what is perceived to be an ugly age, or is the myth of the ugly only the other side of the looking glass?

Michael Petry, artist, writer and Co-Director of the Museum of Installation, London, also guest-edited the A&D profile *Abstract Eroticism*.

PB 0-471-97684-9 £19.95 $29.95

ART & ANIMATION
Guest-Edited by Paul Wells

ART & DESIGN PROFILE 53

As a genre, animation is currently receiving serious attention from art, film and cultural critics. This profile addresses how fine art and the animated film interrelate. As witnessed by the recent huge success of the characters Wallace and Gromit in Oscar winner Nick Park's *The Wrong Trousers* and Disney's innovative and technologically masterful *Toy Story*, animation is now becoming a force to be reckoned with at the box office.

Art & Animation looks at subjects such as Walt Disney and Classical Art; the established tradition of European animators; Japanese Manga films; the connections between animation, dance, computer graphics and the puppet theatre together with the role of animation in art education.

Dr Paul Wells teaches media studies at De Montfort University, Leicester. He has made a number of film related series for BBC Radio and has written widely on aspects of comedy and animation.

PB 0-471-97760-8 £19.95 $29.95

THE FLUXUS READER
Edited by Ken Friedman

The Fluxus Reader is the first comprehensive source book on the international community of artists, architects, designers and composers described as 'the most radical and experimental art movement of the 1960s.' Celebrated as a leading force in the development of post-modern culture but often dismissed as a bunch of charlatans, Fluxus left its mark on our era by incorporating the work and thought of major artists such as Joseph Beuys, Yoko Ono, George Brecht, Nam June Paik, Dick Higgins and Per Kirkeby. Neglected by the market-oriented art world, Fluxus became a source of ideas and practices adopted by fields ranging from architecture and industrial design to cultural theory and psychology.

This compendium presents a wide range of voices – the artists themselves, their friends and their enemies. They speak through a selection of original writings and documents, summary essays by leading historians and scholars and notes by critics and journalists from around the world. The book also includes a comprehensive reference section with a complete chronology and bibliography on Fluxus, along with charts and biographies on the key Fluxus artists.

Artist, writer and central member of Fluxus whose work is currently exhibited around the world, Ken Friedman teaches at the Norwegian School of Management in Oslo.
£29.95, $48
size, 288 pages
Illustrated throughout
October 1997

IMRE MAKOVECZ
Edited by Edwin Heathcote
ARCHITECTURAL MONOGRAPH 47

Prior to his highly acclaimed Pavilion for Expo '92 in Seville, the architecture of Imre Makovecz (b 1935) was little known outside his native Hungary, where he has been a household name for many years. This is the first book in English to examine his refreshing originality and his use of primal and organic forms and ancient archetypes.

This study of Makovecz's work – inextricably entwined with his nationality and the circumstances of the Hungarian nation – explores the themes and myths which have permeated his architectural career, by analysing his most important buildings, including cultural centres, domestic houses, schools, ecclesiastical and commercial buildings.

PB 0-471-97690-3 £21.95 $38.00
305x252 mm, 128 pages
Illustrated throughout
June 1997

FTL ARCHITECTS
INNOVATIONS IN TENSILE STRUCTURES
ARCHITECTURAL MONOGRAPHS 48

With over 800 projects and 30 awards for their designs, Future Tents Limited (or FTL as they are now popularly known) are acknowledged as pioneers in technological innovation. Anyone who wants a lightweight membrane structure, who has a need for a deployable shelter, who understands the favourable economics of building with tensile technology, automatically turns to Todd Dalland and Nicholas Goldsmith, partners in FTL.

Their evolution from the design fringe to the mainstream is a story of persistence, dedication, vision and a strong belief in themselves. Today, their commissions include roofs for sports stadia, entertainment complexes and circus pavilions, recreational facilities, and special on-site facilities for the military, in addition to more traditional (although highly unconventional) office and showroom design work for clients such as the DKNY clothing chain.

This monograph examines their modus operandi, their constant search for new materials that will enable them to design even more advanced structures, and looks at a number of their recent projects.

PB 0-471-97693-8 £21.95 $38.00
305x252 mm, 128 pages
Illustrated throughout
June 1997

FRONTIERS
ARCHITECTS AND ARTISTS
ARCHITECTURAL DESIGN PROFILE 127

This profile focuses on the relationship between art and architecture, artists and architects: a potentially controversial subject of great interest to both practitioners and patrons alike.

Recent years have seen a notable shift in working practices, with, for example, artists moving out of the studio into the expanding arena of 'public art', and there is a greater willingness to explore new contexts, new media and new territories. Of course, this is nothing new: the Arts and Crafts Movement saw a great deal of inter-disciplinary collaboration, resulting in many fine buildings and artworks. Many architects, however, seem reluctant to collaborate, yet the product of such collaborations is often quite different to what either party would have achieved independently.

PB 0-471-97695-4 £18.95 $32.50
305x250 mm, 112 pages
Illustrated throughout
May 1997

Acknowledgements

We would like to thank Andrew Benjamin for guest-editing this issue of *Art & Design* and all the writers, artists and galleries for their generous contributions.

All work courtesy the following artists and galleries: *p1* Rachel Whiteread and Anthony d'Offay Gallery, London; **Intro** *pp2-3: p2* Lisson Gallery, London, with thanks to Susan Waxman for her help; **Piecing the Pieces Together Again** *pp4-17 p4* Richard Serra and Gagosian Gallery, New York, *p9 Above* Postmaster's Gallery, New York *Centre* Estate of Robert Smithson, John Weber Gallery, New York *Below* Paul Dickerson Estate, *p10* Paul Kasmin Gallery, New York, *p12, p13* Sonnabend Gallery, New York, *p15* Jay Gorney Gallery, New York, *p16 left* Lombard-Fried Gallery, New York *right* Susan Inglett Gallery, New York, *p17 left* David McKee Gallery, New York *right* Postmaster's Gallery, New York; **Minimalism: Architecture and Sculpture** *pp22-29: p22* Tadao Ando and Associates, *p24* Imi Knoebel, *pp27-28* Kazuyo Sejima and Associates; **Chromaphobia** *pp30-37:* 'This essay was originally commissioned by Penelope Curtis and published by the Centre for the Study of Sculpture, The Henry Moore Institute, Leeds, to coincide with my exhibition 'Polymonochromes' which was also organised by Penelope Curtis for the same venue, 17 January – 6 April 1997. I remain extremely grateful to Penelope and her colleagues at the HMI for their interest and support, and for permission to republish the text here. There are a couple of small revisions in this version.' *DB, p30, p32* Lisson Gallery, London, *p33* Anthony d'Offay, London, *p34* The Judd Estate with thanks to Peter Ballantine, *p35* Metro Pictures, New York, *p36 above* John Chamberlain *below* Laure Genillard Gallery, London; **On Colour and Abstract Art** *pp38-41:* images courtesy David Batchelor; **Which World** *pp42-49:* this essay originally appeared in *Harald Klingelhöller*, exhibition catalogue, Art Gallery of York University, Toronto, 1996, images courtesy Harald Klingelhöller; **Three Ends of Art** *pp50-55:* images courtesy Didier Vermeiren; **The Activity of Space** *pp56-59:* an earlier version of this essay appeared in the catalogue accompanying the exhibition of Christine Boshier's work at Oriel 31, Newtown, Powys, 1995, images courtesy Christine Boshier; **Held, Held Back** *pp60-63:* images courtesy Lucille Bertrand; **Memory Block** *pp64-75:* a version of this text was read to the Architectural Association, London, November 1996, images courtesy Rachel Whiteread with thanks to Joanna Thornbury for her help, *p64, p70* Anthony D'Offay Gallery, London, *p69, p72, p73* Luhring Augustine Gallery, New York; **Latent Tectonics** *pp76-83:* images courtesy Tony Cragg, photos the Lisson Gallery, London, *p78* Collection Buchmann Gallery, Basel, *p81* Private Collection, *p82* Collection Fundacío La Caixa, Barcelona; **Sites of Tension** *pp84-87:* images courtesy Serge Spitzer.

Contributors' Biographies
Andrew Benjamin is Professor of Philosophy at the University of Warwick and has lectured in philosophy, art and architectural departments worldwide. His publications include *Art, Mimesis and the Avant-Garde*, *The Plural Event*, and, for Academy Editions, *Object • Painting* and *What is Abstraction?* **Saul Ostrow** is an artist, critic and organiser of exhibitions. Since 1989 he has been the Art Editor for *Bomb* Magazine (a quarterly magazine of art, literature, theatre and film) and in 1994 became Co-Editor of Lusitania Books (publishing anthologies focusing on cultural issues) and in 1995 the Editor of *Critical Voices in Art, Theory and Culture* (Gordon and Breach). **John Lechte** is Senior Lecturer in Sociology at Macquarie University, Sydney, he has published widely in the fields of philosophy, literature and the visual arts. **Stan Allen** is an architect and Assistant Professor of Architecture at Colombia University, New York, he is Projects Editor for the journal *Assemblage*. **David Batchelor** is an artist and writer on modern and contemporary art. He is Senior Tutor in Critical Studies at the Royal College of Art, London and his most recent book is *Minimalism* (Tate Gallery Publications 1997). **Charles Harrison** is Professor of Art History at the Open University Press and currently teaches at the University of Texas at Austin. **David Moos** is a curator and art historian who received his doctorate from Columbia University, New York. He is author, together with Rainer Crone, of *Kazimir Malevich: The Climax of Disclosure* and *Jonathan Lasker: Telling the Tales of Painting*. **Michael Newman** is Head of Theoretical Studies and Art History at The Slade School of Fine Art, University College London, and in 1997 is visiting Senior Research Fellow in Philosophy at the University of Brabant, Tilburg, The Netherlands. He is currently preparing a book on the trace, memory and forgetting in Heidegger, Levinas and Derrida, and a volume of essays on art. **Jean-Luc Nancy** teaches at the Université des sciences humaines de Strasbourg where he is Director of the faculté de philosophie. His books include *L'absolu littéraire* (with Philippe Lacoue-Labarthe), *La communauté désoeuvrée*, *L'expérience de la liberté* and his recent *Etre singulier pluriel*. **Simon Sparks** is a Leverhulme Trust post-doctoral research student at the Université des sciences humaines de Strasbourg and is Editor and Translator of Lacoue-Labarthe and Nancy *Retreating the Political* and Editor of *On Jean-Luc Nancy* (Routledge). **Rebecca Comay** lectures in philosophy and literary studies at the University of Toronto and writes on modern Continental philosophy and critical theory. **Jesse Reiser** is Adjunct Assistant Professor at Columbia University, he is also a practising architect and Principle of Reiser & Umemoto Architects.

COVER: David Batchelor, Polymonochromes, 1994-97, acrylic sheet, gloss paint, steel, photo Ori Gersht
INSIDE COVERS: Kazuyo Sejima & Associates, Villa in the forest, detail

EDITOR: Nicola Kearton ART EDITOR: Andrea Bettella
PRODUCTION TEAM: Alex Young, Rachel Bean DESIGNER: Mario Bettella

First published in Great Britain in 1997 by *Art & Design* an imprint of
ACADEMY GROUP LTD

Art & Design Profile 55 is published as part of *Art & Design* Vol 12 7/8 1997
Art & Design Magazine is published six times a year and is available by subscription

Other Wiley Editorial Offices
New York • Weinheim • Brisbane • Singapore • Toronto

Distributed to the trade in the United States of America by
NATIONAL BOOK NETWORK, INC, 4720 BOSTON WAY, LANHAM, MARYLAND 20706

ISBN 0-471-97694-6

Printed and bound in Italy

Art & Design

SCULPTURE
CONTEMPORARY FORM AND THEORY

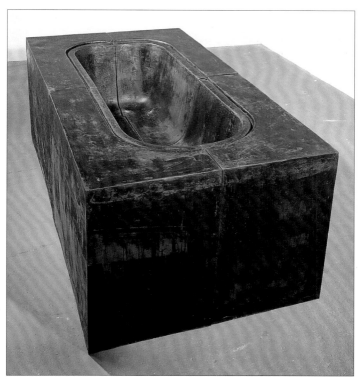

Rachel Whiteread, *Untitled Black Bath*, 1996, pigmented urethane
and urethane filler, 80x207x110 cm, photo Mike Bruce

ACADEMY EDITIONS • LONDON

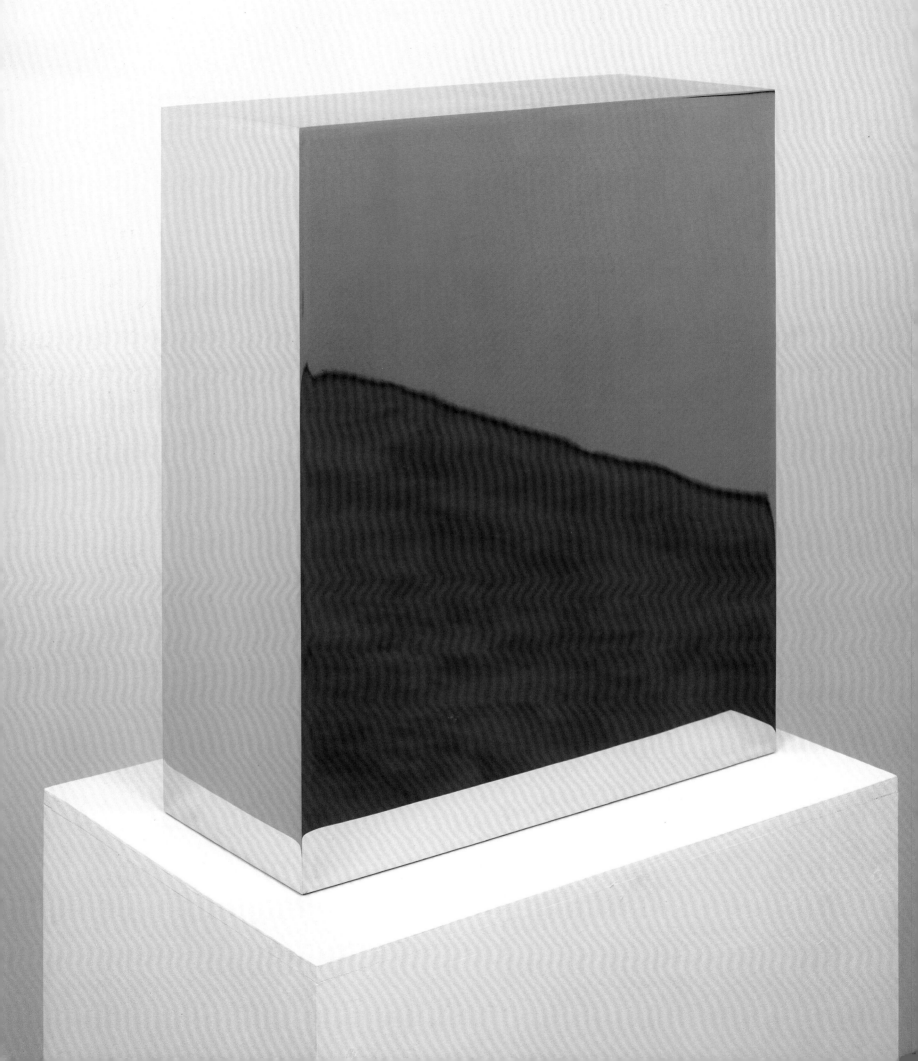

INTRODUCTION
ANDREW BENJAMIN

Sculpture continues to play a fundamental role within the visual arts. The orientation of this issue of *Art & Design* however is not towards an overview of contemporary sculpture but has a more difficult and demanding task. Rather than being either a survey or a historical sketch, what is presented here is a series of different engagements between sculpture and contemporary theory and philosophy. As such, what is intended is to present a series of interchanges between developments within theory and philosophy and the activity of sculpture. Rather than the simplistic claim that sculpture has in some way become philosophical, there is a more nuanced position. Indeed, it is possible to understand it as the advent of two interrelated positions.

In the first place it is to allow the demand that contemporary work makes on both theory and philosophy to be registered. While the second is that contemporary sculpture demands a response that is best given by utilising the resources of theory and philosophy. As has been suggested this does not mean that sculpture has attained the status of philosophy, sculpture remains an activity that is concerned with the complex possibilities of spacing. It is rather that once the complexity of certain sculptural possibilities is to be explored – and this entails a form of respect for the integrity of specific works' own activity as sculpture – then the resources of theory and philosophy are demanded in order that the nature of the work be traced, developed and evaluated.

One of the important developments stemming from this demand is an insistence on singularity. Rather than works being viewed as either the expression of an individual hand and thus as idiosyncratic or as individual instances of a more general trend, it is possible to insist on the singularity of the object as in some sense exemplary of itself. In fact this form of exemplarity has two further consequences. The first sets the condition where it becomes possible to integrate work into larger projects.

While the second enables the production of different histories and thus of other possibilities within a more generalised writing on sculpture. It is always necessary that the history of developments and moments with the visual arts be rewritten. The important question is what will set the limit allowing such a rewriting to take place? Rather than the incorporation of any new object into an already present generalised, and perhaps generalising, history, there is the other possibility of allowing the object's own insistence to set the limit condition enabling such histories to be rewritten or to demand that accounts for specific moments or developments be given.

Rather than establishing a predictive history in which sculpture's developments would be set by the demands of history, movement will have become necessarily linked to the nature of the object and the demands, both interpretive and historical, that a given object is going to make. This will have the further consequence that once freed from the demand of a particular conception of the historical art writing will have also been freed from the necessity of a traditional narrative form. While the conventions of narrative will always play a fundamental role, the utilisation of the convention will be strategic rather that the response to a form of propriety. Other modes of writing and thus other ways of allowing the work to enter the frame of writing will be possible and thus will, in such writings' own utilisation of formal innovation, register the impact of any given work's insistence.

Sculpture and writing are at work in this issue. However neither is given an essentialised and therefore banalised presentation. Allowing for the singularity of work, allowing for its insistence, is to stage different registrations of that insistence. The articles presented here from the most abstract to the most direct can be taken as working within the opening created by allowing the ineliminable presence of the work to work.

John McCracken, Crystal, *1988, stainless steel, 56x46x19 cm, photo John Riddy*

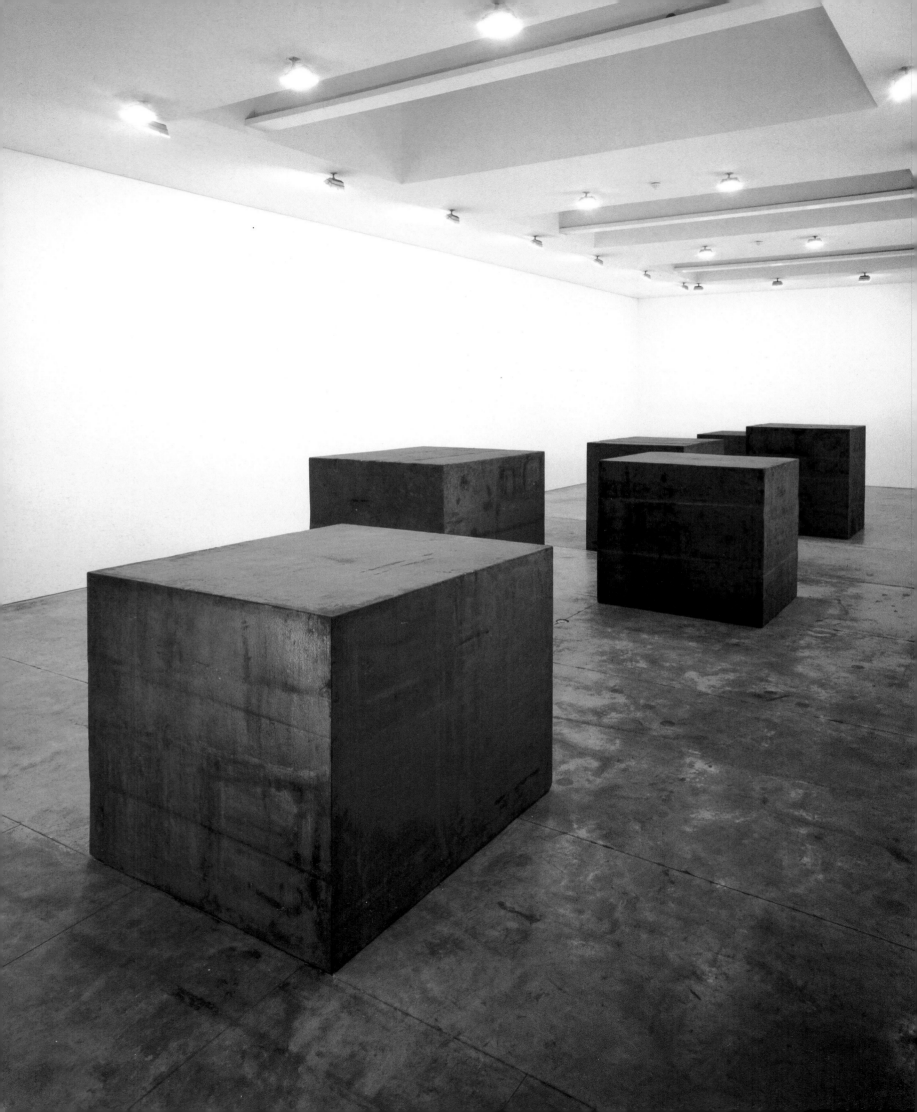

PIECING THE PIECES TOGETHER AGAIN

Phenomenal Objects, Pictorial Events

SAUL OSTROW

From the mid-50s through the 70s, sculpture embodied the dialogue between the 'real' (everyday) and the formalist project of self-representation and self-referentiality. Sculpture came to be located at the intersection of the Modernist pursuit for essential form and the philosophical investigation of the relationship between mind and matter. Both of these analyses had come to focus on our ability to construct generalisations based on isolating the various individual qualities of an experience or a phenomena. Ironically, this conjunction which brought sculpture to the fore, eventually led to the near dissolution of sculpture's difference from and its absorption into the 'real'. By the late 70s all that stood between the viewer (beholder of art) and a world full of potential sculptures was an institutional framework and a historically defined conceptual context.

The variety of material objects, situations and acts that came to be included in the category traditionally known as sculpture, seemingly confirmed that its identity was an assemblage of diverse concepts and agendas. Formalism's dialectical process of seeking greater specificity of content and form was generating results that contradicted its premise. It became difficult for artists and audience alike to imagine that art's forms were conflicted 'selves' circumscribed by an on-going process of defining their ontological 'Self'. It was this that seemingly closed abstract art off, by exposing it to Modernism's most dreaded criticism: that as a form it was arbitrary.

The course of events that led to the near demise of sculpture as a category of specific objects begins in the mid-50s when the effect of the mass media with its capacity to record, store and play back images and sounds in the comfort of our own homes had begun to make us sense the fragmentation and loss of what had once been the domain of the body and memory. Suddenly we found ourselves living in a world of ethereal voices and endless repetitions of ghostly images, first in black and white and then in 'living colour'. As the time/space of the pictorial was being converted by the simultaneity of electronic media into the 'here and now', vision was becoming dissociated from the bodily experience of tactile objects. The ear was becoming the equal of the eye as a source of information and the complex network of our senses and emotions was being fragmented. Each aspect of our sensory life was relegated to its own individuated territory within a world of intangible representations from the latest music to yesterday's news. The mind/body split was being resolved by the technological displacement of the body.

The mass media in the years of its emergence (1910-30) was perceived as a threat to authentic experience. The Frankfurt School and other left-leaning intellectuals were already sensitive to its potential effect not only on culture as a whole, but also on an individual's perception. By the 1950s these mediums had become the dominant means to externalise, objectify, synthesise and communicate information and experiences. The avant-garde which both resisted this trend and used it to challenge cultural stasis found its own position at the time to have been co-opted. Its own critical terms and practices were gaining institutional status and their 'Art' was being converted into an object of historical determinacy rather than a source of sensory data and self-reflection. As society became more uniform and centralised, museums in keeping with the post-war idealisation of democracy, began to be reconceived as educational institutions whose task was to make our cultural heritage and contemporary production more accessible. Given the relative prosperity of the time, culture was gaining a social status in direct proportion to the degree that painting, sculpture, architecture, and even nature, was increasingly only known through book and magazine reproductions. Such images constituted what André Malraux had dubbed the 'museum without walls' and functioned in accordance with the emerging electronic media's undermining of the sensuous conditions of our material existence.

Technology's alteration to the discourses and habits of daily life in the mid-50s combined with experiences of the Depression and the Second World War resulted in a reappraisal of the philosophical and historical views concerning agency and the cultural vision of capitalism. The ensuing disorientation and dissatisfaction caused by this manifested itself in a cultural revolution that sought to produce new subjects and imagery from which a different social and cultural order might project itself. The collective intent, though made up of diverse and differing agendas, was to dismantle the master narrative embodied in the existing system of representation and replace it with new concepts and values. At first, this undertaking manifested itself as a struggle for new freedoms, morals, and a re-ordering of society's priorities. The consequence of this was the struggle against racism (civil rights struggle and ethnic pride), war (Vietnam and the arms race), and eventually sexism (women and gay liberation), as well as a counterculture whose anti-establishment stance and do-it-yourself ideology found expression in its attitude towards drugs, sex and

Richard Serra, 58 x 64 x 70, six forged steel blocks, each block 147x162x177 cm (58x64x70 inches)

rock 'n' roll, as well as the slogan, 'Tune In, Turn On, Drop Out'. These two trends, drop out and reformist, were the result of the baby-boom generation and differing social and ethnic groups coming to realise that not only were they being misrepresented within the general cultural economy, they were also excluded from participating in it. Paradoxically it was only artists adhering to the traditional avant-garde stance who found solace by viewing their own marginalisation and economic failure as a mark of their success.

Culture, which once held the promise of being a noble and unifying mechanism, now appeared to be a field of inter related activities each with its own criteria and codes defined by the dominant ideology. It seemed that there were more parts to culture than could be sustained by the existing liberal–humanist model. In conjunction with this shift, the ideals of 'nature', imagination and self-expression which had been important tropes were being displaced by industrial models and the notion that all was artifice. Reciprocally, structuralist approaches to cultural and social anthropology became the theoretical basis for a challenge to the Kantian/Marxist dialectic model of progress that was the basis for understanding as well as critiquing the dynamics of 'bourgeois' culture.

Though represented as a crisis of spirit, Western culture was clearly experiencing a structural conflict between its material circumstances and modes of thought. The theories and practices that sustained Modernist culture had been formulated during the mid-19th century and had not been significantly revised since. By the end of the 1950s in an age of electronic media, the master narrative of humanism, individualism, progress and the practices premised on these, no longer seemed capable of ordering peoples' experiences or understanding. Partially this situation was a consequence of the uneven development of the relationships of the various national and international communities to the changing discourses that had affected Modernism's paradigms of historical determinancy, self-consciousness and emancipation. The liberal response to this crisis of the underlying principles of humanist culture and its capitalist base was that through decentralisation, these various groups would at least gain symbolic access to cultural representation. This position had long been a significant part of the left-liberal critiques of bourgeois institutions and their instrumental logic.

The problem with this model of pluralism was that for these parallel structures to be compatible with the general ideological goals of Western society, they would have to adhere structurally to the common criteria of historical determinism, individual

freedom and progress. In other words, in the field of cultural production, the arts of women, ethnic and national minorities, or works of regional importance would be acknowledged. This did not mean they would be considered significant contributions to general culture, because such judgments depended on the traditional practices of art history, criticism and philosophic speculation. These practices continued to be premised on a cause and effect logic whose primary task was to establish the relationship of a style, an object or a practice, to its historically determined category. Such determinations were inscribed within a dualism whose own logic was inevitably validated and replicated by its implementation.

The pressure to create pluralistic criteria did result in exposing the contradictions and dichotomies inherent in Modernism's practices, as well as the broadening of critical terms to include political, social and technological concerns. Even if this did not result in the inclusion of other cultural paradigms, it revealed that such terms were not just an intrinsic component of art's rationale, but also our social ideology and its substantiation. If there was nothing new in this realisation, at least this time, it had a significant effect. In response to this situation, the task of critics, art historians, philosophers, social and cultural theorists was transformed from describing iconographic interpretation or constructing historical continuums to proposing the very terms by which works of art could make aesthetic as well as social sense.

The effect of this questioning of cultural criteria and critical practices influenced a wide range of art writers from diverse backgrounds. Critics such as Harold Rosenberg, David Bourdon, Lawrence Alloway and Gregory Battcock approached the new art sociologically, emphasising not only its participation in the logic of industry, but also elucidating the political and intellectual ramifications of its newly emerging forms and practices. Significantly at this time a number of young art historians such as Robert Rosenblum, Michael Fried, Robert Pincus Witten, Barbara Rose, Rosalind Krauss, Cindy Nemser, Jack Burnham entered the field of criticism making it the central focus of their practices. They brought with them a sense of professionalism as well as the methodology and perspective of their discipline. This was something an earlier generation would not have done despite the fact that such notables as Meyer Schapiro, Leo Steinberg and Duane Anderson had dabbled in the criticism of contemporary art.

Counter to the stance of these art historians, Lucy Lippard (even before turning to feminism and political activism), John Perreault and Wiloughby Sharp viewed their own efforts as a

form of artistic collaboration or intervention. They focused their attention on evaluating the social and political terms and context in which works of art came to have meaning. Besides these critics there was a growing tradition that seems to begin with Barnett Newman and Ad Reinhardt of the artist as critic. By the mid-60s such artists as Allen Kaprow, Fairfield Porter, Donald Judd, Sidney Tillim, Walter Darby Bannard, Robert Smithson, Robert Morris, Tony Smith, Joseph Kosuth, Dan Graham and Mel Bochner had begun to use their readings in symbolic logic, philosophy, psychology, sociology and cultural anthropology to write extensively on the theoretical and art historical premises of their own work as well as that of others. These artists/writers perhaps more than anyone or anything else transformed the traditional relationship between artistic and critical practices.

By the end of the 60s, critical writings and artists' discussions were peppered with philosophical terms and references to the works of Ludwig Wittgenstein, Marshall McLuhan, Alfred North Whitehead, Herbert Marcuse, Thomas Kuhn, Karl Popper, George Kubler, Claude Levi Strauss, Merleau Ponty, Susanna K Langer, Robert Quinne, Morse Peckham, Noam Chomsky and Norman O Brown among others, as well as such subjects as game and information theory, symbolic logic, developmental psychology and linguistics. They found in these thinkers and subjects allies in their struggle against the homogenising and historicising stance of formalism (in the USA) and *Art Concret* (everywhere else) which had come to dominate abstract art.

The search for new critical, theoretical and social foundations upon which to recuperate art's materialist project as well as absorb (rather than replicate) the influences of mass culture, paradoxically hinged on the influence of Clement Greenberg's vision of Modernism. This vision which was already under criticism was based on the argument that art could only be maintained if artists were indifferent to extra-aesthetic issues. From Greenberg's perspective, this was the only way to preserve culture's autonomy and safeguard the ideals of individualism, creativity and self-expression. The irony is that the mixed goals of the Minimalists, Post-Minimalists and Conceptualists, all of whom opposed his views, were as much informed by this formalist conception of Modernism as they were by their opposition to the restrictive nature of its proscriptive practices, and goals. To this day Greenberg (though now dead), by making formalism central to any discussion of abstract art, controls this critical discourse.

Clement Greenberg who wrote little on sculpture opposed any art that was dependent on ideation, systemisation and reductivism. This closed Minimalism off from any consideration other than critical dismissal. He viewed all artists who ostensibly sought to extend the means of representation or expression to new mediums and forms as engaged in minor practices, didactic exercises and non-essential commentaries. At best such practices were premature and at worst banal. All of this 'nonsense' for Greenberg had no place in the realm of the art (aesthetic) 'experience' which was to remain subjective, sensuous, historically determined and resulting in a non-specific self-consciousness.

From Greenberg's perspective, the goal of abandoning or transforming art's traditional forms could only result in the relinquishing of Modernism's objective of producing an art that would be cohesive and specific within its history, or an exercise in self-indulgent nihilism. 'Art' has no worse enemy for Greenberg, than the total availability of all forms, for this results in aestheticisation and the regression of art into a world of arbitrary effects and objects which leads to a nostalgia for what had been (conservative reaction). In either case, 'true' avant-garde culture would suffer so the only way Modernist culture could continue to exist was by sustaining and protecting the Western tradition, its forms and practices against the encroaching world of standardisation, repetition and middle-brow desire for an art that would represent their values and understanding. Greenberg proposed the only possible resistance to this situation was an art for art's sake that manifested a self-conscious desire for that which is knowingly impossible to realise. Such a practice, he theorised, would give the viewer access to concrete experiences and possibilities. In Greenberg's case this 'impossibility' seemingly was a moment of un-alienated self-consciousness.

What differentiates Minimalists such as Donald Judd, Carl Andre and Sol LeWitt from such formalists as Anthony Caro, Michael Steiner, Isaac Witkin, James Wolfe and Joel Perlman, resides less in their approach to materials, form or process, than with what they hold to be a desirable relationship between the work of art, the viewer and society. Both groups use industrial materials, non-illusionistic structures and they have in the main abandoned traditional means such as casting and carving. In his essay 'Art and Objecthood', Michael Fried identifies the confrontational anonymity of Minimalism as theatrical (the work's effect comes from an extrinsic logic) in that it makes the viewer self-conscious of being outside the work. Fried instead ascribes to the idea that sculpture such as Caro's produces an 'absorptive' effect, allowing the viewer to dis-

cover the decision-making process (the intrinsic logic) that had gone into the work. Through reflection it is assumed that the viewer would come to identify with the human being behind the work, rather than the object itself. To what effect? To induce a humanist self-awareness on the viewer's part. Fried's problem is, or was, that he did not or could not see (with the exception of his support for the work of Frank Stella) that the Minimalists were seeking in materialist, rather than transcendent or idealistic terms, a similar goal.

Despite this 'critical' war and the rhetorical remarks concerning the necessity of maintaining, escaping or dismantling formalism's goals, the events taking place within the cultural field of the late 60s and 70s can now be understood as being fabricated upon differing interpretations of how and to what ends artists were to investigate the nature of 'Art's' specificity, challenge its audience, and induce consciousness. Seemingly it was the realisation that this was not an either or situation that led Rosalind Krauss in the mid-60s to denounce Greenberg and his circle as cultish. She then embarked on a project of dismantling both their critical terms and their criteria, seeking to demonstrate that the formalist project was premised on nothing more than Modernist myths. In 'Sense and Sensibility' she addresses Minimalism from this perspective, demonstrating that while these works are the product of ideation and systematisation, they are not antithetical to formalism, but extend its terms beyond essentialist tendencies and historicised goals. Using 'structuralism', she constructs a parallel formalism that allows her to approach such work as a carrier of extra-aesthetic content as well as art historically and phenomenologically. Yet even this view arises from and exists within the then dominant formalist model of Modernism.

In opposition to the increased reification of Modernism's principles, the romance of self-expression and the metaphysical goal of inducing a self-consciousness capable of taking pleasure in its own consciousness, there emerged a collective attitude among artists who were engaged in the idea of producing the most advanced work the Western tradition would allow. Their view was that Modernism was becoming academic and esoterically élitist while formalism itself led only to the decorative and respectable. What these artists strove to produce was an art that would induce a different and more socially useful, self-reflective consciousness. Under the pressure of the short-lived period of cultural revolution (1962-76), this task came to be focused in an attempt to differentiate between the effect of the literal object and its signification through metaphor and simile. The result was an investigation of the inter-relationship between process (making), duration (perception) and interpretation that connected the mind to the object of our senses. Temporality (the transitory) and reception (interpretation) came to be proposed as the principles underlying both the subject and the object of 'art and life'. The models for this approach were to be found in the materialism

of Jackson Pollock's paintings, once the transcendental and psychoanalytic mumbo jumbo that had been attached to it was severed.

Such changes in outlook and practice were the product of the cumulative effects of a tradition that had pressed its forms, aesthetic ideologies and their content to the extreme. This situation, combined with the changes wrought by technology, had begun to make art appear to be objectively nothing more than a formless edifice of amorphic possibilities waiting to be transformed into concrete and persuasive propositions concerning 'Itself' or its institutional existence. The result was that art's categorical imperatives were losing their coherence and its social status as a necessary service was brought into question. Ironically by this time both 'Art in the Age of Mechanical Reproduction' by Walter Benjamin and 'Avant Garde and Kitsch' by Clement Greenberg had become mandatory reading for artists, critics and theorists alike. These writings, perhaps more than any others of their time (written respectively in 1937 and 1939), reflected the general struggle taking place within Western society between an as yet underdeveloped idea of synthetic multiplicity and the existing ideal of reductive singularities.

Artists emerging in the wake of Minimalism abandoned the look of objectivity and instead pursued a rational subjectivity. They sought to create new subjects, forms, formats and modes of production, as well as sensibilities capable of producing an art that would be socially, if not politically, relevant, without having to negate Modernist history. The approach of these Post-Minimalists constituted a pragmatic investigation of what lay beyond an adherence to binary oppositions, reductivism and nihilistic reverie. To achieve this, they found it necessary to rethink the nature of art's autonomy and its processes as they connected with such themes as 'everyday life', 'life into art' in the age of mass media and 'cultural revolution'. From this perspective, the cultural field was assessed to be a potential testing ground for the re-ordering of our relationship to the material world. In this we can see a variation of both Greenberg and the Frankfurt School's theme of an art for art's sake that is a manifestation of a self-conscious desire for that which is knowingly impossible, yet capable of producing concrete models and experiences. By the 80s, this situation was reversed, meaning took precedence over experience, and the object functioned as a signifier and a commodity.

The fact that these technological, political and social events inscribe themselves in the field of sculpture, rather than painting, has much to do with the fact that the generation of artists associated with Post-Minimalism had come of age in the late 50s, early 60s. They had witnessed the impossible dilemma of Abstract Expressionism's '2nd generation' which had led to Pop Art's return to figuration. A decade later they still felt that they could never surpass the First Generation's achievements within the framework of abstract painting. Sculpture on the other hand continued to be an underdeveloped form.

It is important to recount briefly how sculpture escaped its indebtedness to its Cubist, Constructivist and Surrealist past. In the mid-50s, the only way forward appeared in John Cage's understanding of Marcel Duchamp's attitude and practice. Cage proposed that any sound could be used in a musical composition. This was mirrored by his friend Merce Cunningham who used any bodily act as a dance movement. This attitude was taken up by a coterie of young artists with whom Cage came into contact at Black Mountain College. These artists soon came to include in their work materials from everyday life or emphasised the potential commonness of art's forms. This grouping includes Jasper Johns and Robert Rauschenberg. Later, in 1958, Cage taught a composition class at the New School for Social Research in New York City which included Allen Kaprow, Dick Higgins, Al Hansen, George Brecht and Toshi Ichiyanagi, all of whom came to be identified with Fluxus. Other people who visited Cage's class at the New School included George Segal, Larry Poons and Jim Dine.

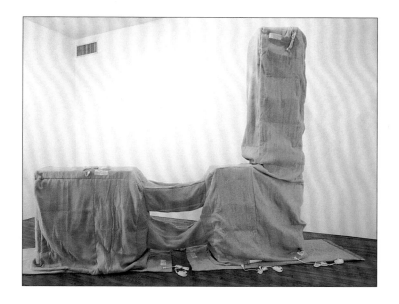

Another trajectory typified by the work of John Chamberlain, Lee Bontecou, Bruce Connor, Ralph Ortiz and Robert Mallory involved the revival and expansion of the concept of assemblage. These artists, among others, rescued assemblage from the quasi-figurative Surrealist kitsch it seemed destined to become by bringing to their work an anti-aesthetic stance that emphasised vulgarity, abjection and a fierce sense of physical reality. Using found objects, trash and unusual materials within a strongly formal syntax, this approach combined with a Duchampian indifference and irony, resulted in assemblage and collage being transformed into literal objects, installation and 'happenings' whose forms, contents and materials referenced the real world.

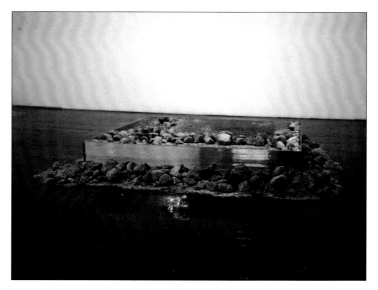

In part the development of assemblage as an alternative to painting and sculpture by Johns and Rauschenberg allowed those artists who later would be identified with Minimalism to recognise the interface between painting and sculpture. Even Jasper Johns's painted bronzes (such as the beer cans and especially the *Savarin Can*) acknowledge this point of confluence. This led to the dismantling of the privileged position that painting had in Modernism. Freed from the project of seeking their essential being, sculpture and painting moved towards the mutual identity of being literal objects. In this environment painting's process, materials and issues were themselves deterritorialised, in that painting was now defined as both an object and a process. It was the nature of its forms and processes that prevented it from being perceived as synonymous with sculpture. Within the domain of the 'real', painting and sculpture were recognised as comparable categories with shared qualities and concerns. If painting's objecthood were emphasised it became sculpture, the inverse was true of sculpture, pushed towards the pictorial it became painting. A hybrid form that was neither painting nor sculpture, but would have the best qualities of both, Judd called a 'Specific Object'.

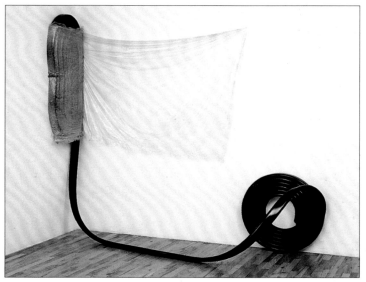

ABOVE: Jack Risley, Double Bin Hi-Lo, *1992, cardboard boxes, electric blankets, 441x297x111 cm; CENTRE: Robert Smithson,* Rock Salt and Mirror Square #1, *1969 (Estate of Robert Smithson); BELOW: Paul Dickerson,* Distension, *1993, rubber, stretch wrap, steel, 223 cm high, width and length variable*

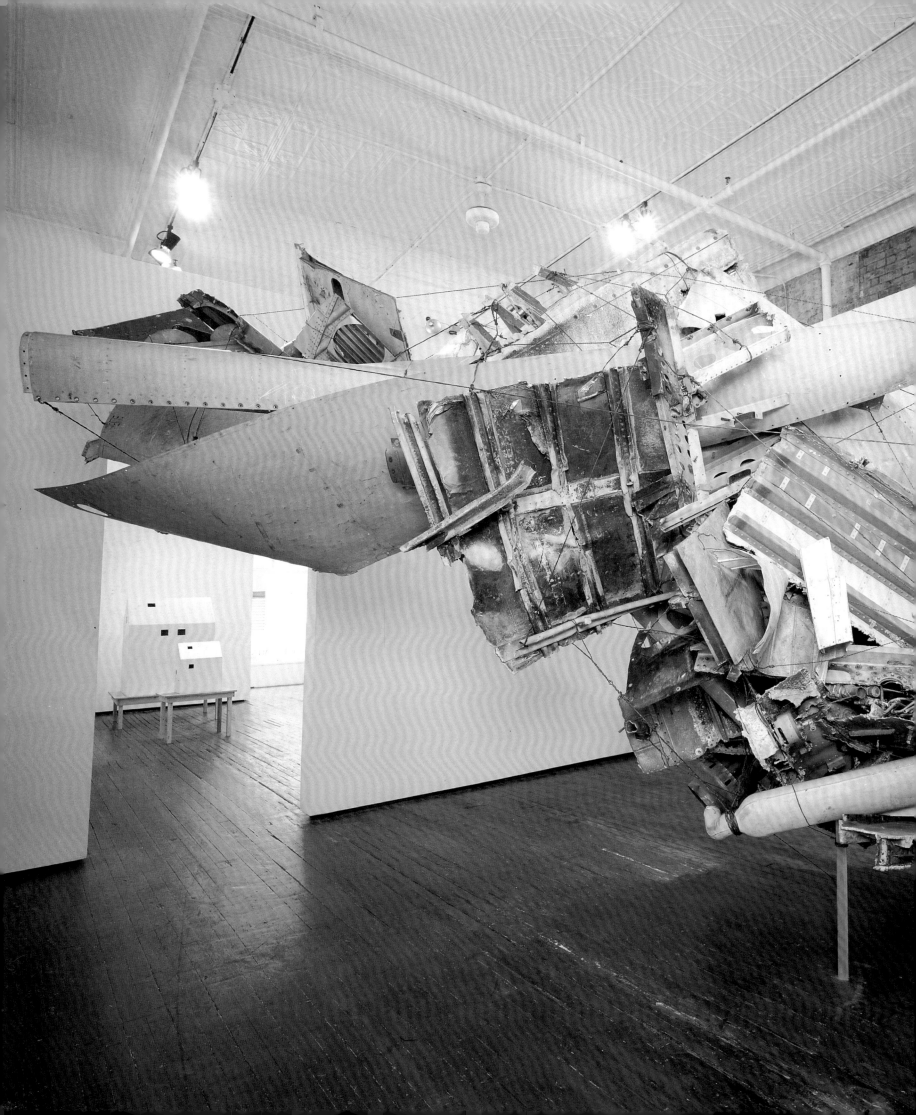

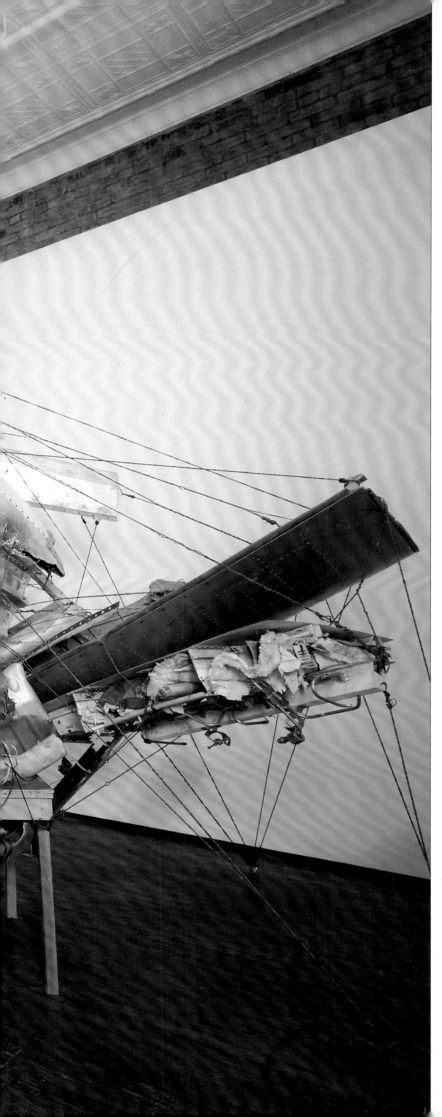

While Minimalism was conceptually, though not procedurally elaborate, it was the dumbness of the experience of Minimalism that challenged not only the status of art's forms, but also what constituted art's content. Minimalism shares with Pop Art the strategy of producing contra ready-mades, objects whose anonymity invests them with the qualities of a ready-made. Such objects transformed the 'transcendental moment' idealised by Abstract Expressionism into a mundane confrontation with an unexceptional object. The success of Minimalism in revitalising sculpture as an idiom as well as dissolving the traditional distinction between painting and sculpture, brought with it a sense of closure. This shift was reflected in the artists' language, for they began to refer to what they did as 'the work' or as 'a piece', rather than as paintings and sculpture. This gave rise to the question that if the art object's essential identity and form had been resolved and art no longer had forms with terms of its own, what was this thing art to be and what could it represent? Momentarily the answer was that art could not be differentiated from any and every other situation, event or environment.

As a response to sculpture's increasingly tentative identity, many artists began to become concerned with issues of what may or may not constitute public sculpture. This newly defined arena was quickly filled with large-scale geometric and constructivist sculptures. Their remains now populate the elephant graveyards that were once the sculpture parks and public plazas promoted by the 'enlightened corporations' and municipalities that once sought to be art's patron. In part those artists who took on the task of producing these gargantuan works had misunderstood the message of Minimalism and formalism's scale. Minimalist works even when they are large are still scaled to the human body rather than dwarfing the viewer the way urban architecture had come to do.

What lay beyond the 'specific objects' and related works of artists such as John McCracken, Larry Bell, Jackie Winsor, Ron Cooper, Robert Irwin, Mary Corse, Doug Edge, Les Levine, as well as public sculpture, were the earthworks of Michael Heizer and those of Robert Smithson and Robert Morris, including the scatter pieces of the latter two artists. Then there are the nearly ephemeral installations of Robert Irwin and James Turrell and the photo-based works of Mel Bochner. The abandonment (around 1965-66) of the Minimalist object marked the beginning of the short-lived era of Post-Minimalist experimentation. This was premised on the idea that the art experience is the by-product of a social event rather than being embodied in an aesthetic 'object'. Increasing numbers of adventurous artists willing to risk all, set out to define the physical limits of art's formal and expressive parameters. This examination of art as phenomena was elaborated by an indiscriminate and literal understanding of formalism's principle of truth to materials, Duchamp's aesthetic indifference, a concern for the sensate experience of the viewer, and the artists' re-conceptualisation

Nancy Rubins, Small Table and Airplane Parts, *wood table and airplane parts, 563x289x317 cm*

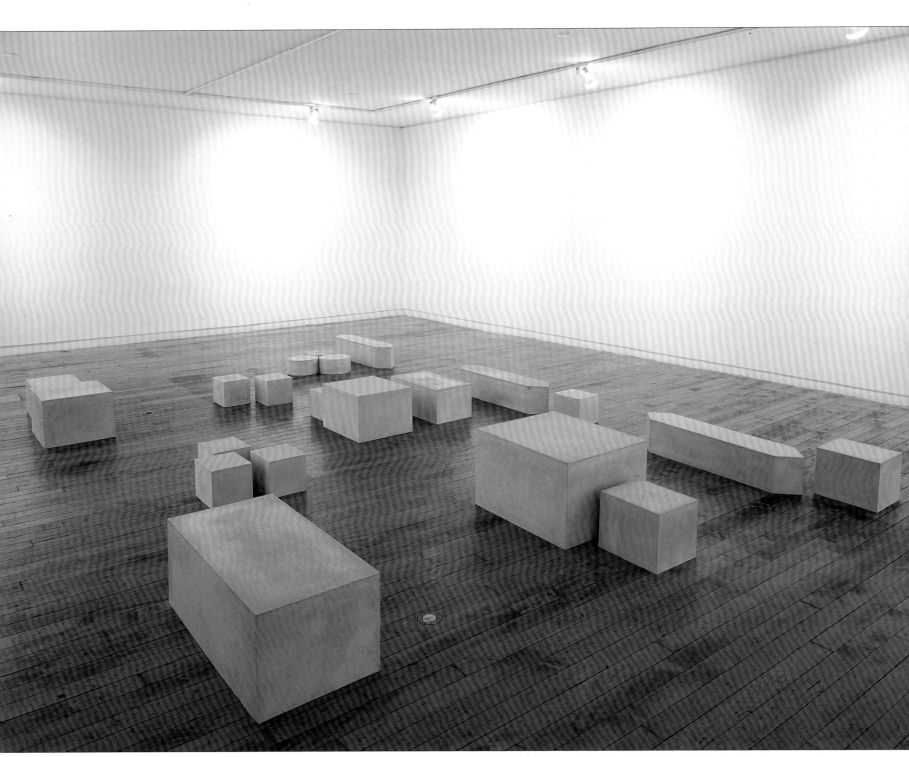

Barry LeVa, Separated, Catalogued, Sealed, Eventually Joined, *1995, cast ultra cal, lutex, sand, 350x564x43 cm*

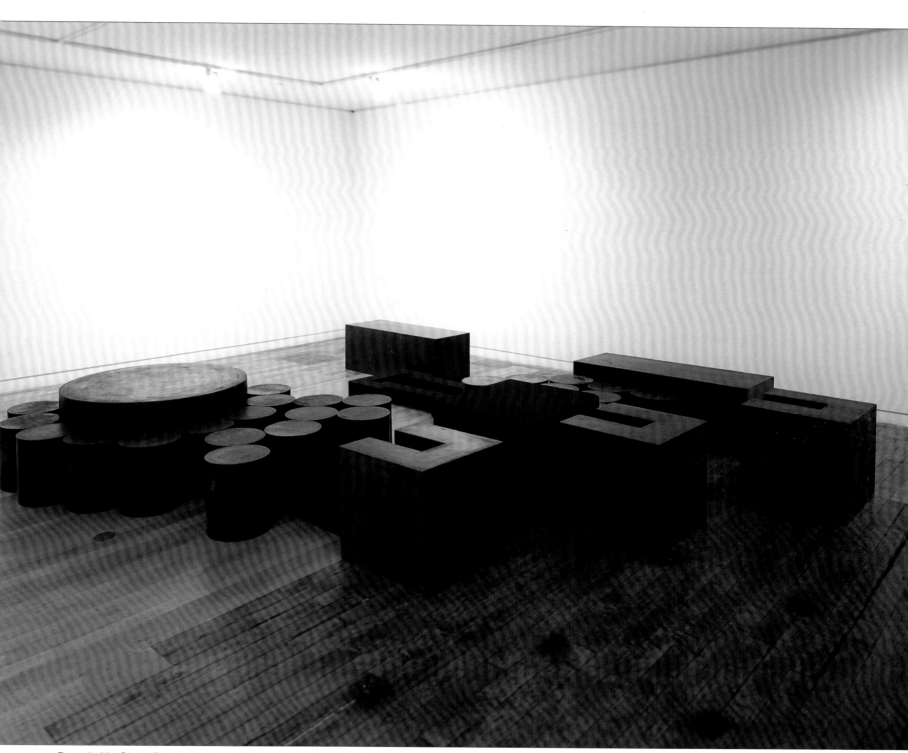

Barry LeVa, Clot – Pushed from the Outside, *1995, cast hydra-stone, rubber, 378.5x460x51 cm*

of their own practices (and bodily presence).

Post-Minimalism's cut through Modernism's ontological bias challenged its epistemology and re-ordered the premises that bound viewer, art object and artist together. The resulting works were characterised by a 'work-in-progress' aesthetic, a de-objectification that emphasised the artists' engagement with the physical properties of materials, basic processes and a heterogeneous methodology. Robert Morris's 1969 exhibit at the Castelli Warehouse was entitled 'Continuous Project Altered Daily'. For the duration of this exhibit, Morris would go to the gallery daily, some days he would work playfully with the broad range of materials stored there, at other times he would perform preconceived tasks.

As with Abstract Expressionism, within the structure of what had become known as Post-Minimalism, irreconcilable differences were conceived of as divergent states mediated by differing concerns and criteria. Sculpture thus came to include all manner of events (actions and performances), industrial materials (plastics, resins and rubbers), media (film, video and electronics) and modes of presentation (site-specific installations, street works). Even photography came to be an acceptable surrogate when used to document such temporal or inaccessible works as earthworks, installations, performances or walks in the English countryside. What held these diverse practices, mediums and forms together were conceptual congruities rather than stylistic consistencies. The consequence was an indexing of those elements that had come to be perceived of as the terms and conditions of cultural expression. This is what should compel us to consider that the period of the mid-60s and 70s, rather than that of the 80s, represents the emergence of a *Post*-Modernist model.

The variety of Post-Minimalist practices extended from the works of such artists as Richard Serra, Barry LeVa, Laddie John Dill, Hans Haacke, Eva Hesse, Keith Sonnier, Mel Bochner, Jackie Winsor, Robert Rohm, Rosemary Meyer, Richard van Buren and Linda Benglis that in the 60s and 70s focused on material processes and chance structures, to the work of Richard Tuttle, Neil Jenny, Louise Bourgeois, Robert Lobe, Alan Saret, Bill Bollinger and Martin Puryear who produced eccentric objects. Other artists whose works contribute to a definition of Post-Minimalism are those such as Gordon Matta-Clark, Michael Asher, Michael Heizer, Nancy Holt and Mary Miss, who all developed the site-specific and post-studio practices that moved sculpture into the realm of architecture and environment, while Richard Artschwager, Gary Kuhn, Walter de Maria, Steve Kaltenbach, Vito Acconci, Dennis Oppenheim, Scott Burton, Chris Burden, Bruce Nauman and Eleanor Antin recognised that objects had anecdotal potential. Beyond this Joan Jonas, Peter Campus and Michael Snow among others applied structuralist concepts to produce self-referential films and media-based installations. Intersecting these works were the object-oriented 'post-paintings' of David Navaros, Paul

Mogensen, Ron Cooper, Craig Kaufman, Tina Gerard, Alan Shields, Mary Corse, John Torreano, Frank Stella and Dorothea Rockburne. Obviously these categories are not fixed or rigid and there is much crossing over in that artists such as Smithson and Morris, first identified as Minimalist, also become identified with Post-Minimalism. Others such as Keith Sonnier, Richard Serra and Bruce Nauman were exploring films and videos while Mel Bochner, Dorothea Rockburne and Michael Asher were at times thought of as conceptual artists.

Such provisional headings as feminist art, anti-form, eccentric abstraction, kinetic art, intermedia and multimedia, process art, anti-form, ideas art, earthworks, environmental and installation, site-specific works, performance and video were all constituent parts of Post-Minimalism. Within these there were an amazing array of sub-categories and regional hybrids. For example, in California, William Wiley, William Geist and Robert Hudson produced what was known as funk art while Terry Fox, Tom Marioni, Paul Kos and Howard Fried had developed their own brand of conceptualism that mixed ritual and Dadaist humour. In Europe, trends such as Italian Arte Povera, the French Support/Surface group and the work of such German artists as Blinky Palermo, Imi Knoebel, Klaus Rinke, Rainer Ruthenbeck, Ulrich Rückriem and Franz Erhart Walter developed related types of work under different circumstances. Similar and parallel developments also took place in England. In part during sculpture's dark days in the 1980s, it was the English that maintained the tradition of making sculpture. It must be noted that none of these lists of artists or categories are definitive, they are presented only to illustrate the wide variety of themes and approaches that are encompassed by the general term Post-Minimalism.

These trends which put sculpture at risk in the process of revealing, articulating and producing itself stem from Modernism's dominant discourses. The difference in Post-Minimalism's approach to revealing art's 'self' was that it abandoned the idea of achieving a fixed definition or teleos. Instead, at a time when art and what it may represent was being threatened, the task at hand was how to keep it in play. In part, Post-Minimalists were engaged in a process that both unfolded and enfolded the terms by which art could maintain itself and resist the transformation of its viewer into a disembodied spectator.

In what had become an age dominated by mass media and communications, body and sense-oriented activities no longer corresponded to our experience. The idea of being able to discern an artist's intent, no matter how baffling or insignificant the content, held greater appeal than being confronted with the perplexing task of having to give order to and make sense of one's own experiences. Having been denied a position outside the situation from which it may be viewed and analysed, sculpture coming down off its pedestal, shedding its objecthood, became a space that could be occupied. The practice of sculpture as a source of experience and reflection

bound to material relationships had become a field of indeterminate effects. By inventing forms that did not differentiate inside from outside, sculpture moved closer to the real making for an even more threatening situation. Seemingly nothing was left of the Modernist ideal of specificity and any object could now occupy the space of sculpture.

By emphasising human scale, material properties (but not assemblage), and varied forms (both derived from process and logically structured), sculpture offered artists such as Robert Irwin, Richard Serra, Bruce Nauman and Barry LeVa among others, the means to address the perceptual versatility of the body and call attention to its role in the intellectual process of determining meaning or arriving at an understanding of its conditions. By inviting such an engagement their work encouraged the viewer to take an active part in determining the terms and conditions of the works as objects of knowledge rather than of judgment. Such work, while emphasising the experiential, did not substitute or pit the aesthetic against the intellectual, but made these two processes reciprocal. By playing out all possible variations, symbolic, psychological and perceptual, this work maintained the utopian quality of Modernism without being didactic. It supplied a model that impacted on our understanding of how we negotiate new and unfamiliar situations everyday.

The very practices of Post-Minimalism in their paradoxical embrace and dismissal of the traditional practices and goals of the modern artist can be considered a premature manifestation of *post*-Modernism. This *post*-Modernism, unlike the 'Post'-Modernism of the 80s, resisted the hegemony of equivalency, for it was premised on a heterogeneity that did not require a cynical abandonment of Modernism's transcendental project of self-consciousness, emancipation and autonomy. Within this *post*-Modernism, images of images, paintings of paintings, appropriations and simulacra are a senseless exercise in futility. These artists understood that appearances are deceptive, formats are expendable, and that commodification posed a threat to authentic experience as well as art. They did not need to help promulgate this state of affairs.

The cultural field by the end of the 70s or the very early 80s was again recording the effects of mass media. This time the effect was not one of detachment and divisiveness, but instead a passive acceptance of the spectacle the media was able to produce. Post-Minimalism's emphasis on the experience of process and duration was replaced by a focus on the processes of signification and mechanical reproduction. It seems that within this period when art has become more demanding, more unfamiliar, the demand for cohesion and comprehension is raised once again. This demand is met by a renewed emphasis on recognisable subject matter and extra aesthetic explanations. In keeping with this hypothesis, much of the work that came to be identified with the first wave of Post-Modernism took as its content, ironic commentaries on art's

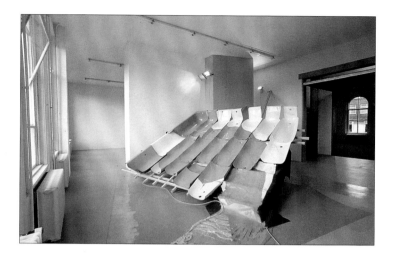

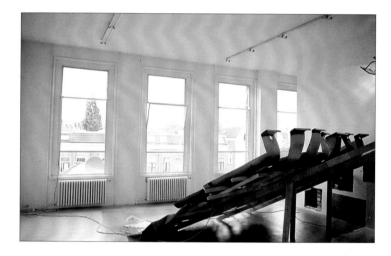

Jessica Stockholder, Catcher's Hollow, *1993, paint, bathtubs, lumber, silicone caulking, lights and wires, coloured filter, paper, 4x14x8 m, installation at Witte de With, Rotterdam, 3 views*

Paul Dickerson, Surfeits, Surfactants, *1996, mixed media*

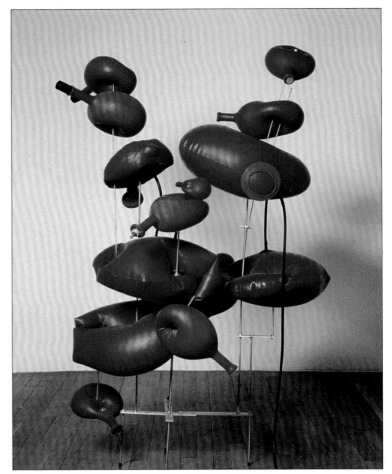

Peter Boynton, Red Balloon Piece, *1995, latex balloons, rubber stoppers, hardware, air pump, 139x99x50 cm*

commodification and our own ignominious (and often puerile) tastes, desires and cultural identity as constructed by mass media and pop culture. Reciprocally, the work produced recontextualised familiar experiences rather than attempting to generate new ones instead. A consequence of this was a proliferation of works that dealt with the representation of the body, or addressed its newly anaestheticised state but did not engage it.

Building on the success of Bruce Nauman and the accessibility of the content of those sculptors who had worked in a conceptual/anecdotal manner (Terry Fox, Tom Marioni, Paul Kos, Howard Fried, Richard Artschwager, Gary Kuhn, Steve Kaltenbach, Vito Acconci, Dennis Oppenheim and Chris Burden), the generation of artists who would come to be known as Post-Modernists such as Jeff Koons, Haim Steinbach, Robert Longo, Mike Kelley, Allan McCollum and Sherrie Levine came to depend on using objects arranged in accordance with semiotic principles to re-territorialise and then liquidate sculpture's practice. What remained was the simulacrum of sculpture. This death or loss of identity can be likened to the Sci-Fi film *The Body Snatchers* in which aliens in the form of pods take over a town by replicating people's appearances. How one could tell the difference between replicant and the original was that rather than being warm and loving they were cold and

removed. In sculpture's case, what took its place was any three-dimensional object or sign meant to represent a series of accessible scripts and narratives.

Unlike Post-Minimalism's heterogeneity, 'Post'-Modernism made 'sculpture' an all-inclusive category – a dumping ground in which objects, installations and events function merely as signs. This mode of production, dependent on strategies of cross-referencing 'ready-made' social and cultural issues and based on the practices of mass media, was incapable of producing self-reflective disclosures. The short-lived result of this work was a didactic and simplistic generic sculpture. 'Post'-Modernism's project of reformulating the critical terms, practices, purposes and forms of art quickly became subsumed by the very rococo model that Modernism had set out to erase. The difference was that it produced its conventional representation not as still lifes, but tableaux of dime-store objects.

Given that 'Post'-Modernism's now banal and academic practices seem only capable of reducing art to memorabilia, Post-Minimalism's model of art and what it may represent is returning. No longer seeking the solution to historically defined problems, artists have begun to seek new strategies that would allow them to secure art's practices and history once again. Their disregard for the idea of mythic rupture, apocalyptic ends to art, or even progress, have allowed them to embrace

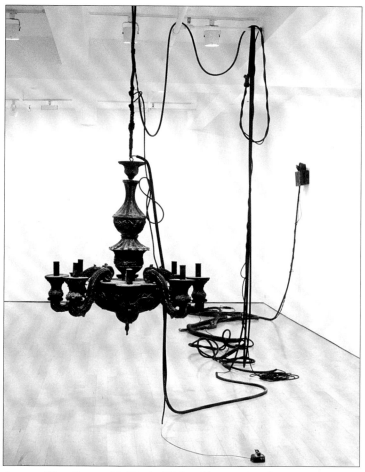

Jeanne Silverthorne, Untitled, *1994, rubber and resin*

Jack Risley, Multiple Blanket, Multiple Bin, *1993, steel, cardboard boxes, wool blankets, 218x203x132 cm*

heterogeneous methods and goals. What they therefore bring to the task of generating a *post*-Modernism is not only a consciousness of the potential that lies within the realm of their social, cultural and institutional concerns, but also the message of the means of presentation. This re-engaging of sculpture as a complex and interactive situation simultaneously rebukes and acknowledges that 'Post'-Modernism's disregard for formal and aesthetic issues produced an equilibrium which now requires a self-critical stance on the part of the artist.

The consequence of this reappraisal of both art and its impact upon the viewer has led to works that emphasise the variety of ways that a subject can be made 'real' or objectified outside the simple and most commonly available modes of representation. Within the installations and assemblages of such artists as Paul Dickerson, Jessica Stockholder, Nancy Rubins, Matthew McCaslin, Polly Apfelbaum, Bill Albertini and the objects of Curtis Mitchell, Charles Long, Jack Risley, Lisa Hoke and Peter Boynton among others we find the formalist and materialist concerns associated with Post-Minimalism have been recuperated. Subsequently in order to explore the relationship between the somatic, the semiotic and the construction of meaning, artists as different as Cady Noland, Jeanne Silverthorne, Matthew Barney, Jason Rhodes, Glenn Seator, Andrea Zittel and Dan Peterman have employed the meta-

phorical potential of Post-Minimalism's structural concerns as the armature for their works.

This return to the aesthetic and themes of Post-Minimalism is not a simple return in kind, instead, these works are marked by the changing conditions not only of art in the intervening years but also of culture in general. A simple return would involve only an interest in style, yet these artists' adaption of this mode of thought once again puts art in jeopardy of not being art. This is done by placing the viewer, not representation, at the centre of their practice. By seeking to give physical form to patterns of social behaviour and cultural narratives, they also re-investigate the connection between experience, the means of representation and their reception. Though such endeavours now may not be seen as a radical break, they do function subtly as a form of revision and differentiation, for it allows them once again to objectify their own visions and potentially to engage those processes by which art and its history are transformed. It is their heterogeneous approach to this task that links them to a *post*-Modernist quest for a fluid and responsive sense of authority and authenticity, which differs from the hegemonic vision of Modernism. This renewed concern is resulting in practices that are now mapping their disparate discourses onto the complex space that was once defined by Modernism's ideal of a totalising transcendent unity.

ELEVEN THESES ON SCULPTURE

JOHN LECHTE

I

The view that there is an essentially material sculpture object needs to be rethought. This is not because of the palpable diversity of claimants to the sculpture mantle (from ready-mades and relief constructions through Gilbert and George to installations, conceptual and musical works, etc), but because sculpture is an idea. In what, then, is it not possible to find the sculptural? – a question raised with particular force by the work of Joseph Beuys.

Sculpture does, then, appear *in* something. Indeed, although it is an idea, it would be wrong to think that the sculptural can appear independently of the sculptural image. It would be wrong, in effect, to think that the sculptural does not appear. The sculptural image is the sculptural, but this image is not contained in familiar genre categories. Modern sculptors have never tired of making this point.

'Image', to be sure, evokes Plato's *eikon* – and the oft-made point that were there no difference between image and Idea (*eidos*), the image would be a poor *eikon* (cf Krell[1]). More than this, were the image not 'defective' in some way in relation to its Idea (model), there would be no image, and no appearing of the Idea either. Consequently, just when sculpture had seemed to shake off a putative idealism concerning its essence, this radical refusal of circumscription has led to the need to recall once again the relationship between appearance and Idea.

Of course, the very notion of the sculptural – and thus of sculpture in general – fails to do justice to the particular work of sculpture. Well, maybe we have to get used to the idea that it is precisely the individual instance of sculpturality which ultimately contains sculpture in general. Every profound sculpture, therefore, is one that addresses the question of sculpture as such. The question: What does it *mean*? is now replaced by the question: What is sculpture? – just as the profundity of Joyce drives us to the question: What is literature (writing)?

The diversity of the sculptural is thus not to be understood in terms of the Romantic view of the artist with something unique to express. Indeed, the sculptural is not simply an ideolect, or the equivalent of a dream script; for every instance of the sculptural also evokes the history of sculpture.

Nevertheless, is it not necessary to admit that something is 'said' by the individual sculptural piece – something that transcends its aesthetic status, as in a Hans Haacke installation?

The answer must be in the affirmative, and all the more so since pure aestheticisation evokes the spectre of the simulacrum:

the entity which refers to nothing but itself – endlessly. The issue at stake, however, is not specific to sculpture, but applies to all the arts and their histories. Such a question cannot be entirely resolved within the sphere of the sculptural.

II

The sculptural moment is not just visual, but also tactile. But it evokes touch as much as it entails real touching. Similarly, the sculptural moment might evoke flight (cf Brancusi's *Bird*) and so much else. This evocative side of sculpture thus places it close to being (a kind of) language. Some might even go so far as to say that there is a sculptural syntax, or a sculptural writing. This would allow the sculptural moment to say something 'other than what it says'. The point is to know what can be uniquely said, sculpturally. The risk is that the notion of a sculpture language will be understood to mean that sculpture speaks of itself to itself. For it is difficult to break free of the vice-like alternative: either sculpture is a language – and thus a *means* of communication (the instrumental view of sculpture) – or sculpture is not strictly a language because it can present only itself (the aesthetic view). Thus we would like to know how something which can be said only through the sculptural can be more than the sculptural speaking.

III

The sculptural moment is also the moment of reproduction. This can be understood in relation to Rodin's *Gates of Hell* (1880-1917) – as analysed by Rosalind Krauss – where the casting took place three years after the sculptor's death.[2] Here, mould and cast turn a facet of the practice of sculpture into a process of reproduction. As such the notion of originality, or meaning, has to include the idea of the work as a statement, as much as its material manifestation.

Reproduction here can also refer to the semiotic, as outlined by Julia Kristeva.[3] This reproduction – this mimesis – does not refer simply to the reproduction of the (objective) work, but to the reproduction of the space of the sculptural gesture itself. In short, the sculpture reproduces the subjective position of the artist. It thus mimes subjective energy flows. This is in no sense an objectification of the subject's position, but is rather constitutive of that position. Given such a focus, it is not possible to say – despite the apparently private nature of the sculptural meaning – that the subject/artist is truly expressed in the work; for there is no subject

position – at the level of reproduction – prior to the work. The work, then, is subjectivity – albeit in process. Subjectivity is thus *Chora*: 'a mobile and extremely provisional articulation', a space of non-differentiation, a 'receptacle', or 'non-expressive totality' formed by discharges of drive energy.

Some sculptures today can be evocative, in their extreme variations of form, of the stage prior to nomination. This is sculpture that is barely identifiable as such. This is sculpture without boundaries. Can there be a thought adequate to it?

IV

The place of sculpture cannot be reduced to the space sculpture. Even those works like Smithson's *Spiral Jetty* (1969-70), remain identifiable *as* works. A work (like Lacan's Symbolic) is never exactly in its place, even if it can well be *in* place. Nothing could be more crucial for the sculptural work than its encounter with a place. For, very often, it is the explicit emplacement of the work which gives it its meaning. We mean here that emplacement in general is constitutive of the sculptural work, and not that each work has a place that is proper to it. The play between the proper and the improper place of the work is constitutive of the emplacement of sculpture.

More than anything, the emplacement of sculpture brings the issue of the sculptural into view. The sculptural is the mode of emplacement of the sculptural work – even if this emplacement is nothing more (nor less) than a 'marking out' of the place of the sculpture. 'Marking out' is as crucial in Duchamp's *Fountain* (1917), as in Christo's wrappings. In each case, it is a question of borders – of the need for borders – if the work is to mean anything.

From a slightly different angle, the sculptural work has to have a transcendent moment. And this moment is intimately tied up with its emplacement as an essential displacement. The emplacement, as a marking out of sculpture means, too, that the work can become an object of contemplation. The emplacement of the work thus gives rise to discourse.

V

If space cannot be separated from the emplacement of sculpture, every emplacement is also a spacing. To refer to 'spacing' also means evoking a latent temporality. The latter point is made by Rosalind Krauss in *Passages in Modern Sculpture*.[4] 'Passages' in the title evokes both a *way* through the history of modern, 20th-century sculpture, and the 'passages' which

become a sculpture – as in Bruce Nauman's *Corridor* (1968-70). Or, we could say, that the book also addresses sculpture in/as passages of time.

Space evokes the kind of volume – whether or not virtual – that is sculpture. Light sculpture (cf Dan Flavin) marks out a quasi-virtual space for itself. To mark out a space is also to inscribe. The emplacement of sculpture would, in this sense, be an inscription – one recalling Derrida's theory of writing.

A notion of sculpture as an emplacement – where the work would only appear through inscription – has to consider the issue of repetition, or of re-inscription. If sculpture is nothing but the inscription and re-inscription of a work through emplacement, from whence would come the Idea of the work? Let us suggest that the emplacement constitutes the space for the appearance of the idea the work embodies.

There is, though, a radical arbitrariness incorporated in the notion of inscription. Strictly speaking, writing is an inscription *because* it is constitutive of both signifier *and* signified. Meaning does not occur outside writing, but is always already marked out in it. Such a conception of writing is possible only because the relationship between the signifier and signified is arbitrary. The idea of eroticism does not have to come through a naked human figure, so that Giacometti's *Suspended Ball* (1930-31), where a split, plaster ball hovers over the sharp edge of another plaster object evocative of a freshly-cut water melon, can, as the surrealists found, arouse a 'strong but indefinable sexual emotion'.

Despite this play of the unconscious in Giacometti's case, the notion of sculpture as pure inscription has to face the emptiness of this for the ego, and thus for the Imaginary. Even if different signifying and aesthetic strategies are both possible and desirable, and the play of the unconscious important, the Imaginary moves from fixation to fixation (as the analyst might say), or from belief to belief, as one might say in a more theological phrasing. The Imaginary looks to the qualities of the thing itself in order to find a modicum of satisfaction. Like every satisfaction, no doubt, this is a fiction. But fictions also expand the limits of the signifiable, as Kristeva has constantly said.[5] There is, then, a point at which the deconstruction of sculpture (or of art in general) is the actual *destruction of sculpture*. It is also the destruction of the Imaginary and thus of a certain pleasure – the pleasure, I suggest, that Roland Barthes attempted to demarcate with a slightly different vocabulary in *The Pleasure of the Text*.[6]

VI

'Sculpture is the meaning of forms.' *Barbara Hepworth*

To say, as Hepworth does, that 'sculpture is the meaning of forms', is to forget that sculpture, as emplacement, is the meaning of an image. For one of the meanings of image – indeed the first given by the concise OED, is: 'representation of the external form of an object, eg a statue (especially of a saint etc as an object of veneration)'. Form, image, outline here come together in relation to any object. Let us assume for the moment that sculpture embodies this relationship between form and image – that form is image, and vice-versa – a relationship which is exemplified by a statue. Very quickly, the issue here turns around the notion of sculpture as sign and as simulacrum. If, finally, the simulacrum refers only to itself, a sculpture as simulacrum has no meaning, or, at best, it has a very reduced meaning. By contrast, sculpture as image is a sign: it refers to something other than itself. There is then an outside of the image which is part of the essential meaning of the image, whereas the outside of the simulacrum is purely accidental and unrelated to the simulacrum as simulacrum.

Little would be required to show that the kind of image designated has Platonic overtones, and that, for this very reason, is suspect. But not even Plato was entirely in control of what he was attempting to define and explain. Who is to say that, in the end, Plato was not warning against the simulacrum and not the image, as various commentators have said? Whatever the case, it is possible to argue that the simulacrum, which, as meaningless, does not call for interpretation, is opposed to the viability of the Imaginary. The Imaginary entails a belief that an image is not a simulacrum, that everything does not refer to itself, endlessly.

Let us say, therefore, in light of Hepworth's statement, that sculpture as form is an image calling for interpretation.

VII

The sculptural is, or is part of, a body in space. This is the horizontal aspect of sculpture. Even as the perfect copy, or imitation of a prior object, sculpture retains a certain horizontality which pushes it closer to an experience of madness. There is always the risk that a sculpture will lose its emplacement – that it will cease to be a displaced object, and merge into its surroundings. The imaginary border between signifier and signified will disappear. Thus a metal car body, as sculpture, will rust, just like any other car body. Indeed, in rusting, such a sculpture becomes just another car body. But the imaginary border between signifier and signified does not have to be erased in any physical sense. A sculpture can literally disappear once it becomes a pure cliché, or a commodity that is endlessly replicated. Perhaps *Aphrodite* and the *Charioteer* are no longer true sculptures for this reason.

Even as the sign of the dissolution of a certain objectivity – of a becoming-thing – sculpture, as sign, retains transcendence, however minimal. Sculpture, indeed, is a transcendence, part of a vertical axis that is rendered transparent by the displacement of its emplacement.

Sculpture as a body in time is a complex notion. If sculpture is 'in time' it might be because the kind of temporality that it discloses puts us in touch with the 'time' as such of the sculpture object. This time, to repeat, is transcendent. It is not, then, simply reducible to the time of physical decay; because this time belongs essentially to the horizontal axis of sculpture. To be transcendent – for a sculpture to speak after death, as it were – another conception of time is necessary. This is the time that sculpture itself gives. Sculptural time is thus the refusal of the horizontal axis of physical time, seen in the example of the car body. Sculpture *as* time, sculpture that marks out another time, is what is at issue. Without the effort to *think* sculptural time, the sculptural moment – perhaps more than the moment of any other of the fine arts – loses its specificity. In other words, sculpture risks becoming just another thing.

VIII

'If you want to explain yourself, you must present something tangible.' *Joseph Beuys*

In light of Beuys, thought becomes sculptural. Does this not mean that the sculptural moment becomes the expression of the sculptor's thoughts? The answer is in the negative because thoughts do not exist prior to the sculpture itself. Sculpture and thought are 'equi-primordial' – to take a term from the translation of Heidegger. Thought is thus embedded in sculpture. This is what makes a sculpture more than an everyday object, even if it sometimes seems to be little more than that (cf Warhol). Beuys's project concerns extending the concept of sculpture 'to the invisible materials used by everyone: *Thinking forms* – how we mould our thoughts or /*Spoken Forms* – how we shape our thoughts into words or /SOCIAL SCULPTURE –

how we mould and shape the world in which we live . . .'[7]

Beuys is the sculptor most in touch with the sense of the sculptural moment. Rather than defining sculpture, he uses sculpture as a defining operator, thereby reversing the usual schema where a definition of sculpture is first required before any further progress can be made. With Beuys, a new syntax of sculpture emerges. In his work thought and sculpture are combined. Thought is sculptural.

Beuys's sculpture, then, is an idea performed of what sculpture can be, and, subsequently, of what art and society can be. The question Beuys raises, without intending to, is that of how sculpture can remain in any sense a monumental and essential art. To ask this is to ask how Beuys's work is not predominantly accidental. Beuys uses fat, but he might well have used wax or some other substance – if he had been a different person, with a different life-history.

Beuys's work thus raises the question of the contingent and the essential even though this is not part of his intention. For him, everything is in a state of flux, is 'in a *state of change*'.

IX

The sculpture of practice is not the production of the illusion of movement. It is not a spectacle of movement. Film is not, in effect, the model of practice. However many views the object implies, however film-like it becomes, it remains caught in an objectification. Instead, the sculpture of practice entails moving to a very different plane in an effort to challenge a certain kind of objectification, without ending up with complete loss.

X

Singularity is not captured in precision. In this light, Giacometti's sculptures, which substitute a blur for precision, signify singularity; they do not pretend to represent it. 'When you represent the eye precisely, you risk destroying exactly what you are after, namely the gaze . . .'[8] Clearly, there is a tension in a situation in which a singular work of art (or where the work strives to be singular) has singularity as a thematic device. The sculptural moment might well be the relationship between these two singularities.

XI

The question: How can we speak about sculpture?, forgets the counterpart: How can we not speak about sculpture? For, to begin with, although only a specific speaking is transcendent in relation to the sculptural moment, much speaking is not itself sculptural. Without thinking that the sculptural as such *can* be spoken, it is crucial to recognise at the same time that not everything is sculptural. This implies that distinctions must be made for the sculptural Idea to be a real possibility.

Notes

1 DF Krell, *Of Memory Reminiscence, and Writing,* Indiana University Press, Bloomington and Indianapolis, 1990, p41.

2 Rosalind Krauss, *The Originality of the Avant-Garde and Other Modernist Myths,* The MIT Press, Cambridge, Mass/London, fifth printing, 1988, pp151-170.

3 Julia Kristeva, *Revolution in Poetic Language,* Margaret Waller (trans), Columbia University Press, New York, 1984, pp57-61.

4 Rosalind Krauss, *Passages in Modern Sculpture,* The MIT Press,

Cambridge, Mass/London, seventh printing, 1989.

5 Julia Kristeva, 'Name of Death or of Life', in J Lechte (ed), *Writing and Psychoanalysis, A Reader*, Arnold, London, 1996, p116.

6 Roland Barthes, *The Pleasure of the Text,* Richard Miller (trans), Hill and Wang, New York, 1975.

7 Joseph Beuys, *Energy Plan for Western Man: Joseph Beuys in America*, K Kuoni (compiler), Four Walls Eight Windows, New York, 1990, p19.

8 R Hohl, *Alberto Giacometti,* Abrams, New York, 1971, p171.

MINIMALISM: ARCHITECTURE AND SCULPTURE
STAN ALLEN

'Architecture and sculpture: the masterly, correct and magnificent play of forms in light.' *Le Corbusier, 1947*[1]

'Over the last ten years,' wrote Rosalind Krauss in 1979, 'rather surprising things have come to be called sculpture: narrow corridors with TV monitors at the ends; large photographs documenting country hikes; mirrors placed at strange angles in ordinary rooms; temporary lines cut into the floor of the desert.'[2] But the effect of such productions, and the critical apparatus around them, is to make the category of sculpture seem 'almost infinitely malleable'. This elasticity of categories has, in the end, something of the opposite effect to what was intended: 'We had thought to use a universal category to authenticate a group of particulars, but the category has now been forced to cover such heterogeneity that it is, itself, in danger of collapsing.' Suggesting that there is something slightly disingenuous in this manipulation of categories, Krauss contrasts the uncertainty of her present with the certainties of sculpture's historical conventions. 'I submit that we know very well what sculpture is. And one of the things we know is that it is a historically bounded category and not a universal one.' Conventionally understood, sculpture is linked to monumentality and shows a disposition for the figurative and the vertical. This logic of commemoration and recognisability persists in everyday critical language. When we call a building sculptural it signals a figurative aspect, and conversely, when we call a piece of sculpture architectural it suggests the presence of tectonic forms. And so it is not surprising that in 1947 Le Corbusier (who had a decidedly fixed notion of disciplinary categories) would revive his own 1923 definition of architecture as the 'masterly, correct and magnificent play of forms in light'[3] to describe the sculptures of Antoine Pevsner. For Le Corbusier, sculpture and architecture could comfortably co-exist as distinct categories with a shared formal vocabulary. The other, more complicated demands of such cross-disciplinary exchange could be passed over without comment.

Today the situation is more complicated. It is precisely the mobility of the category of sculpture that makes for a difficulty in constructing a useful relationship between architecture and sculpture.[4] The boundaries of the category 'sculpture' have been extended to include theatre, landscape, film, video and, above all, architecture. It is not coincidental that Krauss begins her 1979 article with the description of a work by Mary Miss that appears to be a fragment of architecture. Works by artists such as Mary Miss, Alice Aycock or others evoke architectural space, either in the landscape or in that obscure territory called 'public art'. Installation art, from Bruce Nauman to Matthew Barney, has remained within the gallery, but engaged the viewer in a series of architectural spaces and sequences. In the case of minimalism, a strange circular route has been traced, whereby artists in the 1960s, in an effort to rethink some of the limits of their discipline turned towards architecture, only to have the favour returned some 20 years later, when, with minimalism firmly recognised in its art historical context, architects begin to look to minimalism as support for contemporary production.[5]

But something is lost in the process. The term itself, and what it might designate, loses all specificity. Instead of referring to a group of American artists active in the middle to late 1960s who radically revised the nature of the art object, redefined the space of the viewer, and challenged the limit between painting and sculpture, 'minimalist' has become an adjective, loosely applied to any work that is formally reductive, insistently rectilinear or starkly detailed.

Symptomatic of the resulting confusion is the variety of work today labelled minimalist.[6] On the one hand, minimalism is associated with a reassertion of architecture's tectonic identity. In the work of architects such as Tadao Ando in Japan, or Alberto Campo Baeza in Spain, or the so-called 'new orthodoxy' in Switzerland or Germany, the architectural work is stripped of all 'inessential' detail and its fundamental structural basis is made self-evident. Louis Kahn is invoked as a precedent for an architecture that is timeless and elemental. Minimalism here is affiliated with strategies of resistance, and characterised as a *refusal* of the temptations of formal elaboration. The architectural constructions and the pronouncements of Donald Judd, one of the most prolific and articulate of the artist/writers of the 1960s, are often cited as another precedent. But this is a narrow and selective re-reading of minimalist tenets. In the case of Judd, the conservative character of his furniture and architectural constructions is at odds with the resolutely a-tectonic proposition of his sculptures, and retreats from the most radical implications of his earlier writings.

Seemingly opposed, another reading of minimalism surfaces in the catalogue essay by Terrence Reily in the New York Museum of Modern Art's recent *Light Construction* exhibition. Reily refers to Rosalind Krauss's interpretations of minimalism to undergird an argument for an architecture of

Tadao Ando, view of Koshino House, Ashiya, Hyogo, photo Hiroshi Kobayashi

simple forms capable of producing complex phenomenological effects. In a reprise of Mies van der Rohe's 'almost nothing', the building as object fades away, to become a blank screen for an ephemeral play of light, shadow and translucency. Although closer in spirit to the original minimalists, this too is a selective reading. As opposed to the insistent materiality of Judd or Richard Serra, here the privileged points of reference are Dan Flavin and Larry Bell. But what both of these positions share is a sense of return – an appeal to the past in order to legitimise present-day practices. Both stop short of embracing minimalism's most radical propositions, and the rigorous empiricism of the best work of the 1960s.

Without insisting on a narrowly correct reading of minimalism, and recognising that its radicality was linked to a specific time and place, it seems worthwhile to briefly recall something of this original spirit. In the 1960s, minimalism worked to empty sculpture of a residual anthropomorphism, and to counter a tendency towards the decorative in painting. It was at war with the vertical, either the latent figurality of sculpture, or the static privilege of the viewer in painting. Minimalism completed a process of formal innovation begun with Abstract Expressionism. Composition by parts – the assemblage of faceted planes and fragmented figures, the lingering shadow of the Cubist revolution – was jettisoned in favour of a new sense of the whole: complex wholes ordered not by conventional relations of hierarchy, symmetry or balance, but instead by serial orders, non-relational composition and unified formal Gestalts.

Minimalism sought to defamiliarise the object, and hence to recuperate unmediated perception, but not by tearing the object from its context or by the use of distorted or fragmented shapes. Instead, minimalism represented known forms in unfamiliar scales, materials or positions. Tony Smith's sculpture *Die* is a six foot (1.52x1.52x1.52 m) steel cube painted matt black. When asked why he didn't make it larger, he responded that he was not 'making a monument'. Asked why he did not make it smaller, his response was that he was not 'making an object'. Minimalism works against recognition, and this defamiliarisation functions not so much to uncover the essential as to assert the undecidable.

This was closely linked to minimalism's other important contribution: the articulation of a new relation of viewer and art object. Attention was shifted away from the object as demarcated solid to emphasise the space of the viewer, the situation of viewing, and the duration of perception. This is why minimalism's reductive forms – cubes, cylinders, grids or planes – should not necessarily be seen (as is often the case in architectural discourse) to mark a return to stable formal values, or to ideal conceptual frameworks. In the minimalist view of the world, the capacity of perception to de-centre form is stronger than the capacity of ideal forms to ground perception. Far from being a symbolic language recalling essentialist values, minimalist geometry aspires to be without content. Its

meaning *is* given in perception: 'I always get into arguments with people who want to retain the old values in painting – the humanistic values that they always find on the canvas' wrote Frank Stella in 1964. 'If you pin them down,' Stella continued, 'they always end up asserting that there is something there besides the paint on the canvas. My painting is based on the fact that only what can be seen *is* there.' This radical insistence on the immediacy of perception moves the work away from idealism: 'Minimalist work corrects the ideality of conception with the contingency of perception,' asserts Hal Foster. The meaning of a minimalist work, 'is produced in the experience of the world, not in the hypothetically pure and prior space of intentionality'.[7] Minimalist geometries are low, not high. Repetition and the simple forms of minimalism are linked to seriality and to the protocols of industrial production, rather than to the timeless and the universal.

Finally, in a conscious critique of the prescriptions of Clement Greenberg, minimalism worked against an ever-narrowing specificity to the disciplines of painting and sculpture. This position was stated most clearly by Donald Judd in his 1965 essay 'Specific Objects': 'Half or more of the best work in the last few years has been neither painting nor sculpture ... Much of the motivation in the new work is to get clear of these forms.' Minimalism moved away from the material constraints of the individual disciplines, and almost inevitably towards objects and spaces: 'The use of three dimensions is an obvious alternative. It opens to anything.'

In the years following, certain ideas and techniques typical of the early work of American artists such as Judd or Carl Andre were taken up and 'reprogrammed' by various European artists. In the late 60s and 70s, the Italian artists of Arte Povera elaborated on the phenomenological and formal innovations of minimalism, while maintaining a certain skepticism with regard to the rigid programme of early minimalism. Instead of understanding minimal forms according to the logics of serial or industrial production, elemental forms are here re-inscribed into the spheres of history, culture and ethnography. In more recent work, minimalism reappears as one paradigm among others to be deployed in a heterogeneous programme which sets out to overturn both the privilege of the author and the stability of the œuvre. Contemporary artists such as Imi Knoebel can operate within the formal syntax of minimalism while provisionally suspending its inquiry into the origins of experience and perception. In the case of Knoebel, the objects are not here to sponsor an inquiry into depth and presence, but as a hollow shell. Material presence falls away, and the object is represented in terms of surfaces without depth, marking spaces, trajectories and voids. Absence rather than presence dominates, and, as in architectural space, the empty interval is thematic.

Minimalism's cross-disciplinary incursions inevitably lead back to the complicated question of its relationship to archi-

Imi Knoebel, Oh Help Me, Oh Help Me, Can Nobody Hear Me?,
400x900x40 cm, documenta 8, Kassel, 1987, photo Nic Tenwiggenhorn

tecture. For Robert Morris, the other key artist/writer of the 1960s, minimalist work is distinguished by the emphasis on the process of its making. But it is hard not to remark how many of the procedures of minimalist making (not to mention formal devices, materials or methods) belong to architecture. With minimalism, the sculptural object was inflated to an architectural scale and propelled into an architectural space. More significantly, these objects were often realised by familiar architectural means, that is to say, fabricated according to measured drawings. The distance between idea and execution that marks the work of the architect is here taken over by sculptural practice.

It is precisely this tendency to borrow across disciplinary boundaries that is the subject of Michael Fried's intense critical scrutiny in 'Art and Objecthood' of 1965. Fried objected to the 'theatricality' of minimalist work, noting that 'What lies *between* the arts is theater.' He was referring, above all, to the modes of reception solicited by the minimalist work. Responding to Morris's comments on scale, Fried notes that, 'The largeness of the piece, in conjunction with its non-relational, unitary character, *distances* the beholder – not just physically, but psychically.' I would suggest, however, that the models of reception invoked by the minimalists owe more to architecture than to theatre. Distance, distraction and duration all characterise the spectator's relationship to buildings and spaces. Commenting on Tony Smith's assertion that the experience of contemporary post-urban space tends to trivialise the experience of the artwork ('All art today is an art of postage stamps'), Fried asked, 'If the turnpike, airstrips and drill ground are not works of art, what *are* they?' The obvious answer is that these are works of architecture. (Or maybe not obvious, but only if we refuse to admit that there exists a large and important category of spaces or artifacts that are architecture but not necessarily buildings.) In fact the entire basis of Fried's critique could be rephrased to say that for him, the problem with minimalist works (or as he says, 'literalist' works) is that they are too close to architecture, that is to say, insufficiently distinguishable from the everyday objects and spaces that frame our day-to-day lives: 'We are all literalists most or all of our lives.' Architecture, unlike painting and sculpture, is not subject to a reductive categorical imperative on the order of Greenberg's definition of painting as the interaction of colour on a flat canvas. Of necessity architecture operates between and around other disciplines (engineering, drawing, politics) and its boundaries cannot be fixed with any certainty. Hence an alternative formulation: what lies between the arts is *architecture.*

There is, therefore, something strangely tautological in architecture's recall of minimalist strategies. In the best of these instances (including some of the recent work by Herzog and De Meuron, Toyo Ito or Kazuyo Sejima, for example), an operative parallel is established, which functions to realign the contingent and the absolute. Here, to refer to minimalism is to recover the immediacy of perception, and a relaxed fluidity of disciplinary limits. An uncertain territory between architecture and art practices is mapped out. In the other cases, the reference to minimalism is an appeal to the prestige of earlier art practices, without recognising their origins in architecture. Here there is no rethinking of architectural practice, in as much as the artworks themselves refer to known architectural models.

If, however, it is true that minimalism's artifacts are more like architecture and less like sculpture, it is equally true that they are not exactly architecture. To refer back to minimalism in its earlier art-world context is also to mark out the limits of the return to minimalism as a project in contemporary architecture. To the extent that minimalism worked against function, context and recognisability, its architectural utility will always be limited. If we stipulate that the procedures and models of perception invoked are already architectural, then the minimalist reference is doomed to be primarily formal. (Think of the 1970s attempt to legitimise a late-corporate modernism by reference to minimalism.) Minimalism, which developed in series, but rarely in fields, is powerless to offer models for the city or for urban agglomeration. Minimalist works still need the architectural frame of the gallery to work against. Moreover, minimalism's ambition to a unified formal Gestalt could be accomplished with materials that were themselves simple and uniform. Not so a building, which, however reductive its formal language, is always a complex assemblage of multiple constructive members (foundation, frame, infill, membrane) and mechanical systems (HVAC, electrical, conveyance and electronic). A sculpture can be self-contained and complete in itself, while a work of architecture cannot.

What all this might imply for contemporary practice could be clarified by looking more closely at some of the recent work of Japanese architect Kazuyo Sejima. Sejima's Saishunkan Seiyaku Women's Dormitory appeared on the cover of the *Light Construction* Catalogue, and her work has been established as the most radical exemplar of present-day minimalism: an architecture of intentionally limited formal means that seeks to engender in the experience of the viewer not a contemplative return to essentials or to grounded perception (as in the case of Ando) but rather, an explosive play of light, reflection, sign and movement. Most evident perhaps in the series of Pachinko Parlors, where the architecture is all but eclipsed in the delirious passage from sign to sign, from reflection to reflection, this character is still visible in her calmest work so far, the Villa in the Forest completed in 1994. In this compact house, subtle asymmetries disturb the stability of the plan figure, and maintain the viewer's gaze in a state of restless motion.

Sejima, for her part, makes no claim for a minimalist affiliation. She describes her work by referring to programme,

media and movement. This is an architecture that travels light, comfortable with the contradictions of present-day reality, and free of avant-garde aspirations: 'I concede that I am indeed living in the present. But that is all the more reason why I don't believe in trying to deny or conceal that fact by creating oppositional architecture . . . I consider it anachronistic to take an impossible concept, present it as something of eternal importance, and completely base your architecture on it.' In part, the freshness of her projects follows from this immediacy: Geometry is not identified with resistance, or with distant idealisms. As Judd has commented in another context: 'The order is not rationalistic and underlying, but it is simply order, like that of continuity, one thing after another.' If we propose a useful relationship to the minimalist work of the 60s, it is not because her work recalls its language of forms, nor even its ability to achieve maximum effects with minimal means, but rather this sense of the conditional – an idea of geometry as one order among many. Geometry is convenient and practical, but carries with it no metaphysical baggage. And because the geometry in her projects aspires to no universal idealism, it is not oppressive or constraining. This is not a vague and subjective observation, but the result of very specific architectural operations. The precision of plan definition is always offset by the delicacy of the enclosing envelope. Containers are multiplied, creating ambiguous zones of enclosure instead of sharp demarcations. The apparent simplicity of the extruded sections is complicated by involuted circulation paths and unfamiliar objects lodged within these rectilinear volumes.

This is also why the qualities of this work cannot be described only in terms of what it refuses, or what is left out. (Minimalism as refusal, or resistance.) It is not only restraint and delicacy that characterise her work, but a very precise and particular plan syntax, a *composition by blocks*, that avoids all sense of montage-like collision; a smooth space that is neither agglomeration nor division, but rather cell-like and topological. Inside-outside relationships are made complex and interesting not only through transparency and reflection, but by the intensity of geometric and programmatic relationships. In the Media Center, for example, there is an evident desire to overlap and intersect programmes and to interconnect spaces and events. The catenary of the inhabited roof-plane connects ground to roof-terrace, and the terrace in turn to the interior circulation. It encloses and protects the spaces below at the same time that it deforms their simple geometries. Finally, at a strategic moment, it doubles and folds down to form the sloping floor of the auditorium. The complexity of this work is not quantitative – an additive complexity of many systems interacting upon one another – but rather qualitative: a minimal number of elements each performing multiple and sometimes contradictory tasks. The trajectory of her work since 1987 has been towards fewer parts, but greater intensity. The

Kazuyo Sejima and Associates, N Museum, *1996, model and plan*

appearance of somewhat figural plan forms in her latest projects (The N Museum, for example) is completely consistent with this line of development.

A discussion of Sejima's work devoted exclusively to individual projects and the conditions of their reception would miss another key aspect. These new forms of subjectivity do not emerge in a vacuum. They are the result of shifting definitions of urbanity, and a response to specific new conditions in the city. If the city today is a dispersed field condition, a network of flows (of information, money or people) then the capacity of architecture to order or to signify these flows needs to be rethought. There *is* an urban proposition evident in this work, which is an extension of the conditions of its reception, but it is something else too. The rigorous formal reduction of her projects shifts attention to the interval, to the space between forms, which could be collective space. The formal syntax of 'one thing after another' is a more useful device to mediate the complexity of the contemporary urban experience than the appeal to collage urbanisms, complex diagrams of force or the delirious montage of signs.[8] Her projects pay close attention to context, while recognising that, in the contexts where she is most often called upon to operate, the old rules are of little use. Here too, her realism and optimism are evident. She writes, for example, that the purpose of the research into metropolitan housing types (1995) is 'towards the privatisation of exterior space.' Now, the privatisation of public space is a phenomenon much decried by contemporary theorists of urban space, who have called for the reestablishment of a viable public realm. Sejima, by short-circuiting such a demand – whose ideological and nostalgic bases deserve to be examined more closely – is able to capitalise upon an actual development to offer a realistic means to enhance the quality of life in collective housing.

As such, it would be misleading to try to understand Sejima's projects from a representational standpoint, and to see them as a mirror reflecting the dispersed and evened-out experience of the contemporary city. Is it necessary to insist once again on the impossibility of such a representational project today? Steven Marcus, for example, in 'Reading the Illegible: Some Modern Representations of Urban Experience'[9] reminds us that 'The city is ceasing to be readable.' In this essay, he contrasts the description of the city given in the novels of Saul Bellow and of Thomas Pynchon. The modern city, he writes, 'has gone out of control . . . it has lost the signifying potencies and structural coherences that it once seemed to possess.' And yet Bellow, Marcus argues, still holds on to the possibility that the novelist can give a coherent account of such an incoherent city. Like Dickens rendering the complexities of 19th-century London, Bellow's descriptions of New York or Chicago retain 'meaning, impressiveness and coherence'. With Pynchon, on the other hand, this coherence begins to fall apart. Significantly, Pynchon writes about decisive moments in the after-

math of the breakdown of order: Post-1945 Berlin, London during the Blitz, or Los Angeles in the 1970s. Fully aware of the long literary history of urban description, he turns that tradition inside out. 'In order to see the contemporary urban world clearly,' Pynchon asserts here, we must be able to see past 'the fiction of continuity, the fiction of cause and effect, the fiction of humanised history endowed with "reason"'. The structural categories are, in these words, 'meaningless deceptions themselves. The whole has become again de-stabilised, obscure, baseless, mystified – and most efforts of understanding or constructing a whole are themselves part of a mystification.' Likewise aware that any attempt at explanation is itself a kind of mystification, Sejima's work does not try to decode the city. It is not invested in its own legibility. It is more about performance and less about 'reading'. It operates in a non-discursive territory, working on the one hand instrumentally to facilitate intense programmatic exchange, and on the other hand in the realm of experience and effect. Architecture only reluctantly gives up its ambition to construct the whole. Sejima's architecture appears effortless, but we should not be deceived. What is not so evident is how difficult it is to step back from the temptation to impose order on the incoherent, or to construct new myths around this incoherence. In the end, the appeal of this architecture – political and otherwise – is simply its existence as an alternative to the chaos of the contemporary city. It is a delicate 'other' to that formless world, deeply enmeshed in its qualities, without pretending to correct it.

Notes

1 Le Corbusier in a 1947 introduction to a catalogue for an exhibition of sculptures by Antoine Pevsner. Cited in Robin Evans, *The Projective Cast*, MIT Press, 1995, p310.

2 Rosalind Krauss, 'Sculpture in the Expanded Field' in *The Anti-Aesthetic*, Hal Foster (ed), Bay Press, Seattle Washington, 1983, p31.

3 Le Corbusier's original formulation is a highly general one: 'Architecture is the masterly, correct and magnificent play of masses brought together in light' he begins, but goes on to say, 'Our eyes are made to see forms in light . . . It is the very nature of the plastic arts.' in *Towards a New Architecture*, F Etchells (trans), Praeger, New York, p31.

4 Krauss's solution in the 'Expanded Field' essay, to construct a Klein diagram around the oppositions architecture/not-architecture, and landscape/not-landscape, is useful in regard to sculpture, but less so in understanding architecture. This, I submit, is because architecture, unlike sculpture, is not a historically bounded category subject to the same categorical definition.

5 A search of the Avery Index of Architectural Periodicals with the subject heading 'architecture and minimalism' turned up 24 entries. What is significant is that for the nine-year period covered, 20 of the 24 entries are from the last three years.

6 This is to leave aside, for the moment, the British phenomenon of a miminalism associated exclusively with fashion (John Pawson, etc).

7 Hal Foster, 'The Crux of Minimalism', LA MOCA, 1986.

8 Jeffery Kipnis has coined the term 'inFormation' to describe an intensive architecture of reductive orthogonal form and blank exterior, which sometimes serves as surface for projection or graphics. This 'encasing of disparate formal and programmatic elements within a neutral, modernist monolith' could well serve as a description of Sejima's works.

However, the effect I have in mind is better described by referring again to a parallel in minimalist art: In 'The Cultural Logic of the Late Capitalist Museum' (1990), Rosalind Krauss has pointed out a kind of reprogramming of minimalism underway today, in which the lived perspective of the 'old' minimalist subject – which promised 'an instant of bodily plenitude' in compensation for the loss of authentic experience in the face of the commodification of advanced industrial culture – is dissolved into the very currents of serialisation, banalisation and reification that minimalism originally set itself against. According to Krauss, this shift, whereby minimalism enters into the logics of the simulacra and the space of post-modernism, is already inherent in minimalism's 'original' project: '. . . the potential was always there that not only would the object be caught up in the logic of commodity production, a logic that would overwhelm its specificity, but that the subject projected by Minimalism also would be reprogrammed. Which is to say that the Minimalist subject of "lived bodily experience" – unballasted by past knowledge and coalescing in the very moment of its encounter with the object – could, if pushed just a little further, break up entirely into the utterly fragmented, postmodern subject of contemporary mass culture.' If the minimalist project can slip so smoothly into the currents of mass culture – signs of 'unmappable or unknowable depth', articulated by a 'de-realized subject' which only begin to cohere around a notion of the 'hysterical sublime' – clearly its capacity to sponsor a return to essentialist tectonic experience and resistant practices is highly suspect.

9 William Sharpe and Leonard Wallock (eds), *Visions of the Modern City*, John Hopkins Press, Baltimore/London, pp232-56.

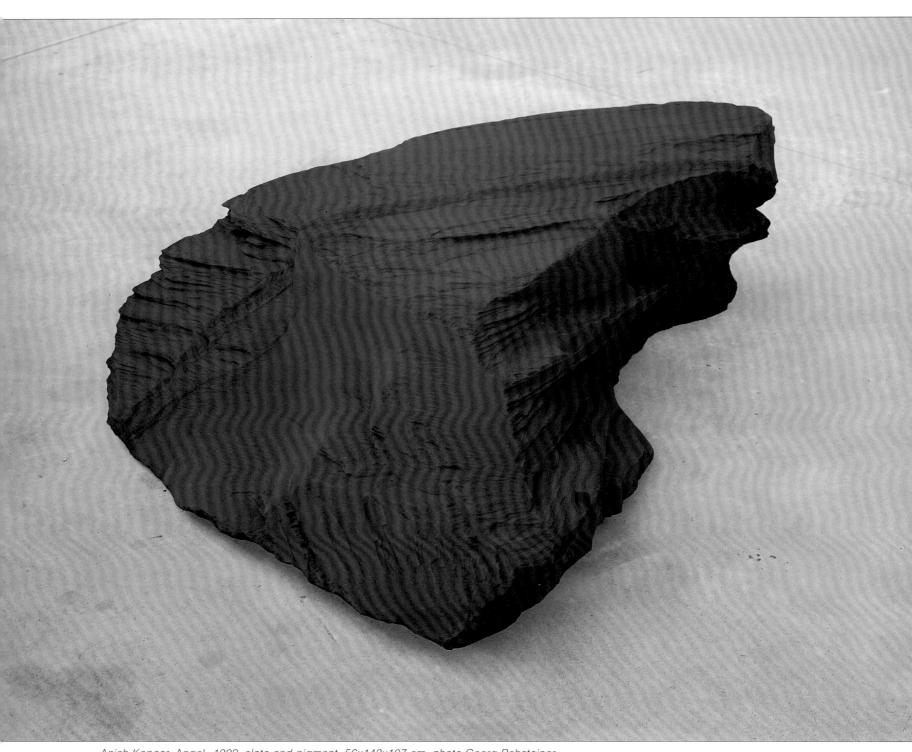

Anish Kapoor, Angel, 1990, slate and pigment, 56x142x107 cm, photo Georg Rehsteiner

CHROMAPHOBIA

Ancient and Modern, and a Few Notable Exceptions
DAVID BATCHELOR

To address the question of colour in art is, sooner or later, to encounter a strange and deep kind of loathing. For example:

> The union of design and colour is necessary to beget painting just as is the union of man and woman to beget mankind, but design must maintain its preponderance over colour. Otherwise painting speeds to its ruin: it will fall through colour just as mankind fell through Eve.[1]

The passage was written by the influential 19th-century critic and colour theorist (and appropriately named) Charles Blanc; it is interesting on a number of counts. First, he identifies colour with the 'feminine' in art; second, he asserts the need to subordinate colour to the 'masculine' discipline of design, or drawing; third, he exhibits a reaction typical of phobics: a massive overvaluation of the power of that which he fears; and fourth, he says nothing at all original. In aesthetics and art theory colour is very often ascribed either a minor, a subordinate, or a threatening role. The devaluation of colour expressed in the phrase *designo versus colore* has a very long history. The idea that adequate representation through line alone is both possible and preferable was revived during the Italian Renaissance from ancient Greek and Roman sources, and continued to inform academic training until the 19th century.[2] When colour was admitted to the equation of art it was, as Blanc indicated, usually within a strongly disciplinarian regime marshalled by the more 'profound' art of drawing. Even Kant, writing in 1790, maintained that while colours may give 'brilliancy' and 'charm' to painting and sculpture, 'make it really worth looking at and beautiful they cannot'. Again, only drawing was 'essential'.[3] As ever, we have to look to William Blake to find the values of the Academy turned on their head:

> That God is colouring Newton does shew;
>
> And that the Devil is a Black outline, all of us know.[4]

Chromaphobia, the fear of corruption through colour, is not inherent in all devaluations of colour in aesthetics, but it is visible in many instances. Associated with decadence, exoticism, confusion, superficiality and decoration, colour has been conscripted into other more well-documented racial and sexual phobias. Taken as a marker of the feminine by Blanc, others as far back as Pliny have placed colour on the 'wrong' end of the rhetorical opposition between the Occidental and the Oriental, the Attic and the Asian, the rational and the irrational. For Aristotle colour was a drug (*pharmakon*); in rhetoric itself *colores* came to mean embellishment of the essential structure of an argument. If colour is not a contaminant, then it is more often than not treated as an addition, embellishment or supplement; relating to 'mere' appearances rather than to the essential structure of things.

A suspicion of colour persists in certain types of art, particularly the kind which aligns itself with the more cerebral, intellectual and moral aspects of experience. A commitment to one or another variety of Realism has almost always been marked by a fondness for brown; Conceptual Art made a fetish of black and white. To this day, 'seriousness' in art is usually available only in shades of grey. The idea that strong colour is the preserve of primitives and children may not be stated much these days but it appears still to have a strong, silent presence.

One of the reasons for the continued devaluation of colour in much art and theory is perhaps that both conceptually and practically it is extraordinarily hard to *contain*. Conceptually colour has proved irresistibly slippery, constantly evading our attempts to organise it in language or in a variety of linear, circular, or spherical, or triangular geometries. For Plotinus, colour was simply 'devoid of parts' and therefore (literally) beyond analysis. When the 22-year-old Newton revolutionised scientific understanding of light and colour, the subordination of colour to a system of laws also became an imperative. But the rationale for Newton's division of the spectrum or rainbow into seven primary colours was based less on any inherent divisions within the colour continuum than on the desire to make it match the seven distinct notes in the musical scale.[5] Evidence of the sheer contingency of colour systems and colour concepts has been produced by a number of ethnographers, linguists and cultural historians in recent decades; though only a few philosophers and theorists have found the awkwardness of colour at all suggestive. Kierkegaard identified intense colour with childhood, as others had before him, but lamented its loss: 'The hues that life once had gradually became too strong, too harsh for our dim eyes.'[6] The problems of matching the experience of colour with available colour concepts became the basis of Wittgenstein's last main preoccupation.[7] For Barthes, colour, like other sensory experiences, could only be addressed in language in terms of metaphor; his answer to the question 'what is colour?' was: 'a kind of bliss'. Barthes sensualising or rather his eroticising of colour is a very striking inversion of Blanc's Old Testament foreboding. In a way there is no disagreement between them: colour has a potency which will overwhelm the subject and

obliterate all around it, even if, for Barthes, this was only momentary, 'like a closing eyelid, a tiny fainting spell'.[8]

The potency of colour presents some real problems for artists. Colour saturation tends to knock out other kinds of detail in a work; it is difficult to make it conform to the spatial needs of bodies, be they abstract or figurative; it tends to find its own level, independent of what is around it; it is, in short, uncooperative. The advent of monochrome painting during the 1950s and 60s might seem like a logical, if extreme, solution to this difficulty: here, for once, colour would not have to cooperate with drawing. And yet, with some important exceptions (such as Klein and Fontana), monochrome painting has often proved oddly shy of chromatic intensity, preferring instead the quieter waters of tonal value and variation (Ryman, Richter, Charlton, for example). The reasons for this are various and complex; but it may have something to do with painting's unavoidable relationship with the (usually white) wall-plane and the need to tune painting to this given of the gallery environment. And this in turn may explain in part why in many instances during the post-war period a pre-occupation with colour has found its

form in sculpture and three-dimensional work. But there are also other, stronger, reasons for this change of direction and dimension.

In his final, posthumously published, essay 'Some Aspects of Colour in General and Red and Black in Particular' (1994),[9] Donald Judd remarked that after Abstract Expressionism, 'colour to continue, had to occur in space'. He also indicated that, in a series of multi-coloured works he began in the early 80s, he wanted 'all of the colours to be present at once'. In painting, even in 'flat' abstract painting, colour will tend to function pictorially, to advance or recede relative to other colours, and to detach itself from the picture plane. In sculpture such as Judd's colours are stabilised by being present as literal surfaces of three-dimensional elements. The edge of each colour coincides with the edges of the object. Being visibly assembled from discrete units, this leaves less room for optical jockeying, and thus more space for a very wide variety of colours 'to be present at once'. This series of works – a large number were made during the second half of the 80s, and many more unassembled works remained in Judd's studio after his death

ABOVE: Tony Cragg, *Plastic Palette II, 1985, plastic, 175x170 cm*
OPPOSITE: Jeff Koons, *Small Vase of Flowers, 1991, polychromed wood, 94x99x122 cm*

– are perhaps the 'purest' colour experiments in recent sculpture. The aim, I think, was no more and no less than an open-ended investigation into the possibilities of colour combination. Derived from the industrial colour chart rather than the traditional colour circle, Judd further freed himself from the baggage of traditional colour theory, with its prescriptions, its grammar of opposites, and its hierarchies of primaries, secondaries and tertiaries. It also made colour a kind of ready-made, something to be selected from a stockists like the range of light industrial materials which are typical of all Judd's work.

For a number of other sculptors, particularly during the 60s, the materials and processes of industry offered a world to work with. While this is well documented, what is often overlooked is how the colours of industrial materials and commercial finishes focused the artists' attention. John Chamberlain has used the spray-painted colour of cellulose car-paints since the early 1960s; Carl Andre's wide range of metal sculptures are marked by strong intrinsic differences in colour which he sometimes explores within a single work; and Dan Flavin has long worked with the palette of commercially available colours

in fluorescent light, again either singly or in combination. There are obvious and important differences between these types of work: in some cases colour is applied, in others it is intrinsic to the material; in the case of Flavin, and in some works by Judd in which he employs transparent acrylic sheet, colour is a quality of light emitted from and reflected in the surfaces of the work. But what this work all has in common is a fascination with the colours and surfaces of modernity; and it is from these sources, from the slick, brash and vulgar world of industry and commerce rather than the more refined and repressed taste of high culture, that these artists, like their contemporary, Warhol, found the most vivid material.

This work is alike also in that it is usually assembled or arranged from pre-existing parts. Except in the case of Chamberlain, the materials are not manipulated in the studio so much as ordered-up from the stockists or fabricators. Usually the materials are also flat, unmodulated planes rather than solids (Andre being the partial exception here); and this has consequences for the experience of colour in the work. Built rather than crafted, joined together rather than whole, rather

ABOVE: Mike Kelley, Pink Shadow, 1990, stuffed animals, 46x13x6 cm; OPPOSITE: Donald Judd, Untitled, (DJ 85-53) 1985, painted aluminium, 30x360x30 cm

ABOVE: John Chamberlain, Plastic Virtue, *1989, painted and chromium-plated steel, 89x118x73 cm; BELOW: Sylvie Fleury,* Agent Provacateur, *1995, shopping bags and contents*

than pictorial, planar rather than solid, synthetic rather than organic, regular rather than irregular: the characteristics of this art are also characteristics of our modernity. And the colours of modernity are inseparable from these other aspects: its surfaces, its shapes, its structures and its arrangements.

It may be the case that the most important and experimental use of colour occurs outside the world of high art. This offers the artist who is interested a vast resource of ready-mades and references, from the developments of the automobile industry and commercial paint manufacturers to the patterns on toys, ornaments, packaging and departure-lounge kitsch. If the New York artists of the 60s tended to draw on a range of *industrial* commodities for their work, several American and European artists over the last decade have exploited the ubiquitous world of *consumer* commodities. Mike Kelley and Sylvie Fleury have both made direct use of such material, and even if their work is not ostensibly about colour, the point is that once this commodity-world is invoked, colour invariably comes with it and makes itself present. Some of the early work of Tony Cragg may have been made in recognition of this. *Plastic Palette II* (1989) is, like all his work of the time, made from the detritus of commerce and industry, the found shards of brightly coloured plastic which insert themselves in the corners of our cities. In this instance the shards' colours become the organising point for the work's imagery – a silhouette of the traditional painter's palette – and this in turn becomes an acknowledgement of ambiguous position – *between* painting and sculpture – which is characteristic of much recent colour-based work, and Judd's and Flavin's in particular.

Colour as a marker of mass-culture or of kitsch is also represented in the work of artists such as Jenny Holzer and Jeff Koons. In Holzer's case the use of light-emitting materials is transformed from the simple and static geometry of a Flavin to a hyperactive spectacle of sound-bites and non-sequiturs. Koons's carved and painted flower arrangements (and his animals and figures) make a positive if ironic value of much which aesthetics has suppressed: the ornamental, the decorative, the domestic, the trivial, the childlike. Note, however, that it is not only through intense colour that Koons invokes the kitsch: he has also succeeded in hijacking white, the last colour in the fortresses of refinement, in works which invoke nothing more elevated than domestic cleanliness or neo-classical sentimentality.

None of the above constitutes anything like a school or a movement. If there is a preoccupation in the work mentioned so far with some or other aspect of mass-culture, the particular reasons for this preoccupation will be quite different for each artist. And not all sculptors who thematise colour have done so by this route. Anish Kapoor and Georg Baselitz both make work in a relatively traditional way (as does Koons, sometimes), by carving or otherwise cutting into lumps of wood or stone; and this immediately distinguishes it from the other work discussed so far. In Kapoor's and Baselitz's case the worked material is then either partially or entirely covered with pigment. And in each case the relationship of the colour to the material is crucial; seeming to dissolve it into a perceptual vapour (Kapoor) or organise it into a loosely conceived figure (Baselitz). In neither case is there anything in the finished work which readily links it with the world of commerce and industry. Rather the opposite: both works seem to involve a turn away from modernity; but in making this turn, coincidentally, they arrive at a point not that remote from some of the other work mentioned so far. In the rhetoric of chromaphobia the vulgar and the kitsch are in the same domain as the primitive and the exotic – the critical and self-conscious reference-points of Baselitz and Kapoor respectively.

The problems for an artist working with colour are not only the various chromaphobic prejudices whereby colour is positioned, in one way or another, as Other to the higher values of Culture; but also the handed-down baggage of traditional colour theory within which colour is marshalled, disciplined, subordinated and subject to entirely arbitrary divisions and codes of conduct. In some respects chromaphobia is preferable to the systemisation of colour: at least chromaphobes recognise and value, in a perverse back-to-front way, colour's potency and indiscipline. Only relatively few artists actively thematise colour these days; and those who do (a fuller list would include painters, photographers and installation artists of various types), do so in an informal and highly idiosyncratic way. To talk of colour in recent art is to speak of instances and highly localised interests; not of systems, models and movements. That is the point: colour is infinitely more complex than the means we have to describe it; and in that space between seeing and knowing there may be occasional moments of freedom.

Notes

1 Charles Blanc, quoted in Charles A Riley II, *Colour Codes*, University of New England Press, Hanover and London, 1995, p6.

2 See John Gage, *Colour and Culture*, Thames & Hudson, London, 1993, especially chapters 1 and 7.

3 Riley, *Colour Codes*, op cit, pp20-21.

4 Gage, *Colour and Culture*, op cit, p153.

5 Malcom Longair, 'Light and Colour', in *Colour: Art & Science*, Trevor Lamb and Janine Bourriau (eds), Cambridge University Press, 1995, pp65-102.

6 Riley, *Colour Codes*, op cit, p17.

7 Ludwig Wittgenstein, *Remarks on Colour*, Basil Blackwell, Oxford, 1977.

8 Riley, *Colour Codes*, op cit, pp59-60.

9 Donald Judd, 'Some Aspects of Colour in General and Red and Black in Particular', *Artforum*, vol XXXII, no 10, Summer 1994.

ON COLOUR AND ABSTRACT ART

David Batchelor's Recent Work
CHARLES HARRISON

The following speculations are prompted by some abstract work in steel and painted perspex made by David Batchelor over the past three years. The first problem this work poses is one of description and nomenclature. Problems of description and definition are of course nothing new. The work which aims to leap out of history and become a genre-in-itself is by now a familiar form of avant-garde production. Batchelor's works have rather the air of scouting about in search of a history to reconnect with, a genre to belong to, a decent job to do. The works are structures but not sculptures. They are painted but not paintings. They are decorative but not decorations. On what grounds, then, do they establish their identity?

The issue of identity can conveniently be considered under two aspects. The first addresses the question: In any single work, by what conditions are the relations between its parts determined? To ask this is to inquire into the conditions of the work's integrity, and into their significance. The second aspect addresses the question: How is the resulting configuration individuated in relation to its surroundings? To ask this is to inquire into the conditions of the work's distinctness, and into their significance. Where Batchelor's recent works are concerned, the answers in both cases tend to go with surprising directness to the matter of colour: the organisation of relations between colours and differently coloured components in the first case; the achievement of some distinct chromatic character for the resulting configuration in the second.

What do we mean by saying that colour establishes character in the work of art? It may help to think of the negative cases. Normally we think of colour as a property of some other thing – the greenness of grass, the redness of blood. Sometimes we think of colours in swatches. At one extreme there stands some form of entirely literal pictorial naturalism, with everything painted according to its local colour, like a Sunday painter's landscape. At the other extreme stands any one of a more-or-less infinite number of monochromes – Yves Klein's perhaps – or one of an infinite number of possible colour charts in the manner of Gerhard Richter. Where any of these is interesting, it is not the *character* of its colour that makes it so. The character of colour is established somewhere between the practical extremes these examples define.

In his 'Salon of 1846', Baudelaire wrote of colourists as 'epic poets' and described one painter's colour as tranquil and gay, another's as plaintive, a third's as terrifying, implying that there could be a typical identity to a palette, independent of what

that palette was used to picture. 'The craving for simplicity', Wittgenstein noted, 'People would like to say: "What really matters is only the colours". You say this mostly because you wish it to be the case. If your explanation is complicated, it is disagreeable, especially if you don't have strong feelings about the thing itself.' What could it mean not to care about 'the thing itself', but to care about the colours, and to want, in some discriminate sense, to be able to represent their character to yourself, and thus to *see* them? In such a case what would you be caring *about*? What would be the nature of your desire? To ask such questions is to ask how colours mean, or, at the least, how they may be thought of as other than meaningless – a question which, as Baudelaire foresaw, is propaedeutic to the issue of how colour may be modern.

This last is the question to which I take it that Batchelor's works are particularly addressed. They aspire, that is to say, to be modern in character, and to establish that modernity primarily through colour, though colour given emphatic physical presence and shape. This aspiration helps both to explain their form and to indicate the nature of their connection to a history, for there can be no non-trivial sense of modernity that is not relative to some sense of tradition. The historical moment they evoke is quite specific. The last time that the relations of colour to shape were made the subject of substantial practical and critical inquiry was in what turned out to be the last vital phase of modernist abstract art during the mid- to late 1960s. It is significant that one of the few works of art by another artist that Batchelor possesses is a small Noland stripe painting in silkscreen on canvas from 1967. It is the more significant that it *is* small and a silkscreen – a slightly artificial and as it were downmarket version of the paintings that claimed whole walls for themselves in 1966-68. For what in the end gave these paintings away was the combination of their large cultural pretensions with their actual vulnerability. They could not withstand rough handling, either physically or critically, and a grubby Noland is an object without aesthetic remainder. The paradoxical consequence was that the highest values of late-modernist culture – which these works did indeed briefly enshrine – could not be recovered from them except under highly specialised conditions. This perhaps said as much about the fate of late-modernist culture as it did about the paintings in question. It was as if the world moved out from underneath them, leaving them stranded.

Minimal art, when it came, proved simply better adjusted to

Polymonochromes, 1994-97, acrylic sheet, gloss paint, steel, photo
Ori Gersht

public life. This was a crucial aspect of its critique of late-modernist abstract painting and sculpture. 'Three-dimensional work' looked like a more viable genre, and when colour became a significant issue for Donald Judd – when the character of his work began to depend upon effects of colour, rather than on its merely being coloured – it came with the properties colour had needed to acquire if it was to persist as a critical ingredient of abstract art: it was synthetic, substantial and durable under the conditions of the present. It seemed that if colour was now to serve as a significant aspect in the qualification of an artistic object it had either to be 'in' the material rather than on it, or if on it then applied in a fashion that was not *merely* artistic. In late-modernist abstract painting – and even in Caro's painted sculptures of the 1960s – colour had always looked *fragile*, which is to say it had tended to establish itself in terms of typically matt surface properties, which are first and foremost painterly properties. For some while now it has been clear that the predicates of painterliness can no longer or not yet be used in oratio recta where the conceptual priorities of art are concerned – or not without sentimentality, which is to say not without conservatism.

Shiny surfaces serve to keep these predicates at bay – or, in Batchelor's case, to preserve them as it were in a state of limbo, the colour in all its particularity being sandwiched between a thick layer of transparent perspex and a substantial backing of steel. If there is a genre to which these things belong, then, it is to the relatively young genre of 'three-dimensional work' which Judd named. And yet, Judd's own art notwithstanding, there has been little work in this genre of which it could be said that a change of colour would be anything like as decisive as a change of form. It may be that the idea of character established through colour became so irrevocably associated with the modernist abstract art of the 1960s, and with discredited talk about 'sheer taste', that it seemed safer for some long while after to put the emphasis upon physical structure. That the relevant prohibitions may now have run their course, however, is an intriguing suggestion that Batchelor's work seems to support. Over the past three years that work has become the more interesting as its physical supports have become more incidental to the matter of organising coloured surfaces in different planes and proportions. The earliest of the steel-and-perspex works seemed marked by a form of anxiety about just what kind of space it was that these things were entitled to occupy, how they were physically to attach themselves and to what. The shelf-like configurations on which Batchelor is currently occupied claim a traditional place, but they do so in non-traditional terms, as an enforced consequence of their means of visualisation and construction. What seems now to be in prospect is a form of improvisation that is neither conservatively painterly nor militantly accidental; colour once again given character and claiming a place, but claiming it under the conditions of the present.

ABOVE: Tower-Like, *1996, 180x52 cm; BELOW:* Grid-Like, *1995, 97x97 cm; OPPOSITE ABOVE:* Shelf-Like I, *1996, 31x66 cm; BELOW:* Shelf-Like II, *1996, 31x66 cm; each piece acrylic sheet, gloss paint, steel, photos Ori Gersht*

WHICH WORLD

The Sculpture of Harald Klingelhöller

DAVID MOOS

The sky is the vaulting path of the sun, the course of the changing moon, the wondering glitter of stars, the year's seasons and their changes, the light and dusk of day, the gloom and glow of night, the clemency and inclemency of the weather, the drifting clouds and blue depth of the ether.
Martin Heidegger, Building Dwelling Thinking

It is October, an evening. Or perhaps November already, when the first cold nights arrive. Raining, a hard rain falls, and the heat in the building comes on for the first time; less, perhaps, to provide warmth than to allay the damp chill. To avoid the stifle one opens a door slightly, props it open – just a slit. There one lingers, on the sill, watching rain fall into pools, puddles of black.

From the outside, if one were to see oneself, the body would only be a silhouette, some dark profile barely visible. Rather, there would be the building's facade: its brick and stone, and doors and windows. All bound together in the constructed logic of a sheer plane, punctuated but integrated.

Yet the door ajar creates a slit in this logic, a diagonal rupture. An opening that is planar in itself, it is an intercession that creates intersection within itself. The hinged-open door as a cut, a movement that opens circulation: between inside and outside; domestic environment and breath of the world; space versus weather; the realm of one's organisation and own making versus that which is beyond. Temperature is the impetus for this gesture.

Why the concern with the weather? Why begin with Heidegger's description of the sky as a way to think about the sculpture of Harald Klingelhöller? Variously constituted of concrete, plasterboard, granite, basalt, steel, paper, Klingelhöller's work would appear more preoccupied with the materials of building than with natural phenomena, the shifting nature of sky and cloud. Restated: Klingelhöller's sculptural objects present themselves as dense, architectonically reasoned works that arise as seemingly self-sufficient, compact entities free from association or contingency upon any environment – be it a pristine exhibition space, the lavish interior of a castle, or a glade outside.[1]

The works are often seen in relation to each other. Clustering or grouping the sculptures into a room sets up a (pre) condition for interrelation that apparently defends against the specifics of any particular space. A communicative network is forged as the sculptures appear to discuss and compare amongst themselves the components of their constitution, how certain elements are iterated, and then reiterated. This manifest affiliation affirms a consistency to Klingelhöller's programme, a closure rigorously determined by the relative value of materials and pure arrangement of forms.

The sculptures coalesce and work together; neither inviting nor denying the viewer passage into their space – the space between and among them that also becomes the space internal to the stacked, leaning and overhanging forms. Such a space is pervasive, consistent throughout itself. In a room occupied by Klingelhöller's work distinctions of inside/outside or interior/exterior, conditions of space are dissolved. The work surmises that space and spatiality have already been provided for. In this manner the forms do not enclose; they ascribe.

How does this lapidary spatiality relate to the world, or as Klingelhöller subtly instructs, engage the world? The title attending a recent plasterboard sculpture is *The House is Inviolable* (1992).[2] If regarded along merely formal lines, the notion of a house, of a completed and thus presumably 'inviolable' dwelling, would seem tenuous. Set onto a base that lies on the floor, a group of forms, individually composed as volumetric letters of the alphabet, lean to one side against a brace. How such a sculpture relates to a house must clearly stand aloof from direct modes of representation. The syntax of what may be associated with a house – from domestic furnishings to external facade – is not at all present here.

Klingelhöller's work is structured around the task of assembly, often appearing to be involved in the very process of its own self-construction.[3] His sculpture is built architecturally but in a significant sense neither produces *architecture* (as style) nor aspires to provide maquettes for a critique of architectural method. And yet, the materials themselves are contiguous with those of modern building.

By broaching or skirting the metaphor of building one may keep open this topic; investigate how reference to *The House* works to narrate a content residing beneath the surfaces of construction. Other titles admonish this direction, referencing the *matériel* of building: *And Stones* (1992), *And Glass* (1992), *In an Empty Factory Area* (1993). A discursive apparatus underpins and appears to unify the diversity present in the œuvre (each of the letter-forms in a given Klingelhöller sculpture exist in the title). The manner of the forms' interlocking simulates building method, posing metaphor at the fulcrum of sculpture. This metaphor, which is inherently linguistic,

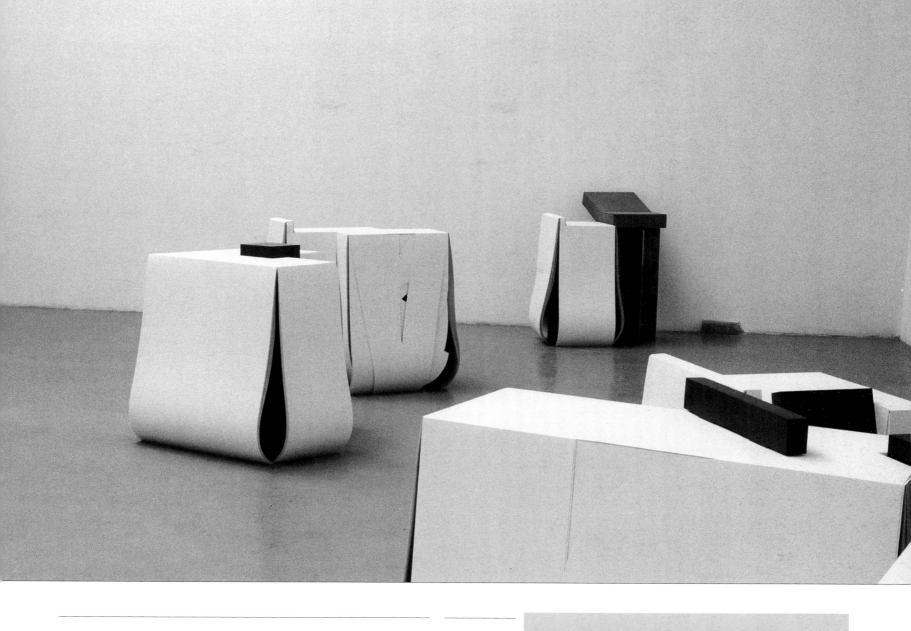

'Toward the Boles of the Jetty',
paper, steel, granite,
1994

'Toward the Pillars of the Forest',
paper, steel, granite,
1994

'Against Whose Edge Whirlwinds of Light Collide',
paper, steel, granite
1994

attends the narrative reference of the work and may, for example, be rendered in relation to philosophy.

After the war, the theme of the house became a dominant one in Heidegger's work. The house represents for him the structure *par excellence* that one may build for oneself. In his 1947 'Letter on Humanism', Heidegger wrote the following formulation: 'Language is the house of being. In its home man dwells.'[4] The particular kind of structure envisioned here concerns the task of existence, parameters for self-constructed Being. In his lecture 'Building, Dwelling, Thinking', Heidegger avers: 'building is not merely a means and a way toward dwelling – *to build is in itself already to dwell.*'[5] Not every building is a dwelling. Stadiums, power stations, railway stations, etc, are buildings but they are not 'dwelling places'.

For Heidegger 'dwelling' presides over all building; to dwell is to *construct* a place rather than occupy it. Early in his lecture, the philosopher is characteristically preoccupied with the etymology of the words he wishes to employ to construct his meanings. 'The Old English and High German word for building, *buan*, means to dwell,' Heidegger writes:

> Where the word *bauen* [to build] still speaks in its original sense it also says *how far* the nature of dwelling reaches. That is, *bauen, buan, bhu, beo* are our word *bin* in the versions: *ich bin*, I am, *du bist*, you are, the imperative form *bis*, be. What then does *ich bin* mean? The old word *bauen*, to which the *bin* belongs, answers: *ich bin, du bist* mean: I dwell, you dwell. The way in which you are and I am, the manner in which we humans *are* on earth, is *Bauen*, dwelling.[6]

From language, from the intimate exegesis of its sources, the concept of dwelling is vitally linked to being – initially, the verb (I am, you are); decisively, existence (*Dasein*).

While the construction of meanings for the concept of dwelling unfolds across linguistic lines, there exists in the world another, tangible reference for Heidegger beside this text. Informing, perhaps in a deep sense performing, Heidegger's thinking about the dwelling of man is the actual house in which he resided when thinking and writing his thoughts.

The now famous small house in the Black Forest near Todtnauberg becomes the very real trope that anchors the Heideggarian imagination. Already in 1934, the fixation with this house is specified in detail, as it becomes the locus of the philosopher's 'work-world':

> On a steep slope of a wide mountain valley in the southern Black Forest, at an elevation of 1150 meters, there stands a small ski hut. The floor plan measures six meters by seven. The low hanging roof covers three rooms: the kitchen which is also the living room, a bedroom and a study.[7]

The sequestered, composed, private world of the mountain retreat provides for an 'inner relationship' between ideas and place; such an abode literally forces ideas onto its inhabitant. The building provides the supreme analogue, a lodge for the building of ideas – dwelling.[8] The idea is simple and rather straightforward.

In photographs 'the low hanging roof' is indeed revealed to be an overhanging roof. An overhang that might begin to explain the black cardboard looming elements which fit atop the other three sculptures installed near Klingelhöller's *The House is Inviolable*. Each of these plasterboard sculptures is similarly composed of hewn letter-forms; the created, dimensional features of sculpture that bespeak language *are* the materialisation of linguistic matter into the realm of sculpturality. Letters are constantly discernable yet the words remain occluded, as if language itself is formulating its roots, testing its own building ability (*bauen, buan, bhu*, etc). In *Sleep Deeply* (1992) the letters lean to one side, akin to the slant of *The House is Inviolable*. In *All Metaphors Become True* (1992) – a title that may here be taken as a hint of 'philosophy' becoming realised in 'sculpture' – the letter-forms are horizontally stacked one on top of the next.

One adduces the twin faces of Being: house /of/ language, revealed through Heidegger as the dwelling. This theme travels to the core of what Klingelhöller's work strives to discover. With precisely formulated non-representational means, his work chases an essence of Being. As a sculptor, he is concerned with making objects that may at once possess and unfold realisations from philosophies of existence.

It is here that the world is encountered; specifically, a landscape world. Entering at a remote referential level, the link between the house and landscape is made when the dwelling is given a role in the world, reified. Again, with Heidegger, from an earlier essay, 'The Origin of the Work of Art' (1935), the house as both 'grounded structure and enclosure' is set against 'violence' – figured against a storm roaring through the landscape. Using this image, the house-as-dwelling comes alive as an abode in which philosophy is transacted, produced from a tangible, turbulent moment in the landscape. It is the storm that prompts thought, further defining the house:

> Standing there, the building holds its ground against the storm raging above it and so first makes the storm itself manifest in its violence . . . It clears and illuminates, also, that on which and in which man bases his dwelling. We call this ground *earth* . . . Earth is that whence the arising brings back and shelters everything that arises without violation.[9]

The image of the house weathering the storm outside, the building framing the storm, its inner calm permeably opposed to the outer violence, recurs with Heidegger to inscribe his conviction that philosophy transpire in the face of the storm, that thought hold in abeyance the storm. 'The house that reveals the weather but blocks it out,' offers protection: 'this blocking, this silencing of the storm, is an essential precondition of philosophy.'[10] For Heidegger, philosophy is called to action by the storm, a violence in nature. The house becomes

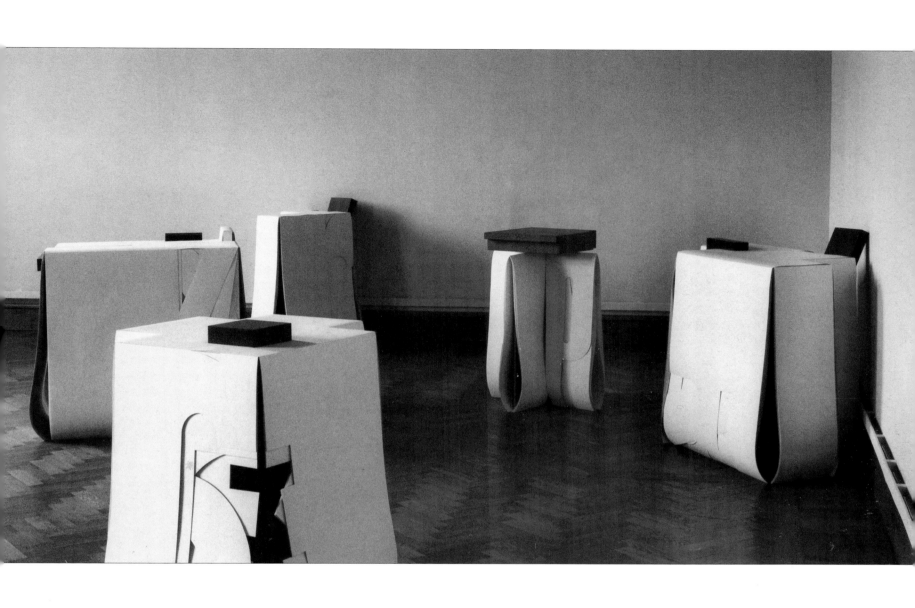

'The Twenty First Century Can Be Repeated',
paper, steel, granite,
1994

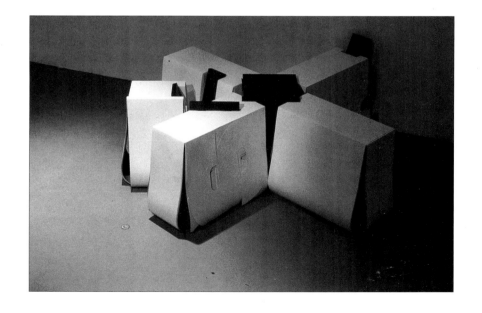

the structure of essential mediation, as internal/external are fused and interposed within each other, bound in the logic of thought's constructed language.

With this theme one achieves a context within which a recent group of Klingelhöller's work may be approached. In the installation at a castle in Keguehennec, Brittany, centrally placed in the lavish salon, appears the sculpture *Storm of Violence, Repeated* (1995). The work, constructed of paper, steel and basalt is composed of two similarly formed structures. Thick sheets of paper, formed as letters, have been draped over the steel frames – an infrastructure which is visible through the exposed corners. The length and languor of the paper flows to the floor, bulging as it meets the floor. Corners are curvaceously opened, permitting space to pass freely through the sculpture. One circulates within and around this work, also to other nearby sculptures, dissolving boundaries of space. The lineaments of the sculptures' built structure are revealed – pronounced by viewing.

The house/storm motif that frames Heidegger's practice of thought provides a circumstance for the production of language, specifically, a language that is philosophy. This originary, primordial home of man is to be found in language. For Klingelhöller, the paper, cut as pieces of language, performs the building function – construction of Being that must endure the violence of the storm. The weight of language, of making, of moving thought into a formed substance – in short, a repetition that is existential – is borne by paper: material of lightness carrying the heaviest weight.

Thought itself is the thinker's burden. Figured in language against landscape, thought's transcription into articulation begins to speak in other tongues. Poetry, thus, becomes the narrative reference in language for another of Klingelhöller's ensemble of sculptures. Three works from 1994 receive titles that have been borrowed from Rimbaud's *vers libre*. For example, *Marine*. Posed together, the sculptures pronounce the concluding three lines of the poem: 'Vers les piliers de la forêt,– / Vers les futs de la jetée, / Dont l'angle est heurté par des tourbillons de lumière.'[11] The chosen poem, one of movement and arduous travel across and through the sea, urges towards a landscape – at times, likens the water-crossing to an upheaval in the landscape. Out of the storm of foam, carving 'ornières immenses du reflux', *Marine* quests for landfall, concluding at the jetty.

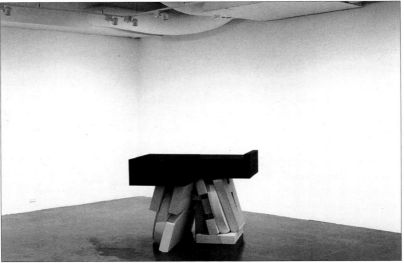

'This as That'
plasterboard, cardboard
1996

Along this juncture in nature, a contour that traces the meeting of water with land, Klingelhöller locates an associative domain for his work. Use of the poem's last three lines, attached to these sculptures as titles, offers the sculptor an explicit intentionality. Themes begin to emerge, out of nature, about turbulence in the phenomenal world.

A set of five works from 1993 further such association, again introducing the world of landscape into (onto) the sculpture. Here the titles derive from a newspaper caption for a photograph of the landscape at the German–Polish border: *Rusty Banisters, Rotten Wooden Houses, Somewhere, In an Empty Factory Area*, or *With That Always Empty Plain* (see p47). A sense of vacancy or abandonment pervades these phrases. Despite the supposed banality of their source, the words retain a trenchant sense of the landscape and its history. Even without knowledge that the caption/photo describes a border zone,[12] from the titles an adequate impression is registered. A transient region is traced, where the defined entity (national borders) loses resolution along the periphery. With this particular region (formerly Prussia) ideologically driven revanchism narrates the space, where tracts of land are the witness-grounds of nations' crushed quests.

For Klingelhöller the sense of the landscape's history is, however, valued against its presence and experience today, its current connotation as a place. That the source of this specificity is a newspaper underlines the present tense of the association: how this border region exists today for the current population which must inhabit a densely connotational site of history. The newspaper sourcing sets up a paradoxical transience, where the ephemerality of daily newspapers is posed against the weight of traumatic history. This flickering of significance is held by the sculptures, recapitulated by the way that they construct their presence: language.

All this referring, the tracking of possible and probable paradigms within which to situate Klingelhöller's work and provide a means to think through the sculptures' apparatus, has revealed relatively little about how the work functions as sculpture. As propositions in which Being resides, as dwellings for the reception of landscape associations, the sculptures retain narrative content. But structurally, how do these works operate? How, for example, should the meaning of paper, so prominent in Klingelhöller's recent work,

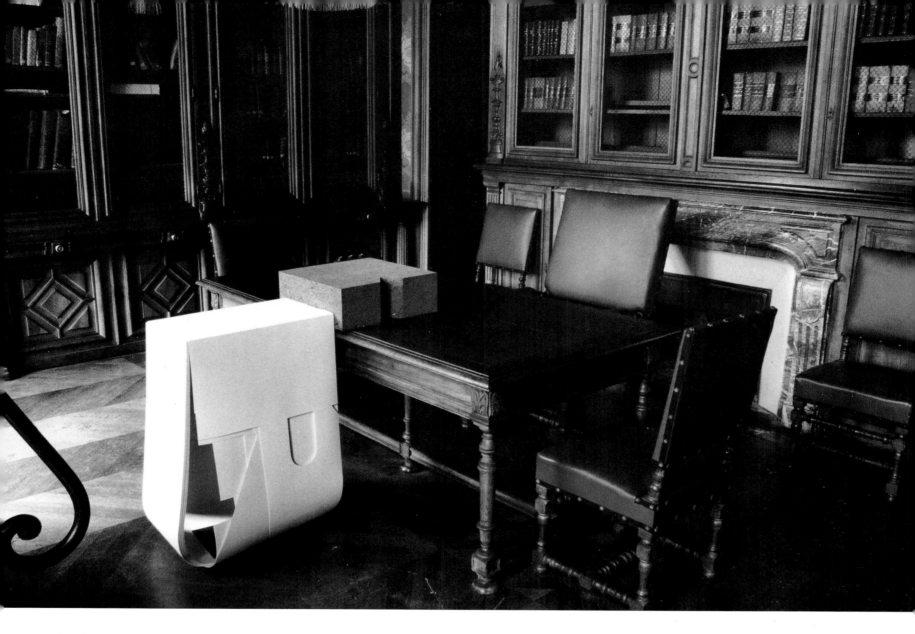

'What Was and Was Possible to Be'
paper, basalt
1995

be theorised; as a skin, as form, as shaped planes?

Beyond the Heideggerian assertion that language is the ancestral home for man, specific meaning over Klingelhöller's use of paper may be retrieved from the structural linguist Ferdinand de Saussure. In his epochal *Cours de linguistique générale* he makes the following well-known formulation:

A language might be compared to a sheet of paper: thought being the recto and sound the verso; one cannot cut one side without at the same time cutting the other; and in the same way, in language, one can neither isolate sound from thought nor thought from sound.[13]

Here, the material of paper may be seen not to represent, but for Klingelhöller to actually *be* the substance of language. Paper is the signifying material that occurs prior to any enunciation, where thought and speech are inseparably bound to each other. By cutting paper, by overlaying successive letter-formed sheets, Klingelhöller, the sculptor, makes the *material* of language speak his thoughts as artist.

Within this logic, there emerges a direct meaning for sculpture. To cut paper (in the Saussurean sense) is to merge thought with speech. This operation is so clearly the method of sculpture, where the act of making becomes synonymous with the act of meaning. Such bound nearness, a merger, creates a structure that is, in the strongest sense of the concept, textual.

Architect Peter Eisenman has defined the structural as that level of meaning which is neither symbolic nor metaphoric. 'A text,' he notes, 'differs from an object in that it is a reading or analysis of another object . . . texts always contain something else.'[14] This 'something else' would 'simulate' the *text* of language, the text of architecture, or of the experience of landscape. For structural meaning to operate signs are relied upon, where 'there is a differentiation and not a representation.' In Klingelhöller's sculpture the densely packed elements create such differential meanings. The basalt elements, for example, which reside within, are suspended on top, or extend outwards from the paper body of the sculptures, act as signs activating a semiotic layer of significance. To decode how these elements work within/against the overall structure of a given sculpture and then of a group of works, would require exhaustive and detailed

investigation: 'The idea of text must be "teased out" from systems of conflicting notation – formal, symbolic, and textual – that may be present in any object.'

Signs in Klingelhöller's work fixate around sculpture's lineage as articulate solid and/or void, directing the dichotomy between enclosure and/or porousness. The enterprise probes the limits of maintenance and dislocation, pursuing the struggle between structure and the validation of experience. His dwelling in the sculpture of language presents clarified constructions: disclosure of thought realised through carefully chosen materials. There are no a priori meanings, only those intrinsic values attained by each work within its own specificity. How one may narrate those meanings – Heidegger, a poem, a newspaper – will offer only provisional, possible venues for discourse. As structures, they textually simulate what the world is. In this manner they deploy language semiotically – the language of their own sculptural being – back onto the world. And it is here, with this *passing through* that their own experience is perpetuated. *The Twenty First Century Can Be Repeated* (1994), a title intones, reiterating a future yet to be lived. This distancing, an attenuation, puts language beyond the grasp of any lifetime, throws our language and our buildings out beyond the reach of our lives to the preserve of culture itself, the home (*Heimat*) that Being seeks.

In the library of the castle at Keguehennec *What Was and Was Possible to Be* (1995) is stationed along the edge of a large writing desk. Its basalt element rests on this desk, attended to by the folded paper component which unfurls to the floor. A large, courtly chair faces the sculpture from across the desk; perhaps this is the philosopher's chair and a dialogue ensues. Along the side of the desk are two smaller chairs, side chairs provided for a listener, an observer who may listen for the sound of thought. Light floods into the room, cascading from a window . . .

And here we must linger, between the chair in which we sit and the window we strive to open. Neither inside nor out, aware that even when the sun tangibly appears, it is we who pervade: embodied, the task of Being – calm of the mind, storm of the world.

Notes

1 For installation of Klingelhöller's sculpture outdoors see *New Sculptures*, Open Air Museum of Sculpture, Middelheim, Antwerp, 1993.

2 Regarding this title Ulrich Wilmes has noted: '*Die Wohnung ist unverletzlich* [*The House is Inviolable*] is a quote from Article 13 of the Basic Law of the Federal Republic of Germany, which guarantees the protection of the intimate sphere of the individual in a self-determined place.' See Wilmes, 'On the Dialectics of Vocabulary of Form and

Linguistic Form', in *Harald Klingelhöller*, exhibition catalogue, Portikus, Frankfurt am Main, 1992, pp40-41.

3 Frank van de Veire has noted a provisional or 'temporary nature' to certain Klingelhöller works, especially those which relied upon the material of cardboard. See Veire, 'Hier als ein Abstand: on Harald Klingelhöller', in *New Sculptures*, pp29-36.

4 Martin Heidegger, 'Letter on Humanism', Frank A Capuzzi and Glenn Gray (trans), in David Farell Krell (ed), *Martin Heidegger: Basic Writings*, Harper and Row, New York, 1977, p193.

5 Martin Heidegger, 'Building, Dwelling, Thinking', Albert Hofstadter (trans), *Poetry, Language, Thought*, Harper and Row, New York, 1971, p146. Emphasis has been added.

6 *Ibid*, p147.

7 Martin Heidegger, 'Why Do I Stay in the Provinces?', *Listening*, 12, No 3, 1977, pp122-24.

8 My account of Heidegger is indebted to Mark Wigley's adept observations about the correlation between Heidegger's philosophical practice and his mountain retreat. See Wigley, 'Heidegger's House: The Violence of the Domestic', in *D: Columbia Documents of Architecture and Theory*, Vol I, 1992, pp91-121.

9 Heidegger, 'The Origin of the Work of Art', in *Poetry, Language, Thought*, p42. Wigley develops the theme of the storm and violence, linking it first to Heidegger's position against new technologies and then to the sensitive question of Heidegger's stance on Naziism. My understand-

ing of 'violence' in this essay is mediated by these connotations.

10 Wigley, 'Heidegger's House', p101. Concerning the 'house' Wigley notes: 'when Heidegger describes language as "the house of Being", it does not simply mean that language is a kind a spatial enclosure in which Being resides. Though 'man' dwells in language, its interior is not like that of a house, which would imply the persistence of some kind of exterior. Indeed, 'man' cannot depart from language; 'man' is unthinkable outside of language; for 'man' there can be no outside to language. The house of Being has no exterior.' See p95ff.

11 'Toward the pillars of the forest,– / Toward the boles of the jetty, / Against whose edge whirlwinds of light collide.' See Rimbaud, *Illuminations and Other Prose Poems*, Louise Varèse (trans), New Directions, New York, 1946, p91.

12 To cite Heidegger's thinking once more: 'A boundary is not that at which something stops but, as the Greeks recognized, the boundary is that from which something *begins its presencing*. That is why the concept is that of *horismos*, that is, the horizon, the boundary. Space is in essence that for which room has been made, that which is let into its bounds.' Heidegger, 'Building, Dwelling, Thinking', p154.

13 Ferdinand de Saussure, *Course in General Linguistics*, Roy Harris (trans), Open Court, Illinois, 1983, p111.

14 Peter Eisenman, 'miMISes READING: does not mean A THING', in *Re:Working Eisenman*, Academy Editions, London, 1993, p11. All subsequent Eisenman quotes are from this essay.

Auguste Rodin, St John the Baptist Preaching, *1878-80, bronze, 200.1cm high, installation at the Museum of Modern Art, New York, 1978, photo D Vermeiren*

THREE ENDS OF ART

Approaching Didier Vermeiren's Sculpture

MICHAEL NEWMAN

The end of art can be understood as its consummation or its dissolution.[1] Art is consummated in the absolute work, or society as that work, or else it is dissolved into the form of the commodity. In the visual arts, the monochrome painting and the ready-made can be taken as standing for these two ends. But to speak of 'two' ends is already to acknowledge a problem with the very idea of the end of art. Art cannot consummate itself in the immanence of its development so long as the latter remains a differentiated sphere of the whole. In such a case, the end of art can only be reiterated in the mode of illusion, since it is not in its own power to disappear. So long as the dissolution of art maintains itself as a possibility within the sphere and discourse of art and as art, it will not have taken place. Monochrome painting and the ready-made become precisely what they should never have been – genres among others. By a movement upwards or downwards the generic was supposed to have been abolished. But rather than being ways of bringing art to an end, the monochrome and the ready-made become the means for its continuation.

Photography cuts across the difference between consummation and dissolution. If the destiny of art becomes to be reproduced in the museum without walls, the photograph itself exceeds reproduction. The 'age of the world picture' is achieved and transcended in the photograph. This 'more', this 'excess' over reproduction in the photograph is the 'index'. The photograph, to apply to it once again the terms of Pierce, is, as well as icon and symbol, a trace of the Real. It is as such that the photograph does not disappear into representation.

Both the monochrome and the ready-made *ought* to have made art disappear. The monochrome by overcoming the delimitation necessary to appearance by including, or excluding – which come to the same – all determinations. The ready-made by abolishing aesthetic value based on the intentionality of the artist. In the end, both served to maintain the autonomy of aesthetic experience within a limited sphere of art.

The photograph implies a desublimation of the aesthetic. Paradoxically, the ontological condition of the photograph is between unsubstitutability and pure substitution. By opening up an abyssal lack of ground in the image – the image as pure simulacrum, substitute without an original term – the photograph reveals things as doubles of themselves, and people as the bearers of their deaths. But as a trace of the Real, touched by its subject, the photograph involves a direct and unmediated transfer from the object to the image, without mediation and without lack. And insofar as non-substitution approaches the refusal of substitution, the condition of the photograph points towards the 'real presence' of the fetish. If we love a photograph it is as trace and contact rather than as representation.[2]

Contrary to what may be supposed, the source of photography lies not in painting – as its purported perfection and displacement as representation – but in sculpture. Specifically, in the practice not of carving or modelling, but of casting. The photographic negative is precisely analogous to the mould. That photography recognised itself as the offspring of the case is clear in the earliest Daguerreotypes, which are of plaster casts and fossils: the one a cast produced by art, the other by nature. Photography thus restores to nature the art of casting, consummating art in the very process of dissolving it.[3]

Didier Vermeiren's sculptures articulate – without reproducing – all three models of the end of art: monochrome, ready-made and photograph. But in each case the model is inflected away from its teleological implication towards an 'outside'.

The dimension of the ready-made in Vermeiren's work refers not to an object other than that of art, but to the support of sculpture. By thus 'doubling' the support – literally the base, plinth, or column – whether this takes the form of a repetition or a mirroring, Vermeiren withdraws from it its traditional grounding role. Instead of condensing space, the displaced base draws attention to the *absence* of the sculpture, and thereby to sculpture as absence. The polyurethane on which some of these 'bases' are placed in works of the late 1970s, or the way in which the sculpture becomes a wheeled frame in the 1990s, indicates that the role of sculpture is no longer to mark a place, but rather to create a *non-lieu*, a non-place, thus inflecting the geometry of space towards an absolute outside, to an outside that has no place, no 'clearing' (*Lichtung*) to borrow a term from Heidegger. Contrary to the Duchampian ready-made, which draws attention to the conditions of art by an act of displacement from the social outside, what is ready-made in Vermeiren's case is 'sculpture'. By 'doubling' this condition, what is presented is the way that 'sculpture' names absence.

The Duchampian ready-made rendered sculpture to painting insofar as it displaced the frame of the latter to the institution.[4] The ready-made points to the institutional frame in anticipation of its recuperation as art, from which it cannot in the end escape merely by an act of decision. This strategy continues to model the notion of condition on a figure-ground relationship that is the condition of painting.

L'Appel aux Armes, *1992, plaster, steel, 247.5x154x174 cm, photo D Vermeiren*

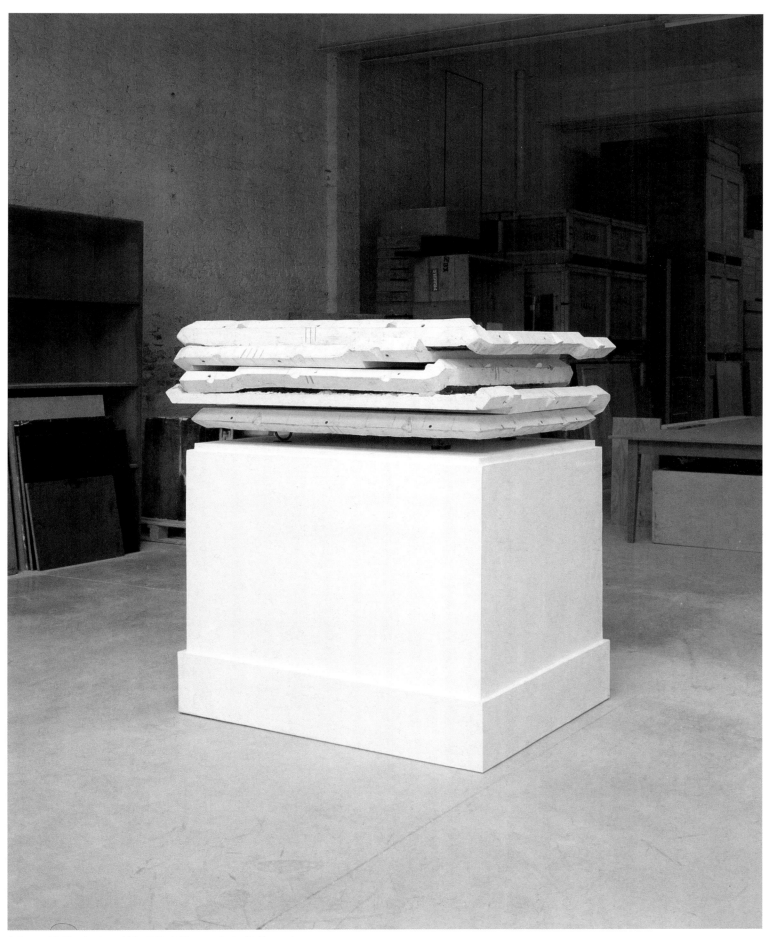

Adam, *1995, plaster, 146x136x113 cm, photo D Vermeiren*

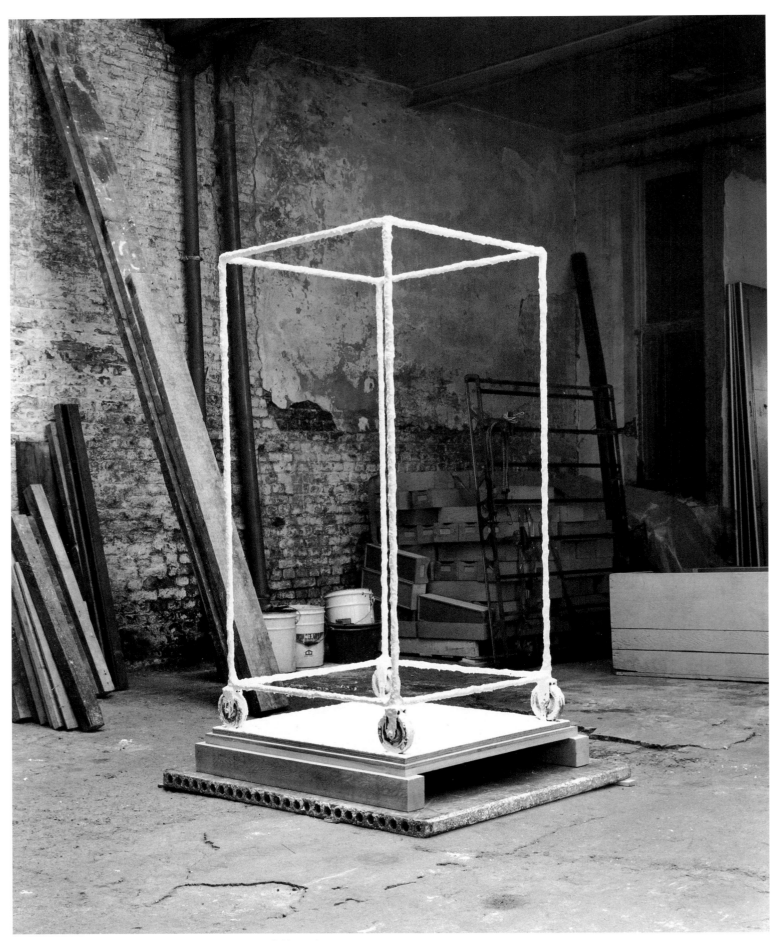

Untitled, *plaster, wood, 182x91.6x99.3 cm, photo D Vermeiren*

It is not so obvious as it might seem that the monochrome painting escapes this condition, since the monochrome does perceptually what the ready-made does conceptually: the wall comes to be read as the ground, and thus the monochrome returns itself to the delimited condition of being a 'figure' in *relation* to a ground that it wanted to transcend, or sublate, in the first place. The inflation in scale after the monochrome by Abstract Expressionism could be understood as an attempt to avoid this fate by allowing the painting to *become* the wall, a condition that it approaches with Pollock. While these paintings are not strictly monochromes, in that they are internally differentiated, all painting after Malevich has to deal with the 'condition' of the monochrome which is, first, that the bare canvas is already a painting,[5] and, second, that any act of differentiation (a mark, a cut or whatever) has disturbed an 'original' condition of non-differentiation. But such differentiation, which relativises the painting by removing its absolute character, is inevitable as soon as the attempt is made to make the monochrome 'positive', to make the end that it stands for appear. Hence the necessity to extend the monochrome to a series: in the hope that the relativisation will take place internally to the series, and thus remain a matter for art which may still be granted its status as absolute.

That there is no obvious equivalent of the monochrome to be seen in Vermeiren's sculpture does not mean that the condition of the monochrome does not weigh upon it. If there is a 'monochrome' to be found in these sculptures – those of the early 1990s – it is in the space of indetermination *between* the mould and the cast, in the completion and interruption of the circle in what is left of emptiness in the mould after the removal of the block cast from it. The mould is now useless, outside the circuit of production, yet at the same time returned to a condition of pure potential. The end is returned to an outside that makes possible – while being occluded by – the beginning. And it is in this that the cast recalls the condition of photography, since the doubling of the cast by means of the mould renders it at once simulacrum and trace, like a death-mask. Yet what is circumscribed is not the life that was, but an emptiness. The mould is an empty sarcophagus. The god is already absent when he needs to be cast. Art does not end by being transcended, but by being repeated. Sculpture wanders.

Notes

1 I am indebted to Alexander García Dütmann for this formulation.

2 I thank Paul Moyaert for this idea. See also Roland Barthes, *Camera Lucida: Reflections on Photography*, Richard Howard (trans), New York, Farrar, Strauss and Giroux, 1981.

3 The ideas in this paragraph have been developed in discussion with Rebecca Comay.

4 For the relation of the ready-made to painting, see Thierry de Duve, *Kant after Duchamp*, The MIT Press, Cambridge Mass/London, 1996.

5 See Jeff Wall, 'Monochrme and Photojournalism in On Kawara's Today Paintings' in Robert Lehman Lectures on Contemporary Art, vol 1 Lynne Cooke and Karen Kelly (eds), Dia Center for the Arts, New York, 1997, pp135-65.

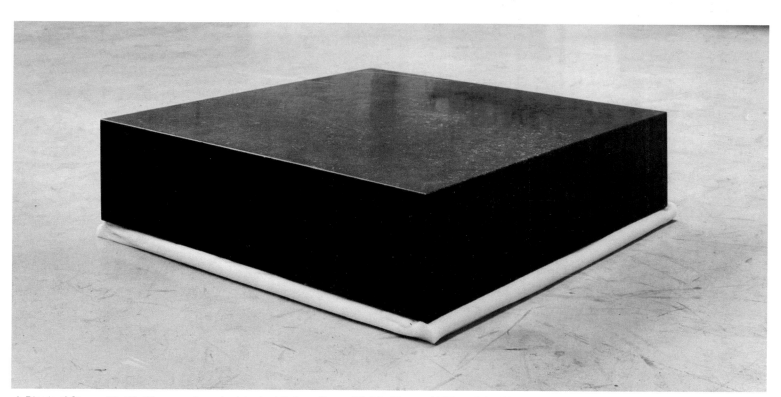

A Block of Stone, 80x80x20 cm on top of a block of Polyurethane 80x80x20 cm, *1985, polished blue stone, polyurethane, photo D Vermeiren*

THE ACTIVITY OF SPACE

The Sculpture of Christine Boshier

ANDREW BENJAMIN

Sculpture will have already entered into a complex relation with space. With sculpture the difficulty that emerges concerns how that already present relation is to be understood. While the necessary generality of this opening will need to be maintained, the specific here will emerge from the recognition that with these sculptures another form of spacing is at work. It is a spacing in which the internality of sculpture will be fundamental to the work of spacing. With the work of Christine Boshier, space is enclosed within the works, as part of their work. This means that there is more at work here than a simple projection outwards. Perhaps, then, when it is time to start, a beginning can be made with spacing understood as projecting an outside as well as an inside. As such these works will need to be understood as doubly spaced; a double movement that occurs at one and the same time. Time is equally implicated. (As will emerge, time is already at work within spacing once spacing admits an already present and insistent complexity.)

Yet it is not as though sculpture simply occurs in space. What had been empty is not filled, partially or otherwise, by the arrival of a sculptural presence. Accepting this as a point of departure will mean that sculpture's relation to space will involve a more complex determination than that which would have been given by viewing space as an empty, neutral and thus static site that comes to incorporate the presence of sculpture. Recognising the singularity of the sculptural will entail having to show greater patience in working with space and thus in detailing its presence. Presence here is the activity of space. Being patient, however, may mean moving slowly. Speed will always have been too easy.

What is most striking about the presence of sculpture is almost pedestrian. Sculpture is there. It fills an area. The way in which it is present is at once elemental – it is there, it is given – even while holding itself apart from any quick reduction to natural necessity. Sculpture is not identical with the presence of rock, stone or metal, for example. Sculpture is not just sheer presence. And yet when it is a question of taking up sculpture's relation to space it is often understood as if it were no more than sheer presence. This shows itself in at least two forms each with its own consequence. In the first instance, the way in which sculpture works to space is not pursued. It is as if sculpture were just assumed to be in space. As such what ever it is that makes sculpture unique is either neglected or denied. And yet, in the second, simply opting for the necessary three dimensionality of sculpture takes the spacing of the object as given and thus has to insist on the neutrality of the site in which the three dimensions are taken to figure. (This site would be space, though in it being named it takes on the quality of a place. Space and place would articulate the same neutrality. It is the neutrality of this construal of space and place it demands that will have to be shown to be there in name alone. What will emerge is neutrality's feint.)

While these two restrictions will be developed, the sculpture of Christine Boshier can be located not at their denial but within the affirmation of the complexity of space. This affirmation will demand the abeyance of those modes of thinking that seek refuge in the interplay of simplicity and neutrality. Affirmation works by its having loosened the hold of loss. In the place of a melancholic preoccupation with that which is no longer possible, affirmation works in the place opened by the recognition of an insistent complex origin. Affirmation, therefore, is deployed within a field of its own making.

What is it to accept the presence of sculpture? Even in allowing that it is there, how is its being there to be understood? These questions do not obfuscate. On the contrary they are central to taking up sculpture's presence. They could, however, have been taken as doing no more than hindering clarity if it were assumed that sculpture was just another object of interpretation; if, that is, that what ever sculpture did that was unique to it were left out of consideration and that as a consequence all that came to be evoked in the interpretive was a certain textual quality. If this is the case then another questioning will have to insist. Once sculpture is freed from its reduction to a visual sign, then the question of its particularity emerges. What is it that sculpture makes its own?

The immediate response to the question of sculpture is three dimensionality. In other words, it is a response occurring within a repetition of what has been taken to be sculpture's own necessity. A way of forcing this response to move further forward is to link it to space. And yet the tiresome oscillation between an object being in space and the space in which it finds itself, works to preclude the object's own work. While it may seem to twist language, what has to be allowed is the possibility that sculpture works by spacing. In other words, that instead of being a site marked by its own substantive presence, space has a verbal quality that will come to define the object's own activity. Sculpture spaces.

What is the activity of spacing? Answering the question will have to involve moving between general considerations and

the actual detail of particular works. However this movement should not be understood as taking place between the pure and the applied. That would be the case only if the claim that sculpture spaced had a generality that rendered all works the same; ie all works became an instance of the general claim. It would be from within that setup that not only would space be neutral and thus only have a singular determination, it would force a type of neutrality and singularity onto the object. Objects would be marked by the necessary absence of particularity. In contradistinction to this setup the position being maintained here involves two elements which when taken together serve to reposition the claims that are to be made about tracing the work of the object. The first involves working within the recognition that while it is possible to make general claims about spacing there is no essence of spacing and thus of the activity of spacing and that therefore, secondly, it is only possible to trace the work of spacing by looking at particularity. It should be added immediately, however, that there will always be a division between works that seek to affirm this set up and those that seek to exclude it from their undertakings. This division will operate as much within art practices as it will within the activity of interpretation.[1]

Arena (1993) presents what could be taken as one of the dominant motifs in Boshier's work. Here, once again concrete is used; nonetheless, what marks this work out is that a solid form, one that is itself the result of a process of construction, comes to encircle and thus mark out an area. It marks it out as part of its presence. The encircling of an area constructs that area. Whatever power it may have it is being given by the sculpture. It works to create a space neither artificially nor as the consequence of a projection. How is the internal to be understood? This question opens up the problem of spacing. Again, to start with the most straightforward: a work in space constructs within it another space. The second space depends upon its exclusion from any form of generalised space. Minimally, what is at work is the construction of an internal space. The construction of that space by a work of sculpture underlines the productive element within sculpture. Sculpture works. And yet this is not enough. The internal world created by the work – created by it as an integral part of its work – in being part of the whole indicates that the external world in which the work is positioned must in some sense have been created by the work. It cannot be that spacing only pertains to the work's internal realm. Equally, spacing must be present in its other

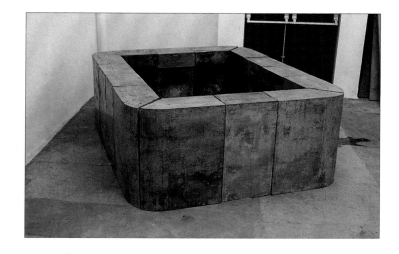

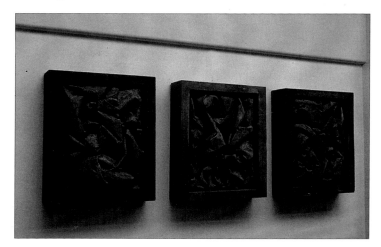

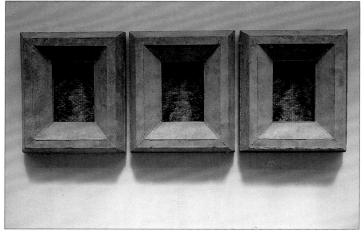

ABOVE: Arena, *1993, concrete, steel, 80x217x176 cm; CENTRE:* Three Graces Revisited, *1994, concrete, each piece 73x60x15 cm; BELOW:* After Departure: Before Arrival, *1994, concrete, glass and photograph, each piece 81x68x16 cm*

projections. Noting that this is the case will necessitate overcoming any easy divide between the work's internality and its exterior projection. What comes to the fore is the question of surface. Ignoring that and dividing the work between a literal inside and outside would be to overlook the other element which is central to the complexity of space, namely, time.

With *Arena* (1994) not only is there the creation of an internal space, it is also the case that the creation of that site cannot be separated from the work's own outside. Here it is an outside that works to create the inside. This should not be seen as a purely semantic play concerning the opposition inside/outside. It is rather that what is at work here is the impossibility on the one hand of effecting any absolute separation of one from the other, while having to allow for the presence of two different activities of spacing. The outward projection gives the work its presence as a spacing in which what is enacted is the continuity of that which is to be experienced. As discontinuous activities – discontinuous in the sense that they are irreducible – spacing involves opening places that are themselves marked by an ineliminable complexity. What allows the complexity is that the discontinuous, instead of taking place over time, takes place at one and the same time. As such time has a material presence since it exists as part of the work's own time. In other words the question of time – and thus what can be taken to be time's plurality – is already inscribed in the work as part of its effectuation.

The specific nature of the work will mean that what it allows for is the recognition that complexity will have already worked against neutrality by showing it to have been a feint, and consequently as an imposition after the event that would serve to deny the event of sculpture. More significantly it would serve to preclude the possibility of its being construed as a plural event. Allowing for the activity of spacing means that the work's own project becomes the creation of space. The space that has been created here only works because of an irreducibility in which the complexity of space figures because it has been created by spacing's own complexity.

Part of the interpretive difficulty posed by a number of Boshier's works is that they involve what amounts to an investigation of sculpture's relation – a relation set up within the activity of sculpture – to painting. Setting up this relation is, of course, not taking place here for the first time. And yet there is an inevitable specificity with these works. Straightforwardly, it resides in the works not lending themselves to an interpretation that begins with the literal surface. It is not difficult to envisage that part of what characterises certain works by Rauschenberg and Schnabel, for example, is a productive concern with a disruption of that surface and thus with an attempt to unsettle what could be described as the hegemony of the surface. (As such, they would be responses from within painting to modernism's own interpretive programme.) Despite the acuity of these moves the surface – though perhaps more accurately the question of the surface – is maintained as the point of departure because its literality is reinforced. In so doing the question of depth and thus the presence of the opposition between surface and depth, even the reworking of that opposition, become activities that can only be played out on and with the surface. To the extent that there is a sculptural dimension within their paintings, it occurs because of a differentiation from within the purity of the surface's dimensionality. Despite an encroachment in which the surface is raised, such that it is possible to locate in the raising of the surface painting's relation to sculpture, the centrality and thus the literality of the surface is maintained. In the case of Rauschenberg this is due, in part, to the over-application of paint, and in the case of Schnabel because the surface is retained as the site of investigation. It is thus that the surface becomes, quite literally, a place of application.

The question that arises with works such as *Three Graces Revisited* (1994), *After Departure: Before* (1994), *Untitled* (1994) and *The Mirror of Bacchus* (1994) is, how are they sculptural? While there is an inevitable difficulty with a question of this nature it should already be clear that it cannot be answered by simple recourse to that which is thought to be essential to sculpture. It must involve spacing understood as an activity that is proper to the sculptural. These works all present what, at its most elementary, is framed space. However the use of the term frame while accurate may serve to mislead. How can one describe these works? At one level it is possible to describe them as though they were paintings, and at another as though they were sculptures. *Untitled* (1994) presents the challenge in an uncompromising way. At the back is a photograph. In front of the photograph are pieces of broken concrete massed at the bottom of the framed area. Over the top of the concrete is steel wire. It criss-crosses apparently holding the rock in place and providing a frame for that which takes place beneath it. The work includes a surrounding frame. There are two of these 'panels'. Taken together they comprise the work that bears the title *Untitled* (1994). What is at work here?

In itself the mere presence of two objects does no more than create a relation. In the case of some of the other works, they are made up of a larger number of objects. A relation does not automatically comprise a work of sculpture. Even within an installation spacing, in the specific sense adumbrated thus far, need not be present. With installations spacing could be purely relational. Here, however, the internality of the object will be central to any response that would be given to the work's work. In this instance the surface that comes to insist is neither open nor closed. The surface becomes an arbitrary moment that is given by the presence of the sculpture in the conventional site of painting. Despite the work of convention, once the specificity of the work is addressed, considerations that would only pertain to painting necessarily come to be displaced.

Taking up the problem of coherence and thus the question of how the work belongs together means that what would have to be described are a series of internal relations which taken one with the other become the creation of space. In other words even in describing what is present the inevitable result is a description of the particularity of space; spacing as the work's activity. Furthermore the detail of the space, and here the detail would not be secondary as though it were an attribution of meaning that was in some way parasitic upon a more fundamental description of what is present, would inscribe space's own particularity with any attempt to think space. It would dispense with the possibility of thinking it as an abstract generality. The layers of activity within these works work in different ways. The retention of gestures that incorporate retention and destruction, holding and displaying, create an effect in which the layering of times and the sedimentation of the past rushing into while abutting the present enable a confrontation with time's own insistent and ineliminable spacing. Here with this form spacing stages not its own history but its place in the presence of time. Time and spacing are present as necessarily interarticulated. Part of their interarticulated presence is the identification – again as the work's work and thus as its activity – of the inherent complexity of both.

Field is a work whose classificatory difficulty is harboured within its experiential complexity. What comes to be experienced is the copresence of objects that work to space, and which comprise, perhaps simultaneously, part of an installation and are thus implicated in another type of spacing. This latter form will be the purely relational. What is meant by the copresence of the two works to create a different field of experience? Again what occurs within this site is an interrelated twofold. In the first instance, what has been checked is the possibility that space may have a unique and thus essential determination. In the second, this result is achieved through the affirmation of a plurality that is there from the beginning. It becomes impossible to ask the question of the essence of space without taking into consideration the necessity of accounting for a complex ontology that is always already present. In sum, therefore, the affirmation of the plural event becomes the work of a founding and irreducible complexity.

Boshier's work operates within an opening made within a metaphysics of spacing in which having worked through the feint of neutrality (revealing it to have been feigned) and the desire for simplicity, there emerges the complexity of space. It is not a complexity harboured in space, nor is it a complexity that remains hidden in objects. It is the complexity that space is. It is affirmed by sculpture's activity; the activity of spacing.

Note

1 This position been argued for in considerable detail in my works *The Plural Event*, Routledge, London, 1993 and *Object • Painting*, Academy Editions, London, 1995.

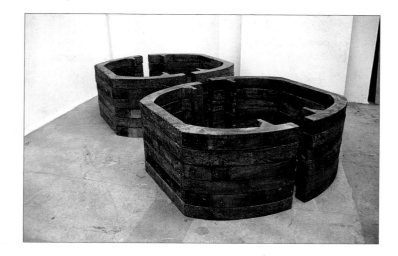

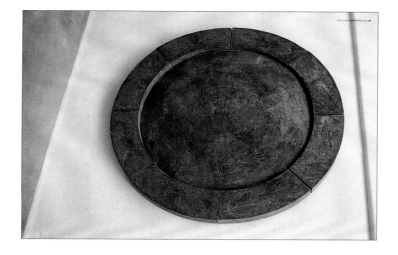

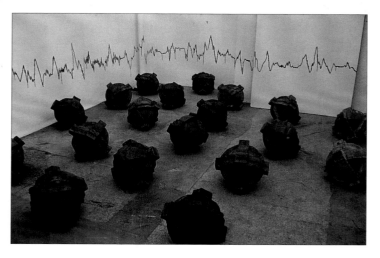

ABOVE: Untitled, *1994, concrete, 30x285x125 cm; CENTRE:* The Mirror of Bacchus, *1994, concrete, 160x160x20 cm; BELOW:* Field, *1994, concrete, coraphite on wall, each piece 40x40x40 cm*

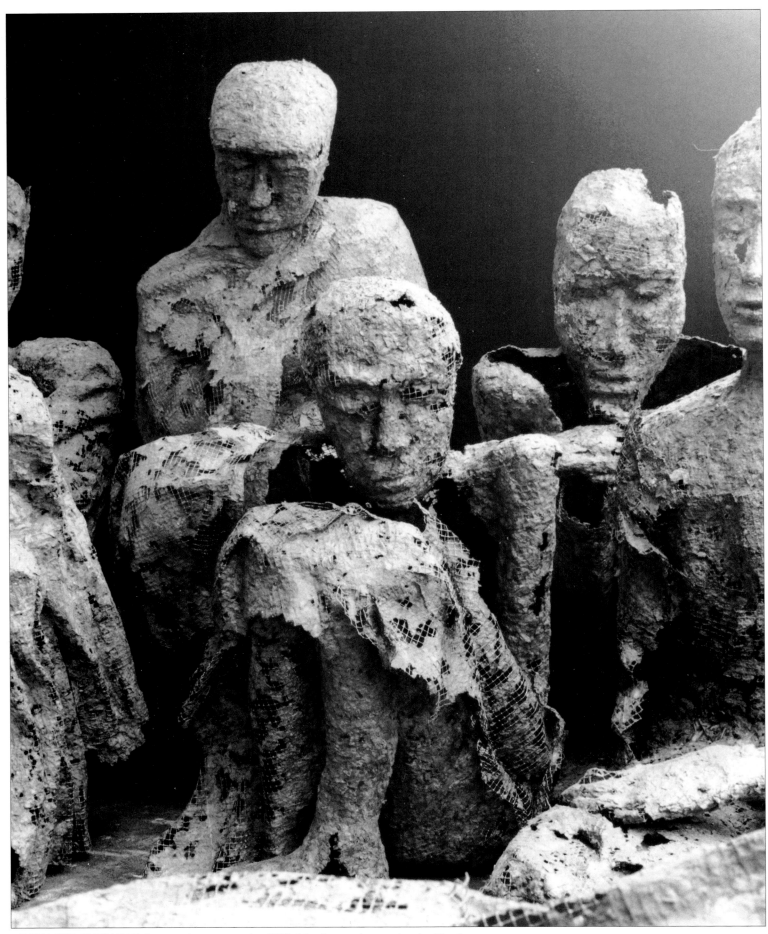

ABOVE AND OVERLEAF: Groupe des accroupis, *1992-94, wire mesh, wood pulp, life size*

HELD, HELD BACK

The Sculpture of Lucille Bertrand

JEAN-LUC NANCY

Two violences, one on top of the other.

* * *

Or else – who knows? – one and the same ambivalent violence twice over, an identical fury, turned against itself or taking itself in hand, flush against itself, compacted, massive and agile, unbridled and restrained [*retenue*], one in the other and one through the other.

Two violences against one another and on top of one another: two buttressed pressures, two stereoscopic images for one and the same balance of an identical relief, of an identical stance [*tenue*] on the ground. A sculpture, first of all, holding and holding itself in place [*tient et se tient*]. Its coming lies in the stance [*sa venue est dans la tenue*]. In it, the two violences come and hold together.

One: a blazon of suffering, bodies reduced to signs of bodies, the body itself absent, replaced by blows, by hunger, by infection, bodies of prison, camp, exodus, virus; masses crazed with massacre; bodies thrown into the grave before being dead because there is nothing else to be done; body-figures, bodies figured so as to recall that there could, that there should have been bodies there. Bodies where there are nothing but bodies, or where there are no more bodies: it amounts to the same thing. Not the monumental or mineral corpse, but the sculpted, gouged open body. The wounded body, the tortured body, has long since been recognisable. A great church had one as an emblem. But from this moment on we have another blazon: that of bodies hollowed out from within, undermined, gnawed away, bodies incorporated into their haemorrhage or their diarrhoea. It is impossible not immediately to recognise in this the image of all modern images: the faceless, the emaciated, the one who exists only in order to certify that he does not exist, the one who is only the place which he ought to occupy, who is only the event which does not befall him, the thought which he cannot think.

The other: a densely woven texture of open mesh, the body on the edge of what drives it apart, the infinite fragility of the skin everywhere finished, everywhere finite, everywhere porous, hollowed out, set free, a worthless cage, wire mesh exposed to the touch. And in this one recognises the image of images: how a body arises in its sole extension, as measure, structure and sculpture pure of a lack of world *in statu nascendi*, uncertain separation, the entire inside suddenly outside, the absolute loss and gain of the other, of all others and first of all of the self, of this body that I am in being nothing but its own crossing, always behind or in front of the body itself. The rhythmic configuration of a presence (without organ: no respiration, no digestion, no heartbeat; rather a tension, a fold, a step). One alongside the other, similar and disparate, similarly dissimilar, each given over to its original presence. The world in billions of open origins in every sense of the term, man without species or genre, violently singular.

* * *

The first violence is that which refuses the second, and which violently forces itself upon it. It does not want that one be torn from the other, nor the other from the one. It is the fear in the face of that which cuts itself off in an absence to self that all share and that no-one wants to know: the fear before the vast strangeness of innumerable men.

The second violence is not constituted by difference: it is the resemblance of this absence, of the one to the other and of the other to the one. It is of never seeing or touching that which one could have expected or awaited as the seen and the touched themselves: love, thought, the secret of being and still beyond. But if one saw and touched these things, there would be neither seeing nor touching. The second violence is thus the distance of a birth, the severing of yet another. The first violence is the rage of not accepting that love, thought, the secret are thus, from the beginning, violently dispersed.

* * *

What one calls a world is nothing other than this dispersal of origins, their dissipation and their prodigality. Neither an absence of origin (this would be a universe), nor an origin compacted upon itself (this would be an earth), but the violent irruption of multiple origins, and, equally, of sense, itself equally multiple. Sense: nothing but sculptured shards of sense.

This is also why the world can destroy itself: entirely peaceable and without the violence which, in its birth, it precisely is, this originary violence carries with it a ferment of fury, however little it can bear it, however much it denies itself. (Nuclear warheads, famine, destruction of the ozone layer, over

population and depopulation, powers, productions, religions, millions of bodies promised to what?)

How to bear not being a universe or an earth to itself and itself alone? How to bear being in the world without anything more or less than that? How to bear having the world as absolute measure? How to bear signifying nothing 'by itself', neither I, nor you, nor species, but only this division or sharing of sense in all the senses of the word? How to stand it?

Here sculpture strives to find the stance. It is a *tecnh* – neither one of seeing nor of touching nor of space nor of volume, but a *tecnh* of the stance: the art and the manner of the stance of a body. Not how it comes to push itself to the fore, but how it appears to the world, how it presents itself.

This is why there has to be the entire space of a coming. Not the two dimensions of a simple presence, but the three dimensions out of the intersection of which comes the fourth: the time of the coming, the infinitely slow, imminent, belated but premature coming, preceding itself but still coming from behind itself, endlessly turning around itself, bending space to this discreet rhythm.

* * *

The sculpture of a woman – sculpting what, of all bodies, is body-of-woman. Which means: not modelling raw material, either drawing form from out of the formless or subject from out of substance by throwing the leftovers out of the image or out of the full and founding idea – but hollowing out the inside, mining the absence right up to the core, folding the wire mesh which encloses nothing.

Sticking skin-tight over wire mesh, not a skin, but multiple skins of paper, layers and strips and fragments, superimpositions and crossings of surfaces without any other hidden face. This skin does not complete and close a flesh (no flesh here, neither emaciation nor tenacity). It is, on the contrary, the meticulous indication, scene by scene, place by place, instant by instant, of the indefinite exposition which a skin is, continuing and discontinuing from a single stance: a network of zones which have nothing in common except their spacing. Their spacing represents nothing: rather, each zone, each space of skin is, in turn, an origin and an end.

In a language concerned with the abstractions of understanding and of judgement, one might say that these zones are 'sensible': susceptible to excitation, to information, to pleasure and pain. It is not this, but the discreet, fleeting and urgent touches of an almost insignificant fragility of sense, that is of concern here.

There was no substance, there will be no subject. No return into the self. No retreating from a violence done to the originary violence. The threat is there, held and held back, but the eyes are not closed in order to interiorise the representation unfolded outside. These eyes do not form images, they see nothing, neither outside nor inside. They are eyes without representation. They are the absenting of vision in the birth of the gaze: out of consideration for the imperceptible passage of sense.

The mouths are not closed in order to gather discourse back

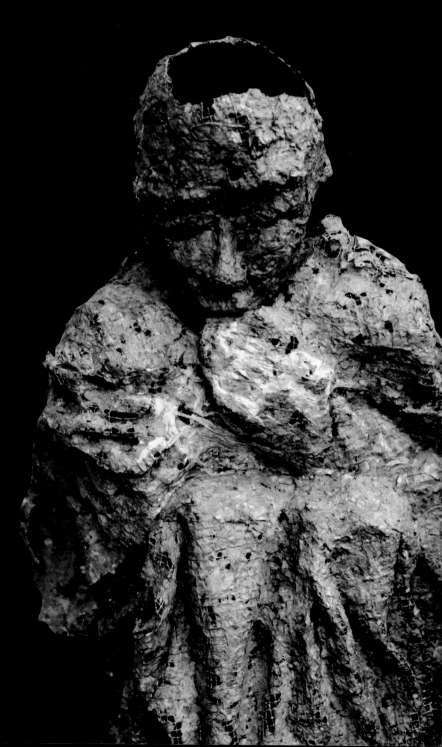

upon itself. They are the absentïïg of speech in a kiss. The kiss does not embrace. Rather, it simply signs, without signifying, it makes the fragile sense that it is, always multiplied.

Sculpted sculptures of kisses, closed, clear eyes.

* * *

Or else, as sculpted by a tear which hesitates and which lingers here and there – a tear of which one could never be absolutely sure whether it is a tear of pain or joy, or of an isolated feeling of being.

Not even a feeling: rather, a having-sense-of-self, a 'self-consciousness', if you like, but one free from any object, including its own substance or its own subject. Free from consciousness, but still clear and distinct. Pure or empty of any object, of any project, full of paper skin, of straw and of pigment, of insignificant marks which make this consciousness known, and full of garments which are the same otherly coloured skin, and pierced by openings which are neither wounds nor tears, but an older and softer violence, an incompletion of birth. A consciousness of being, amassed as a long patience and gathered together in a brief impatience.

* * *

Sculpture, the art of mass: the gathering of a presence, the light massiveness of its immanence, the curvature of space. Mass not as a mass, but as density and as gravity, as the measure of presence.

A gathering of the dispersed which remains dispersed, which presses itself dispersed and dissipated at the origin and within the origin, shattering it – without there being any necessity to this violence nor any salvation in speaking out against it. On the contrary, it is in wanting to absolve oneself from this violent birth that one gives birth to ruinous violence.

Calculation of the measure and the stance which are necessary in order that nothing be salvaged from birth: in order to leave safe that which does not need to be saved. Save that *safe* here does not mean intact, unharmed, unscathed; it means, quite the contrary: nascent, touched, breached for always.

Translated by Simon Sparks, October 1996

Note

1 What follows is a translation of Jean-Luc Nancy's 'Tenue, Retenue' (in *Lucile Bertrand: Sculptures*, L'Arbre à Lettres, Paris, 1995, unpaginated). In order to give Nancy's present remarks some context, one might consult an earlier work, *Corpus*, Métaillé, Paris, 1992, in particular the central sections entitled 'Signifying Body', 'Black Hole' and 'A Wound' (pp60-71), in which some of the themes and the overall lexicon – indeed, the style – of the body is first established. I am thinking, most obviously, of a remark such as the following: 'Let us write (*soit à écrire*), not *of* the body, but the body itself' (12). A translation by Claudette Sartilot of a much earlier and much abbreviated version of *Corpus* has been published as 'Corpus' in Jean-Luc Nancy, *The Birth to Presence*, Stanford University Press, Stanford, 1993, pp189-207 (see, in particular, pp193-98). I would like to thank Charlotte Taylor and her 'sculpted kisses' for listening to an earlier version of this translation.

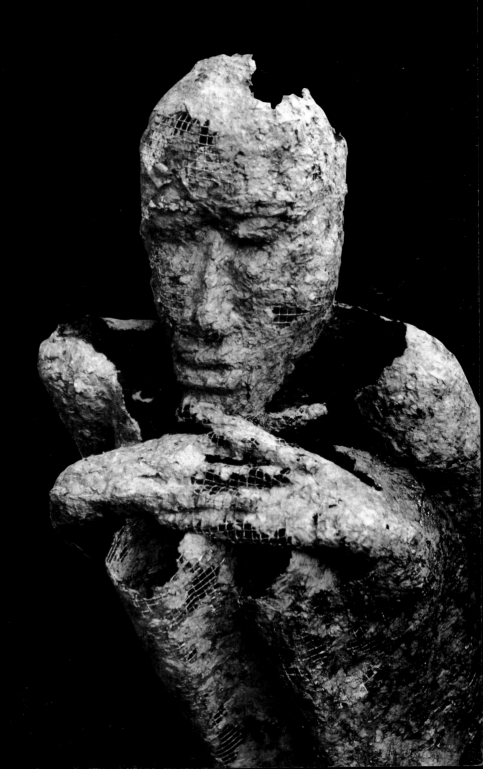

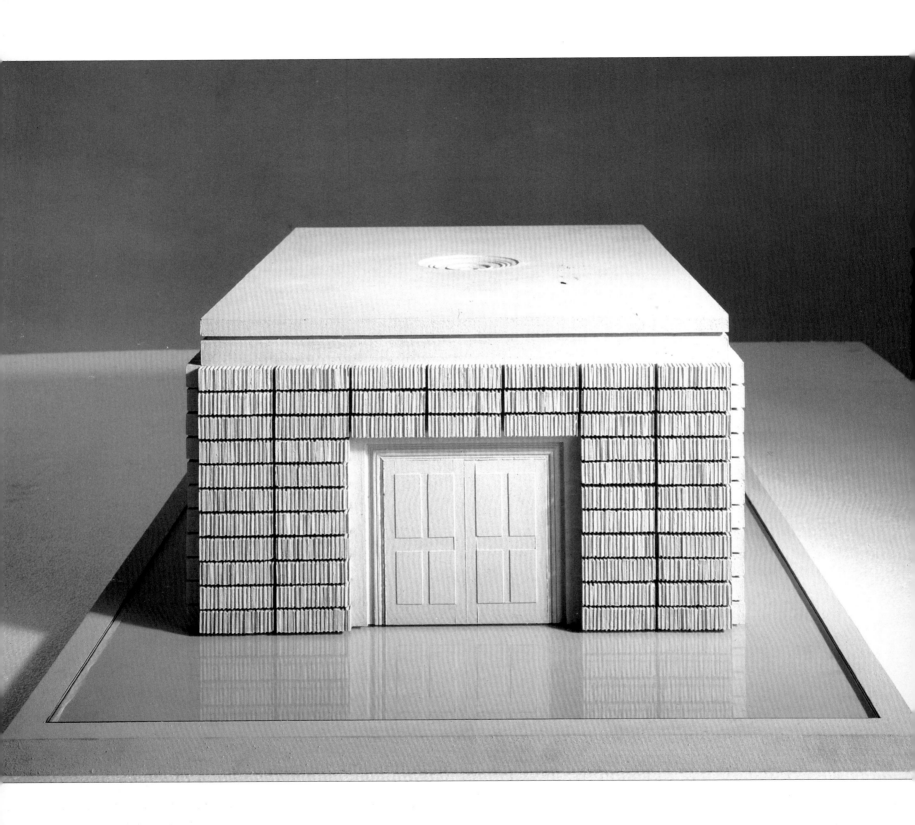

Rachel Whiteread, Model for Judenplatz Holocaust Memorial, *1995, mixed media, height approx 30 cm, photo Mike Bruce*

MEMORY BLOCK

Rachel Whiteread's Proposal for a Holocaust Memorial in Vienna
REBECCA COMAY

Note: In early 1996, after an international competition, Rachel Whiteread's holocaust memorial project was commissioned by the city of Vienna to be erected on the Judenplatz, in the heart of the old Jewish ghetto, on 9 November 1996 – the 58th anniversary of Kristallnacht. An intense controversy immediately followed the jury's decision. Resistance from every conceivable side of the political and cultural spectrum – fuelled by the archaeological complications arising from the recent excavation of the medieval synagogue underlying the projected site of the memorial, intensified by bureaucratic red tape, compounded by devastating electoral losses for the social democrats – have resulted in an indefinite suspension of the project. Now ready for installation, the inauguration has been already twice postponed. Initially postponed until 15 June 1997, more recently put off until 9 November 1997, the eventual installation of the monument now appears to be in some doubt. This article thus concerns a phantom memorial: an architectural model whose materialisation is at the present time uncertain. The crucial differences in detail between the phantom and the reality, between the model and the monument, may nonetheless reveal an essential ambiguity.

'I am a sculptor: not a person of words, but of images and forms . . .' *Rachel Whiteread*

One of the most intriguing proposals to come out of the recent storm raging in Vienna was offered in August 1996 by Johannes Hawlik, the environmental spokesman for the Austrian Peoples' Party (*Volkspartei*). Hawlik did not simply reproduce any of the arguments persistently advanced from every conceivable direction to show just why Rachel Whiteread's monument would be inappropriate for the Judenplatz: the shopkeepers' arguments (bad for business); the residents' arguments (not enough parking spaces); the security arguments (an invitation to neo-Nazi provocation); the archaeological arguments (the risk to the integrity of the recent excavation of the medieval synagogue and the sad irony of putting up one memorial in order to bury another); the 'aesthetic' arguments (the alleged incompatibility of the cold concrete cube with the architectural splendour of the site, the predictable 'hunk of concrete' [*Betonklotz*] insult[1] which in this case, it must be said, had turned rather quickly into the chilling characterisation of the 'Jewish bunker' as a *Fremdkörper* (foreign body) defacing the organic perfection of the baroque square); even the theological arguments ventured in some quarters (the affront to the Book and the Name posed by this shrine to illegibility and anonymity);[2] the 'identity-politics' arguments (the too easy stereotyping of the people-of-the-book, the ignoring of all the doctors, the bankers, the workers). Nor, indeed, as 'people's' representative, did Hawlik invoke any of the vexing issues which inevitably arise whenever the issue of 'public art' comes up – whose monument? which public? which people? Instead, he suggested that the real dissonance here was neither architectural nor archaeological, neither economic nor ideological, but arose rather from the fact that there was already a monument on the square, in this case, a bronze statue of the 18th-century dramatist and Enlightenment philosopher Gotthold Ephraim Lessing. He then came up with the rather striking one-liner which in the context had the distinct ring of a Western movie: 'this square's not big enough for two monuments.'[3]

Rather than piling this 'environmental' consideration on to the mounting heap of arguments as to just why Whiteread's project should be modified, relocated or, as was usually argued, scrapped altogether, Hawlik proposed, perhaps in jest, that it was actually the Lessing monument which might well be carted off and relocated – where? it was, after all, meant to be a 'symbol of tolerance' – right in front of the Vienna Rathaus or City Hall. Erected by Siegfried Charoux in 1934, melted down for ammunition by the Nazis in 1939, rebuilt and reinstalled in Morzinplatz by the same artist in 1968, relocated to the Judenplatz (posthumously) as late as 1982, the Lessing memorial had clearly become a simulacrum of itself, had already relinquished all claims to site-specificity, authenticity and auratic originality. It could well stand to function as the displaced remainder and reminder of the ubiquity and universality of the by now rather frayed values of civic rationality, consensus and debate. Much like the self-multiplying ring in the famous parable told by Lessing himself in *Nathan the Wise* (a parable recycled from Boccaccio), the statue had already been forcibly submitted to the logic of mechanical reproduction, mass-production, self-substitution; had moreover endured the fascist inversion and perversion of the utopian promise of such a logic; and was perhaps ready to announce to the world the ultimate lesson of Lessing himself in his explication of the paradoxical truth of monotheism as being nothing less than the very undoing of every hierarchy and exclusivity – what Lessing calls the 'tyranny of the one.'[4]

Whether facetious or not, Hawlik was perhaps on to some-

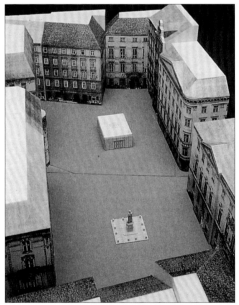

ABOVE: Siegfried Charoux, Statue of
Lessing, 1934; CENTRE: Judenplatz,
summer 1996, showing excavation with
Lessing statue in background, photo Sylvie
Liska; BELOW: Model of Judenplatz with
inserted memorial

thing more than he could have imagined. A shortage of space
would have been the very least of the issues. Nor is the most
interesting tension or discrepancy between the two memorials
the rather banal opposition between post-minimalist cube and
figurative or 'traditional' statuary, a contrast which the jury was
to note approvingly in their official endorsement of Rachel
Whiteread as the winner.[5]

The tension goes deeper than the obvious irony of having
Lessing, the seer of the Enlightenment, suddenly cast in the
position of witness and overseer to an object which would
seem simultaneously to insist on the promise of enlightenment
and to spell the latter's ultimate opacity and relapse into myth
and barbarism. Poised above the projected monument, the
statue had by the summer, in any case, become a kind of
remnant and bystander beside the growing rubble field of
recent excavations unearthing the charred remains of the syna-
gogue, burnt (along with so many of its members) in the
famous pogrom of 1421. The stones of the original ghetto had
been soon enough incorporated into the construction of
Vienna University. If the closed doors and unreadable books
of Whiteread's edifice seem to describe the essential relapse
or reversion of the very institution of *Bildung* from being a
place of openness and emancipation into a place of simulta-
neous exclusion and confinement, it is worth recalling that for
the Haskalah Viennese Jews of the late 18th century, after the
emancipation under Joseph II, it was specifically learning and
enlightenment, the route of high German literary culture, which
was to break down the barrier or 'hedge' [*Hecke*] of the ghetto.
This was to allow the Jews to assimilate or 'melt' – as free
rational individuals – into the surrounding populace.[6]

Occupying the highest point on the square and facing the
sealed doors of the stony library, the figure of Lessing would
also be forcibly in the position of viewing from above what
would be strictly invisible to the actual passerby or spectator.
The inverted ceiling rose which is to be exposed to Lessing's
eyes would seem to function here in a rather over-determined
manner. A mounting for a missing light, evoking a source that
no longer casts a light, the rose would in the first place sug-
gest an absence or blindspot at the very origin of enlighten-
ment. A seemingly decorous, decorative moment, a circle and
centre interrupting the rigid rectangularity of the structure, the
rose would appear furthermore to function equally as artist's
signature. Here we find the quintessentially inside-out, trace-
like, mnemonic index, cipher of expropriated domesticity, every-
thing that by now quickly abbreviates into the paradoxically
familiar trademark of the 'uncanny', everything that paradoxi-
cally reinstates as 'style' the very technique of casting as the
'without-style', everything that marks this monument as
indeed unmistakeably, a 'Whiteread'. Such a secret flourish
would trace the paradoxical signature to that which speaks of
the absolute effacement of every proper name and signature.

But the ornament also has a more tangible engineering

function: drainage. If Whiteread had drilled holes in her earlier bath pieces in order to break or punctuate the suffocating intensity of the vault or coffin – to provide, in her own words, an orifice for 'release' or 'airflow'[7] – what in this context functions literally as drain or opening cannot fail to mark equally an indelible metaphorical association of tomb with the peculiar apparatus of hygiene as 'shower'.

But the debate with Lessing perhaps goes far deeper. It is not only the spokesman of liberal humanism who is being confronted on the Judenplatz. Lessing is also the author of the *Laocoön*. The *locus classicus* of the idealist debate between word and image – a text stimulated by a work notorious in antiquity for being known only ekphrastically or by verbal hearsay (based exclusively on the authority of Pliny) and equally famous in the 18th century for being seen most commonly in effigy, reproduction or plaster cast – Lessing's *Laocoön* stages what will for the next two centuries continue to dominate discussion of both visual art and literature.

The specific details of Lessing's polemic with the Simonidean thesis of the 'sister arts' need not detain us now: *ut pictura poesis*, the mutual convertibility or translatability of 'poetry' and 'painting', word and image, time and space, succession and simultaneity, event and structure, along with the affiliated series of oppositions that for Lessing accompanies this (spirit and body, speech and writing, sublimity and beauty, male and female).

What is at stake in Lessing's attempt to legislate the respective boundaries or limits of 'painting' and 'poetry'? (These rather charged terms function as metonyms for the entire opposition between visual and verbal forms of *poiesis* or production.) What appears to be risked by blurring this opposition – in failing to block the reciprocal transition between word and image, in succumbing to the genre (and gender) transgressions summarised by the oxymorons of 'dumb poem' and 'speaking picture'[8] – is precisely the threat of a certain uncanniness. The miscegenation or mutual contamination of time and space, of text and image, implies nothing less than the confusion – the issue is nothing short of theological – between life and death itself. The descriptive poet who tries to paint in words, to depict spatial relations in time, is said not only to expend labour in vain,[9] but indeed to assume the symbolic castration or muteness of the seraglio,[10] and moreover (in his 'dry', 'cold' and 'lifeless' enumerations[11]) to inflict upon the very body he would represent an irreparable fragmentation and deformation[12] which would block the very possibility of the latter's redemption. The allegorical painter who tries to narrate in images, to display the temporality of events in space, is compared to a fetishist and idolater who would revive or spiritualise what is dead or mortified – this by temporalising matter and thereby raising it to spiritual dignity – and would in this way transgress the monotheistic imperative.[13]

The specific details of Lessing's argument are not what concern me now.[14] What is essential is that Lessing's prohibition becomes sharpest precisely where it becomes a question of representing or 'painting' pain. If the plastic figure of Laocoön, unlike his verbal counterpart in Virgil, is forbidden to scream, if the open mouth would become a 'spot', 'stain' or 'hole' abjecting the pristine surface of the white marble,[15] this is precisely because the 'painter' would in exposing such an open orifice explode the very continuum of space, would expose the traumatic eruption of time in space. This would block the contemplative aesthetic conversion of horror into a beautiful spectacle capable of evoking the spectator's empathic identification or 'tender feeling of pity.'[16] The *punctum temporis* or pregnant moment famously celebrated by Lessing is about nothing if not about this essential possibility of consolation. The penultimate instant, the moment *before* the disaster, is precisely the last moment still unmarked by the traumatic memory of that which could only function as a stain and irreparable reminder of what resists presentation and the living present, and would as such constitute a radical limit on what can be seen. The trace of memory would be in this sense something from which the spectator could only, as Lessing says, 'avert his eyes'.

It would be too quick to transpose the terms of the Laocoön debate into the terms of contemporary art: that is, to apply Lessing immediately to trace the trajectory of the very project of the minimalist artwork into its various self-displacements into text, installation, photography or architecture; its self-inscription, broadly speaking, into language. But I do want to pause to recall what has by now become a familiar theme of contemporary criticism. Such a story would describe an inevitable tendency or movement of (and out of) minimalism – this by virtue of what has been taken to be the latter's tautological positivity ('what you see is what you see') – from a condition of hyper-visuality towards a certain condition of textuality epitomised in the conceptualist turn to language as indeed to architecture. Such a move would signal nothing less than a reaffirmation of art's repressed utopian promise. If minimalism's unbearable positivity had for some come to signal its ultimate self-reification, its lack of reflexivity with respect to its own conditions, the conceptualist response would have been precisely to rupture any such satisfaction insofar as it would inscribe within the artwork itself a critical relation towards its own conditions of production and reproduction. Hence the interventions in the various channels of presentation, distribution and consumption – museums, institutions, urban spaces, publications, and so on – by which conceptual art in its first flush distinguished itself.[17] The conceptual undermining of minimalist visuality would in this sense paradoxically direct itself in the first place to what would remain the latter's ultimate blindspot and hence its acquiescent servility to its own context. The apparent mitigation of visuality would thus in a deeper sense secure precisely minimalism's ultimate vindication as

the very promise of enlightenment.

Now what is striking about Whiteread's building is that it would appear to evoke a minimalist object while at the same time resisting or blocking the conceptualist translation of that object into either text or architecture. The object remains an object: it does not make that transition which was once described as art's last gasp, its final, flickering possibility of redemption, its only remaining alternative to positivity and thus collusion. This is significantly a move which Whiteread's object appears not to make. Its very subject matter would on the one hand seem to *evoke* a certain synthesis of both text and architecture (no more perfect mediation than a library), while on the other, as an object, the work would seem to renounce the very mediation to which it alludes. In this respect it is crucial to insist that this object is strictly speaking *neither* sculpture *nor* text *nor* architecture. It rather suspends itself between these as a kind of monument or testimony to a frozen possibility and as a mute renunciation of a negotiation now and henceforth impossible to achieve. Here the object would seem to bear the essential stigma of its own failure to transcend. Indeed it would expose the very promise of transcendence as the guilty idealism it must inevitably become. The encrypted books, the unnavigable space, the impenetrable facade: all this speaks of a blockage at the very kernel of what is most visible. It announces the very persistence of the visible in its most extreme opacity.

It is the Proustian library which is here effectively being deconstructed or reread. It is essential that the final series of epiphanies marking the end of the *Recherche* should conclude and culminate in a library. Waiting for the music to end, so he can finally join the party, the narrator absent-mindedly casts his eye over the elegant bindings of the 'magnificent first editions'[18] adorning the posh interior of the Guermantes. If it is the red cover of the book which here haphazardly attracts his attention, if he insists here on the physical materiality, the spatial density of the volume, this is ultimately in the name of an interiority both recaptured and redeemed by the very exteriority which would seem at first to undermine it most. If the ideal book is in this respect the unread book, the useless book, the out-of-work book (as Benjamin, Adorno, Blanchot will in their own rather different ways insist on), if one can – and must – come to judge a book by its cover, this is because in the end it is the very body of the book, the opacity of the binding, which here provides the final resistance to memory as a movement of pure interiorisation or idealisation, and as such constitutes the most essential obstacle or barrier which needs to be posited if only in order to be overcome. (The ultimate proximity of Proust and Hegel is rather striking here.[19]) In this sense the visibility of the binding here stands for the very possibility of the 'binding', mastery or symbolisation of the child's initial trauma (in Proust, a trauma significantly enough

set off by over-reading). As such it is a promise of the overcoming of the brutal anonymity, stammering and general imbecility into which the narrator has for the past several thousand pages been cast. Thus the official conversion of the dead letter into living spirit: the transformation of the book from a 'huge cemetery in which . . . the names are effaced' into the Book as cathedral in which the buried child is to be resurrected;[20] the translation from traumatic 'imprint' or 'impression' to the printing of the book of inner memory; or, if you like, and whatever this might come to mean in this context, the conversion of 'Jewish' into 'Christian' forms of reminiscence.

It is this last move that Whiteread's memorial would seem to block or inhibit. The refusal to expose the spines of the books here comes to express rather more than the signature of reversal, inversion and so on, that has by now become her trademark. Such a refusal here begins to take on a rather specific charge. For if the exposed page edges reveal a kind of secret 'inside on the outside' which resumes the previous experiments in disclosure (the exposed stairway of *House*, the stain on the bath, the writing on the underside of the sink, the imprint on the mattress), the very fact of their exposure points equally to the ultimate encrypting not only of the 'outside on the inside' (the spines now incarcerated in cement) but equally, and for this very reason, of the 'inside on the inside': the page surfaces themselves whose final inaccessibility would here seem to be most sharply underlined. Illegible and irretrievable, the books in their impossible visibility announce the ultimate opacity of an archive all the more impenetrable in its self-display. If to see the page edges is to see what cannot be seen, what should have remained hidden, we are here in the presence of a secret all the more absolute for being revealed. Opaque in their exposure, all the more entombed in being unveiled, the inverted books signal the impossibility of either concealment or manifestation, either protection or exhumation – ultimately either burial or resurrection – and thus announce the endlessness of a mourning without term.

In this respect a comparison with two rather distinct strategies of book-burial may be instructive. The diametrically opposed projects of Marcel Broodthaers and Anselm Kiefer here come to mind. Whiteread's concrete library is clearly neither the plastered book of *Pense-Bête* nor the monumental library of *Zweistromland*.

Broodthaers was to inaugurate his career as artist (and to end his career as 'poet') with the hyper-Mallarméan gamble which would efface and deface the book by materialising the signifier: whether by literally embedding his own literary remains in plaster (*Pense-Bête*, 1964, there is perhaps homage to Duchamp here, to the plastered *Tongue in my Cheek* 1959 which had announced the speechless self-parody of the artist); whether by installing them as objects behind the protection of the glass museum case (*La signature de l'artiste*,

1974); whether by patching over the pages of *Coup de dés* with his own adhesive, tomb-like lozenges, thereby visually erasing or deleting the semantic power of the poem so as finally to liberate the word to the plastic regime of the letter (*Un Coup de dés n'Abolira le Hasard. Image*, 1969, a 'trace' [*sillon*] of his precursor's text which will be eventually engraved on anodised industrial aluminium); or whether, finally, by producing his famous 'industrial poems' of 1968 – embossed plastic plaques, 'paintings' (as he called them) blind stamped in 'limited editions'. These latter, in their monochromy and seriality (an effect enhanced by the linguistic repetitions incorporated within the actual inscriptions), are brought to the point of near illegibility by virtue of the very process of reproduction by which they are brought into relief.

It could be argued that in each of these various spatialisations of the text, Broodthaers appears not only to reverse the conceptualist transition from image to language (thus denouncing the secret idealism of the latter) but, moreover, in so doing to announce art's ineluctable persistence as a 'thing of things'[21] and thus its immersion in the very commodification it would contest – the ultimate 'tautology of reification'.[22] What might seem to be a blurring of the line between language and object is thus equally a parody of any claim to reciprocal permeability or translatability. Rather than expressing synthesis or mediation, the object rigorously suspends itself between text and image while negating both. It offers only the parody of 'the shining hand-in-hand of poetry and the visual arts'.[23] It exposes the essential failure of conceptual art to transform viewing into reading, and hence marks the relapse of such a project into the museal resuscitation of pictorial and sculptural forms.

For example, *Zweistromland* (1985-89). How are we to interpret Kiefer's gigantic lead books heaped on their massive steel shelving? On the one hand, these titanic volumes present the spectre of an absolute unreadability: weighing up to 300 kilograms each, impossible to handle, they announce absolute ruin both in their substance (encrusted with salt stains, emulsions, ash and the mouldering traces of transience) and in their content (incorporating so many apocalyptic photographs of abandoned factories, decaying cities, archaeological relics, not to mention the inevitable shots of vanishing railway tracks with all that is implied). On the other hand, redemption beckons in the very ciphers of destruction. The persistence of heavy matter points simultaneously to an essential promise of transfiguration – the alchemical potential of lead is never forgotten here, any more than its protective anti-radioactive capacities. This equally gestures towards an unexpurgated residue of meaning as emblematised by the references to the secret knowledge of the Tarot ('The High Priestess') as indeed to the cradle of civilization in the Near East.[24] It is perhaps in this sense less that the books are illegible than that they forestall, restrict and ultimately vindicate reading: the gigantic volumes 'preclude access by the

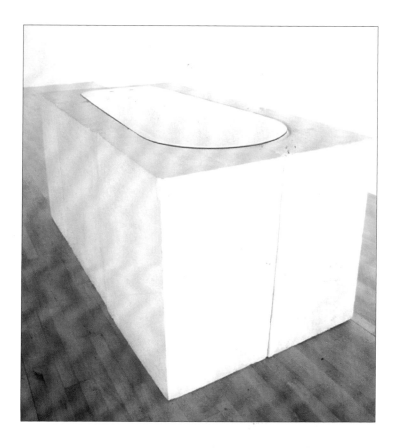

Rachel Whiteread, ABOVE: Untitled (Bath), *1990, Tate Gallery Liverpool, installation view Sept 96-Jan 97; BELOW:* Table and Chair (Green), *1994, rubber and polystyrene 68.6x81.3x122 cm*

Anselm Kiefer, Zweistromland, *1991, unique book, cover and 50 pages, photograph mounted on board, some with emulsion, bound with cloth, inscribed with title by artist, 47.5x34.5x11 cm*

ordinary mortal'[25] precisely so as to reserve their truth for those invested with the authority to interpret them. Such a promise is perhaps formally inscribed in the very arrangement of the shelves, which are themselves angled like the pages of a book, such that the sculpture as a whole assumes the shape of an open book which the spectator can walk around as if to peruse both recto and verso in their entirety. It may be argued that *Zweistromland* finds its logical fulfilment in the publication of the lavish, oversized book which bears the same name, which includes not only the artist's documentary photo-essay of the installation but also photographs of a small selection of the otherwise inaccessible leaden pages.[26] Here the promise of a reciprocal conversion of image and text, of sculpture and book, becomes nothing less than the promise of the *Gesamt-kunstwerk* – the 'becoming space of time' (*Parzifal*) which announces the ultimate suspension of history within the mythic plenitude of nature.

What is at work in Whiteread's library? Neither the conceptual negativity of a Broodthaers nor the monumental positivity of a Kiefer. How are we to understand the strange interplay of seeing and reading in this construction? Is there a third possibility between negation and positivity?

Nor exactly is Whiteread's memorial like the recent memorial to the burned books at Bebelplatz in Berlin. Indeed it would seem to perform its precise inversion. Micha Ullman's 1995 memorial commemorated destruction with the ciphers of absence: thus the sunken pit, the painfully empty shelves (built to hold 20,000 volumes), the shiny glass covering (at once ceiling, floor, and window) reflecting back only the vacancy of the sky, the clouds, the trees, the transient traces of a nature at once forgotten and suddenly turned sinister in its own obliviousness. It is also of course the spectator who would be reflected – but this precisely as stain or blindspot. To approach the pit would inevitably be to block the transparency of the window-floor and thus to occult the very ground on which one stands. By contrast, Rachel Whiteread's monument would seem to substitute height for depth, presence for absence, books for shelves, contents for container – to the point where the very frame supporting and enclosing the ensemble here evaporates without a trace.

There is no trace of shelving in the model submitted by Whiteread for the competition, not even a negative trace. In what is perhaps the most startling deviation from Whiteread's habitual practice and signature, the model represents the books not only in positive form, but as apparently lacking every trace of support or context. This is in striking contrast to her recent experiments with book-sculptures (see, for example, *Untitled [Five Shelves]*, 1995). In the model, the bottom edge of each shelf-load is emphatically not flush.[27] As if gravity itself had been eliminated, there appears to be complete vertical symmetry here between the uneven, wiggly planes described by

the top and bottom edges of each row of books, which as such now register only the absence of the missing support or ground. Not even the negative imprint or empty space left by a shelving system is registered in this sketch for a library in which the arrays of books, invisibly bolted to the recessed wall, appear to float between the vacant interval defined by the symmetrical intrusion and confrontation of the facing horizontal edges.

One can surmise in Whiteread's corpus a certain trajectory of increasing complexity of incorporation or containment – a perceptible movement from casting containers used by human bodies (hot-water bottles) to objects used to contain or support both human bodies and their objects (beds, chairs, baths, tables, floors, cupboards), and in turn from containers to containers containing containers (desks with encrypted drawers) and containers of containers (rooms, houses).[28] The library would stand at the extreme limit of such a logic of incorporation. A room full of shelves full of books full of pages full of words would logically function as a container of a container of a container of a container of a container. At every stage, what is 'inside' here presents itself as radically 'outside' – exterior to its own exterior – insofar as it would seem to form a limit to what can be enclosed, contained or included. Interiorisation would here reach its absolute limit.

It is striking that at this point, where the logic of containment reflexively intensifies itself, there is a sudden movement of reversal. The essential technique and suggestive power of the cast has in fact been apparently relinquished. Rather than functioning negatively as the materialisation of an absence, the model here presents us with a positive volume without a trace of negativity or absence.

In this respect the memorial might seem to go against the grain of Whiteread's entire practice. No doubt it will for this very reason be suspected. For does it not seem to reverse the entire pathos and promise of the cast as the refusal to reify or posit what can only be rendered as absence or as negativity? Does it not threaten to reinstate – indeed at the very level of the monument – a kind of positivity which would in this context be more than suspect?

By now the problematic is somewhat familiar. In Germany, perhaps above all, it has become the essential mark of the 'holocaust memorial' to remark on its own impossibility – its inevitable function as alibi, substitute, pacification, absolution – and as such to unmark or efface itself so as to displace the guilty traces of its own subsistence. A whole genre of anti-monuments can be easily catalogued: sunken pyramids in Kassel, disappearing obelisks in Harburg, buried inscriptions in Saarbrücken.[29] One might begin to suspect a certain grandiosity in such self-effacing performances. Even apart from the suspicion that the very performance of disappearance would inevitably reinstate the prestige and aura of the

vanished original, one might equally question the longing for purity inherent in the work's own self-negation or self-unworking – the secret promise of the *tabula rasa*.

Indeed it could easily be argued that such literalising strategies of effacement could only reinstate the idealisation of memory by reintroducing the hierarchy of mind over matter, concept over object – thus the displacement of the commemorative imperative from the exteriority of the body to the inner spirituality of the pure (even absent) spectator – and ultimately, indeed, the inwardness of an imaginary community constituted within the transparency of a public sphere of democratic consensus and dissensus. Thus Jochen Gerz's invisible monument at Saarbrücken (*2,146 Stones*, 1991) was explicitly referred to and relocated within the 'interior memorial' of a public both informed and formed by the media debate which was inevitably to follow. Thus, too, Jochen Gerz and Esther Shalev-Gerz's 'sinking monument' at Harburg (*Monument against Fascism*, 1986-93) – 12-metres high, six years to sink, a surface for inscription, properly buried in the end. This was to incorporate both defacement and effacement, both graffiti and self-occlusion, as an essential moment of its own erection. It thereby both deferred to and vindicated the prior existence of an enlightened public commissioned to assume the burden of remembrance within the interiority of the heart. Thus, too, Horst Hoheisel's buried monument at Kassel (*'Negative-Form' Monument to the Aschrott-Brunnen*, 1987) – no doubt the exemplary form of this specifically German genre of anti-monument. At once replica and mirror inversion of the demolished monument it was to commemorate, while it simultaneously registered the impossibility of all restitution or symmetrical return.

Whatever Whiteread's projected monument is inverting here, it would appear to perform a rather different kind of negation. It is particularly striking that the peculiar hallmark of the negative cast – everything that we have come to associate with Whiteread – is in this work almost entirely abandoned. The ceiling rose and door mouldings are the only truly negative forms or strict inversions in the entire structure, and would effectively function here only as artist's signature.

Much could be said about the evocative potential of the cast: Pompeii, the death mask, the inscription of a negative space which may or may not – this is the danger and the uncertainty – be converted into positivity. Thus the familiar 19th-century discourse regarding casting as the speculative movement of negation, negation of the negation, whereby a mortified matter reifies and eventually redeems itself in living spirit. Rodin, infamous for his castings, famously referred to the plaster stage of the process as the time of the subject's death, to be followed by a triumphant resurrection in the final product. He would admonish his sitter – 'don't worry . . . life will return'[30] – as if to acknowledge the risk of an irrecuperable mortification.

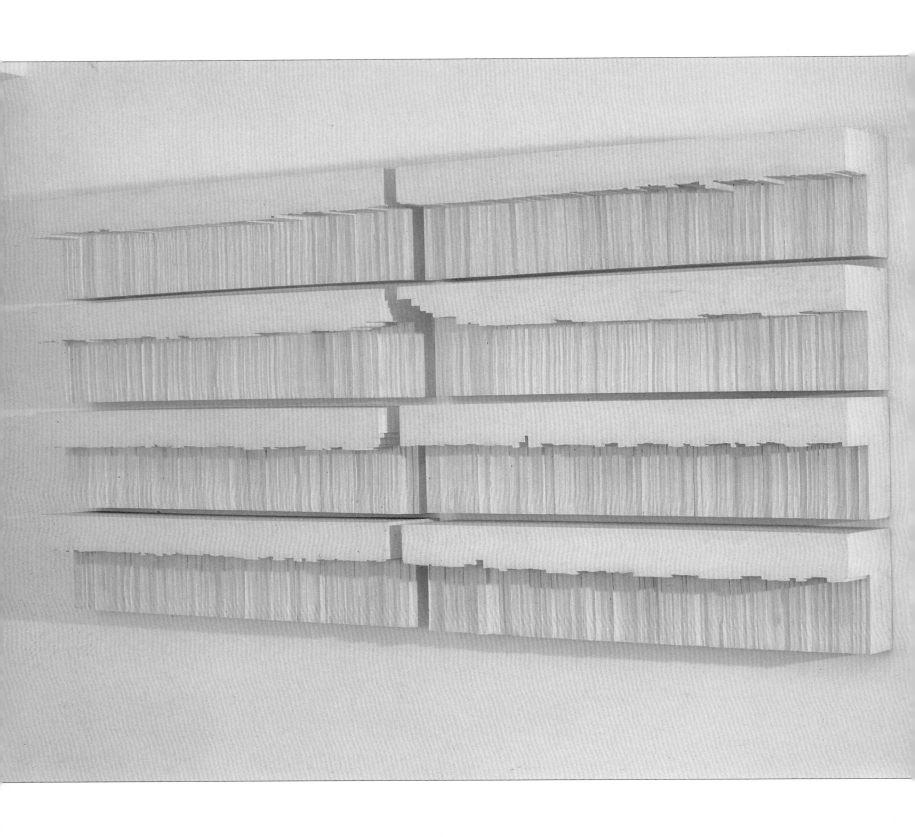

Rachel Whiteread, Untitled (Eight Shelves), *1995-96, plaster, 27.9x118x21.6 cm, eight units*

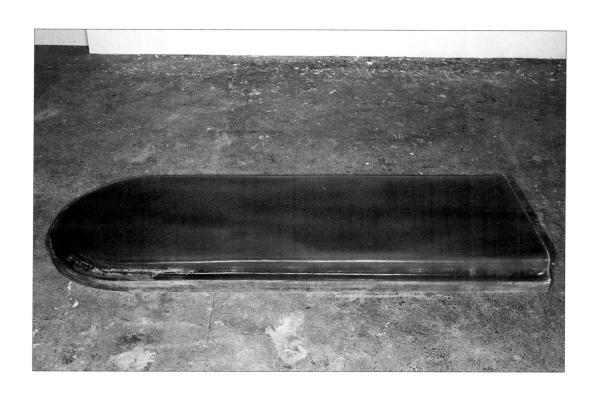

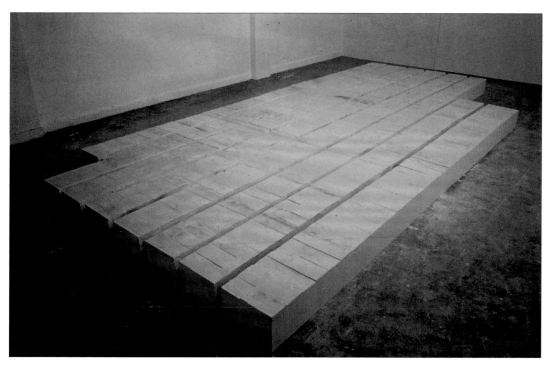

Rachel Whiteread, ABOVE: Untitled (Slab II), *1991, rubber, 14x196x75 cm; BELOW:* Untitled (Floor), *1992, plaster, 24x280.7x622 cm*

Hence the classical association of casting with photography, which in every respect (negativity, indexicality, reproducibility) would seem to function rather similarly. Indeed it is significant that the history of photography is bound up with the history of casting to such an intimate degree that it not only shares the latter's basic vocabulary (negative/positive, editions, enlargements, etc) but indeed takes the latter as its exemplary subject. As if reflexively registering what is essential about its own medium, early photography finds in the fossil and in the plaster cast – two favourite props of 19th-century studio still lifes – a specular object for its own self-investigations. The earliest known print by Daguerre himself (*Still Life*, 1837) features decapitated plaster cherub heads gazing vacantly into the empty space of the photograph: death confronts the viewer in the most kitschy symbols of resurrection.

Why does the *Holocaust Memorial* stage this apparent turn to positivity? Whiteread's work has distinguished itself up to now by its rigorous materialisation of absence: its emphatic arrest of the casting process at the moment of an irrecuperable negativity. Why, and why above all in a holocaust memorial, are we confronted with this seeming return to figural representation?

The model presents a rather startling final feature. According to the original proposal, the memorial was to be mounted on a glass base on which were to be engraved the two official inscriptions stipulated by the initial terms of the competition making reference to the more than 65,000 Austrian Jewish victims of the Holocaust as well as providing a list of the sites of extermination. What is striking here is that the monument seems to achieve a kind of weightlessness in being absorbed within its own reflection. Here we find the perfect inversion of Whiteread's earlier floor pieces, with their downward tug, their gravitational density, their 'base materialism'. In the glass the sculpture finds its own inversion or specular negation. In this respect it is the mirror which now performs, but only virtually, the negative function of the cast.

The visual multiplication of the shelves would suggest a demonic or Borgesian repetition suggestive of a Romantic specular regression. More striking still, the glass would function simultaneously as a surface for reflection and as a surface for writing or engraving. To look into the glass would be to observe the superimposition of blank book edges upon the traces of an indelible inscription. And, indeed, vice versa. In the mirror, language would return to sculpture, sculpture would return to language, the latter now reduced to its barest abstraction as the empty list of names which marks the very limits of commemoration.[31] Suspended between the negative and the positive, such a moment might indeed have marked the impossible porosity of image and word as the paradox of a redemption that can henceforth only arrive too late.

Alas. In the final version now awaiting assembly in Vienna, the glass base has been replaced, I am told, by opaque white concrete.[32]

Notes

1 'Aber was soll denn [der] Betonklotz sein? – ein Mischmasch aus zerreibenen Stein und Eisen ...' (Alfred Hrdlicka, quoted by Britta Bulmencron, 'Der Streit um das Mahnmal eskaliert', *Kurier* (Vienna), July 30, 1996, pp11f.

2 *Die Gemeinde* (Vienna), June, 1996.

3 'Der Judenplatz ist zu klein für zwei Denkmäler.' See 'ÖVP-Hawlik: Lessingsdenkmal soll übersiedeln,' *Der Standard* (Vienna) 26 August 1996, p6.

4 Gotthold Ephraim Lessing, *Nathan der Weise*, III.vii, Goldmann, Munich, 1954, p91.

5 *Judenplatz Wien 1996: Wettbewerb Mahnmal und Gedenkstätte für die jüdischen Opfer des Naziregimes in Österreich 1938-1945*, Kunsthalle Wien, Folio Verlag, Vienna, 1996, pp78, 82.

6 Steven Beller, *Vienna and the Jews, 1868-1938: A Cultural History*, Cambridge University Press, Cambridge/New York, 1989, quoting Theodor Gomperz. See also Gershom Scholem, 'Jews and Germans', in *On Jews and Judaism in Crisis*, Schocken, New York, 1976, pp71-92.

7 Interview with Iwona Blazwick, *Rachel Whiteread*, Stedelijk Van Abbemuseum, Eindhoven, 1992, p12.

8 Gotthold Ephraim Lessing, *Laocoön: An Essay on the Limits of Painting and Poetry*, Edward Allen McCormick (trans), Bobbs-Merrill, Indianapolis and New York, 1962, p5. It is the allegorical painting and the descriptive poem which for Lessing epitomise the problem.

9 *Ibid*, pp86, 91.

10 *Ibid*, p59.

11 *Ibid*, pp83, 96, 91.

12 *Ibid*, pp88, 104, 109.

13 *Ibid*, pp55ff.

14 For readings of Lessing's argument and its implications, see WJT Mitchell, 'The Politics of Genre: Space and Time in Lessing's *Laocoön*', *Representations* 6 (1984), pp98-113; Carol Jacobs, 'The Critical Performance of Lessing's *Laokoon*', *Modern Language Notes* 102 (1987), pp483-521; and David Wellbery, 'The Pathos of Theory: *Laokoon* Revisited', in Ingeborg Hoesterey and Ulrich Weisstein (eds), *Intertextuality: German Literature and Visual Art from the Renaissance to the Twentieth Century*, Camden House, Columbia, SC, 1993, pp47-63.

15 Lessing, *Laocoön*, *op cit*, p17.

16 *Ibid*, p17.

17 For the most influential and sophisticated version of this argument, see Benjamin Buchloh, 'From the Aesthetic of Administration to Institutional Critique (Some Aspects of Conceptual Art 1962-1969)', in *L'art conceptual, une perspective*, ARC, Paris, 1989.

18 Marcel Proust, *Remembrance of Things Past*, CK Scott Moncrieff and Terence Kilmartin (trans), Penguin, Harmondsworth, 1981, vol 3, p918.

19 The unreadable binding in Proust corresponds in Hegel's *Encyclopaedia* account of language to the 'without book' of an expropriated or 'mechanical' memory [*Gedächtnis*], epitomised by the serial list of proper names held together by the 'empty link' or 'empty volume' [*leeres Band*] of an abstract subjectivity. Proper remembrance (involuntary memory in Proust, *Erinnerung* in Hegel) would require in each case the interiorisation of such externality within the fullness of the living (no longer machinelike or corpselike) subject. See GWF Hegel, *Philosophy of Mind*, William Wallace (trans), Oxford University Press, Oxford, 1971, §§ 462-463.

20 Proust, *Remembrance*, vol 3, *op cit*, pp940, 924.

21 Marcel Broodthaers, 'Ten Thousand Francs Reward', in Benjamin HD Buchloh (ed), *Broodthaers: Writings, Interviews, Photographs*, special issue of *October* 42 (1987), p45.

22 Quoted by Benjamin HD Buchloh, 'Open Letters, Industrial Poems', in *Broodthaers: Writings, Interviews, Photographs*, pp67-100 at p84. I am grateful to this entire essay for demarcating so clearly some of the ideological issues at stake in Broodthaer's encounter with conceptualism. For other excellent readings of the relationship between text and image in Broodthaers, see Dieter Schwartz, 'Look! Books in Plaster: On the First Phase of the Work of Marcel Broodthaers' and Birgit Pelzer, 'Recourse to the Letter', both in *Broodthaers: Writings, Interviews, Photographs*, pp57-66 and pp157-81 respectively.

23 Broodthaers, 'Open Letter', Ostend, Sept 7, 1968 (quoted by Buchloh in 'Open Letters, Industrial Poems', p91).

24 *Zweistromland* (Mesopotamia) and *The High Priestess* are, respectively, the German and the English names given to the installation.

25 Anselm Kiefer, *Zweistromland. Mit einem Essay von Armin Zweite*, DuMont Buchverlag, Cologne/Anthony d'Offay, London 1989.

26 See note 25.

27 The actual monument – if it is to be erected – would seem to deviate rather crucially from the model. The modular units of books (cast in concrete and fibreglass from carved wooden models) have now been constructed with their bottom edges horizontally flush, as if, in fact, registering the absent pressure of a supporting shelf. This is not the only discrepancy which is to be noted between the model and the final product. Many thanks to Andrea Schlieker for supplying me with these and other details of the construction.

28 This point has been noted by Mark Cousins in his essay, 'Rachel Whiteread: Inside Outcast', *Tate Magazine* 10 (Winter, 1996), p37.

29 For an excellent overview of the phenomenon, see James Young (ed), *The Art of Memory: Holocaust Memorials in History*, Prestel, New York and Munich, 1994, as well as *The Texture of Memory: Holocaust Memorials and Meaning*, Yale University Press, New Haven, 1993.

30 Albert Elsen, 'When the Sculptures Were White: Rodin's Work in Plaster', in Albert Elsen (ed), *Rodin Rediscovered*, National Gallery of Art, Washington, 1981, p132.

31 See note 19 above.

32 Many thanks to Karsten Schubert for generous access to his archive of press reports on the Holocaust Memorial Competition; to Andrea Schlieker for much useful information about the current situation in Vienna; to Michael Newman for helpful comments on this article and to Emilia Angelova for her generous assistance.

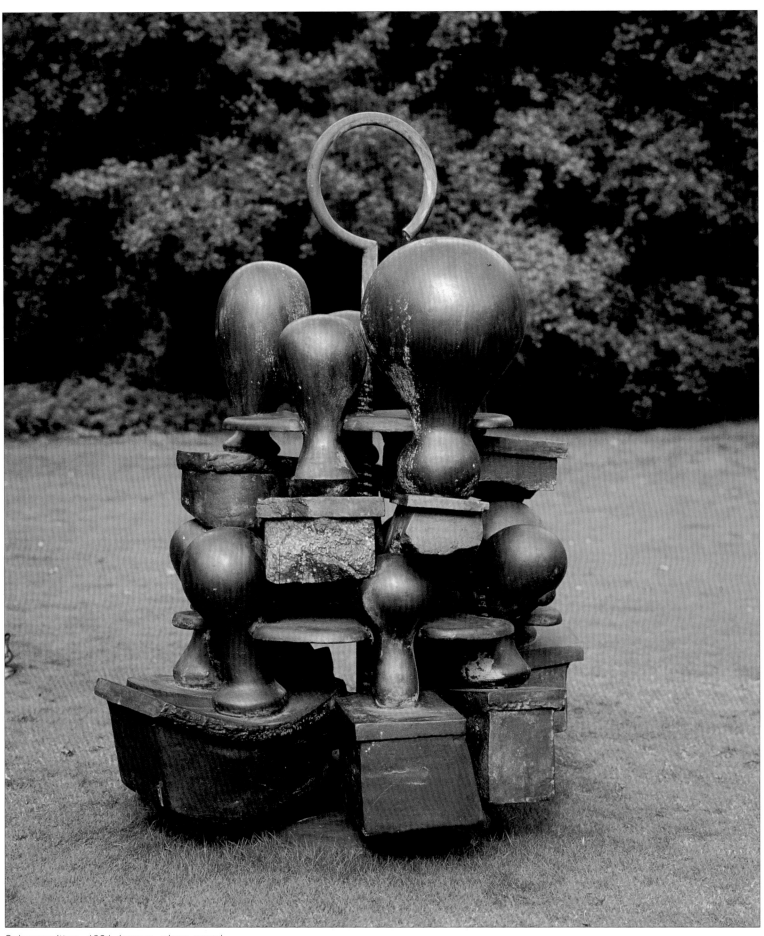

Subcommittee, *1991, bronze, glass, wood*

LATENT TECTONICS
IN THE WORK OF TONY CRAGG
JESSE REISER

The current debate regarding limits of sculptural practices and those of architecture has generally moved in two distinct yet complementary directions, with sculptors and architects each decrying the respective usurpation of their métiers by the other. The first argument issues from a set of classical norms which establishes the limits of architectural practice and sculpture hierarchically, with architecture forming a limiting and regulating framework within which sculpture/ornament's otherness might be domesticated. The second, one might call romantic synthesis, attempts to ameliorate the perceived loss arising out of the autonomous condition of sculpture and architecture in modernism: by reinscribing the place of sculpture within architecture either as a historicist revival of the classical hierarchy; as *Gesamtkunstwerk*; or, more recently, as practices that pretend to be unproblematically co-extensive with one another (Frank Stella, Frank Gehry).

These accommodations obscure a more profound shift which is beginning to manifest itself in the work of younger architects and artists who have focused on issues of complexity. While they regard their projects as essentially different they, nevertheless, share certain common interests especially in their reformulations of the nature and implementation of hierarchy itself. From the direction of architecture, new potentials arise out of the fundamental reappraisal of the status of ornament/sculpture and its implicate architecture. Axiomatic to this approach is the critique and ultimately the dismantling of the dualistic structure that has heretofore regulated these conceptions: first and foremost by assuming, contrary to the classical formulation, that ornament is not subservient to structure and that in fact ornament is pre-eminently structure in itself; and furthermore, what would classically be understood as structure is an inherent subset to and of the general ornamental organisation. The collapsing of this duality has potentially far-reaching consequences though not as one might immediately suppose as a vehicle for producing yet another sculptural architecture or conversely architecturalised sculpture.

In his recent work, sculptor Tony Cragg exemplifies this trend in the way his process negotiates the categorical antagonisms between sculpture and architecture and how this conflict is resolved through methods that variously pass through forms of historicism, synthesis and destitution in order to arrive at what Deleuze would term a machinic modality. By charting a genealogy of five works[1] I will attempt to describe this trend. Whether or not this genealogy coincides with the chronology

of the works is unimportant. What is at stake is the development or uncovering of 'universal' logics that might extend across the disciplinary boundaries of sculpture and architecture (though in distinctly different scales, terms and effects).

Subcommittee (1991) consists of an assembly of meticulously crafted shell-like extrusions in bronze. As such they suggest the initial incarnation of the genealogy; where the classical patrimony of sculpture as detached numinous objects is most evident. These 'primitive' forms may be located easily within the modernist economy of contradiction, that is, simultaneously occupying the side of autonomy and pathos.

Secretions (1995), the dice sculptures, begin to exceed the impenetrable depth and effects of distance ascribed to nature and primitive sculpture by Walter Benjamin in his well-known essay 'The Work of Art in the Age of Mechanical Reproduction'. A purely mechanical procedure, that is, the mapping of dice onto a geometric primitive (doubtless very much like the previous work) exchanges experiences of depth for a developed surface rendered machinic through the unchanging modularity of the dice. Further, the dice cubes begin to initiate a trajectory that while intensively associated with the particular object upon which they are arranged, simultaneously exceed the simple definition of that form. While approximating the underlying form, the dice automatically describe catastrophic points of failure or fissure along zones of extreme change on the complex curvatures. Significant also is the analytical dimension inherent in the procedure. Freely developed form is, as it were, read by an external system which simultaneously reveals the limits of that system as well as the unforeseen geometrical potentials in it. Repetitive systems, here embodied by the dice, when mapped onto complex surfaces reveal the emergence of precise singularities.

In a similar way, a series of plaster pieces known as *Forminifera* (1996) involve the progressive transformation of a sculptural substrate through the precise and highly localised accumulation of perpendicularly drilled holes. In contrast to the dice strategy where a system or repetition is applied to a surface and registers a hidden order in the substrate, the drilled holes attempt to produce a system of pure regularity but because of the narrow focus of the field (deployed on a gradual and inexorably changing surface) error is multiplied until it becomes so extreme as to make the driller gradually deviate from the normal until his error is recognised and he abruptly returns to the normal. As in Beckett's *Molloy*, the world is

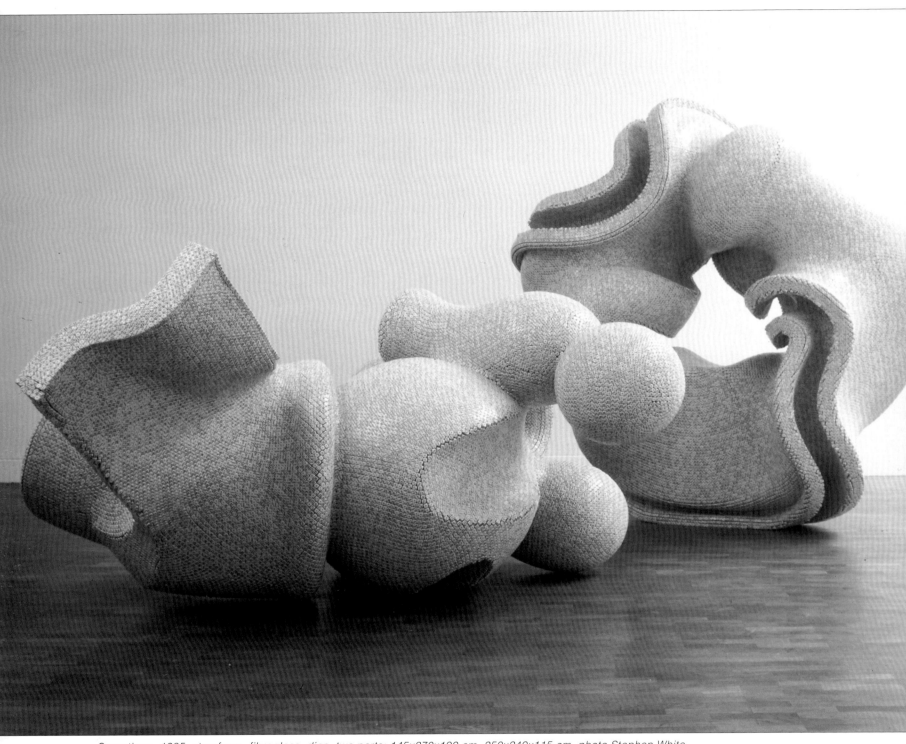

Secretions, *1995, styrofoam, fibreglass, dice, two parts: 145x270x190 cm, 250x240x115 cm, photo Stephen White*

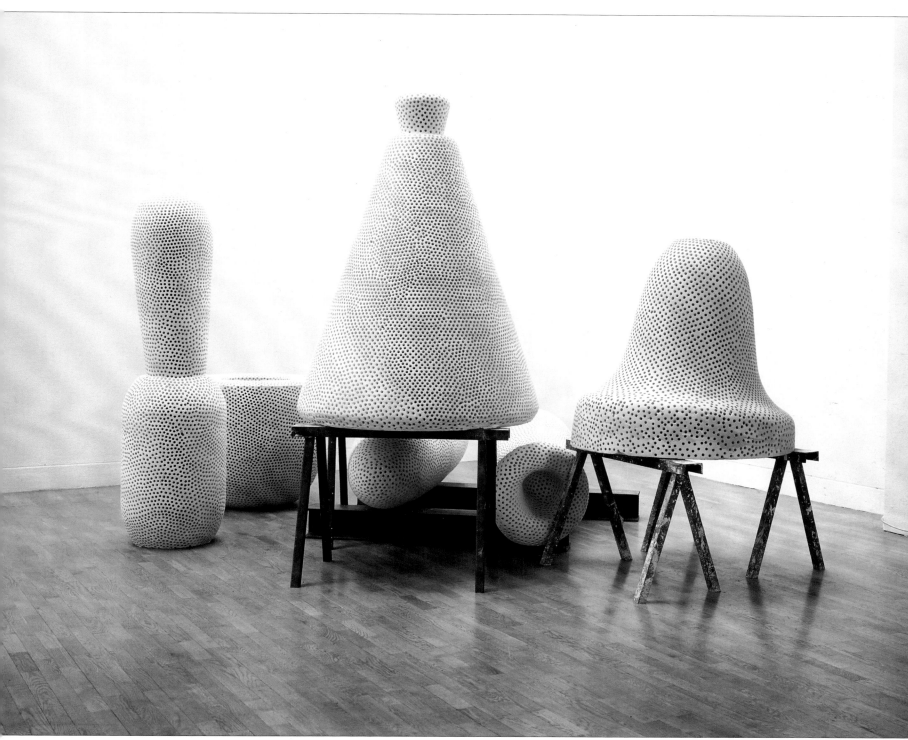

Forminifera, *1996, plaster with steel holders, 150x200x140 cm, photo Stephen White*

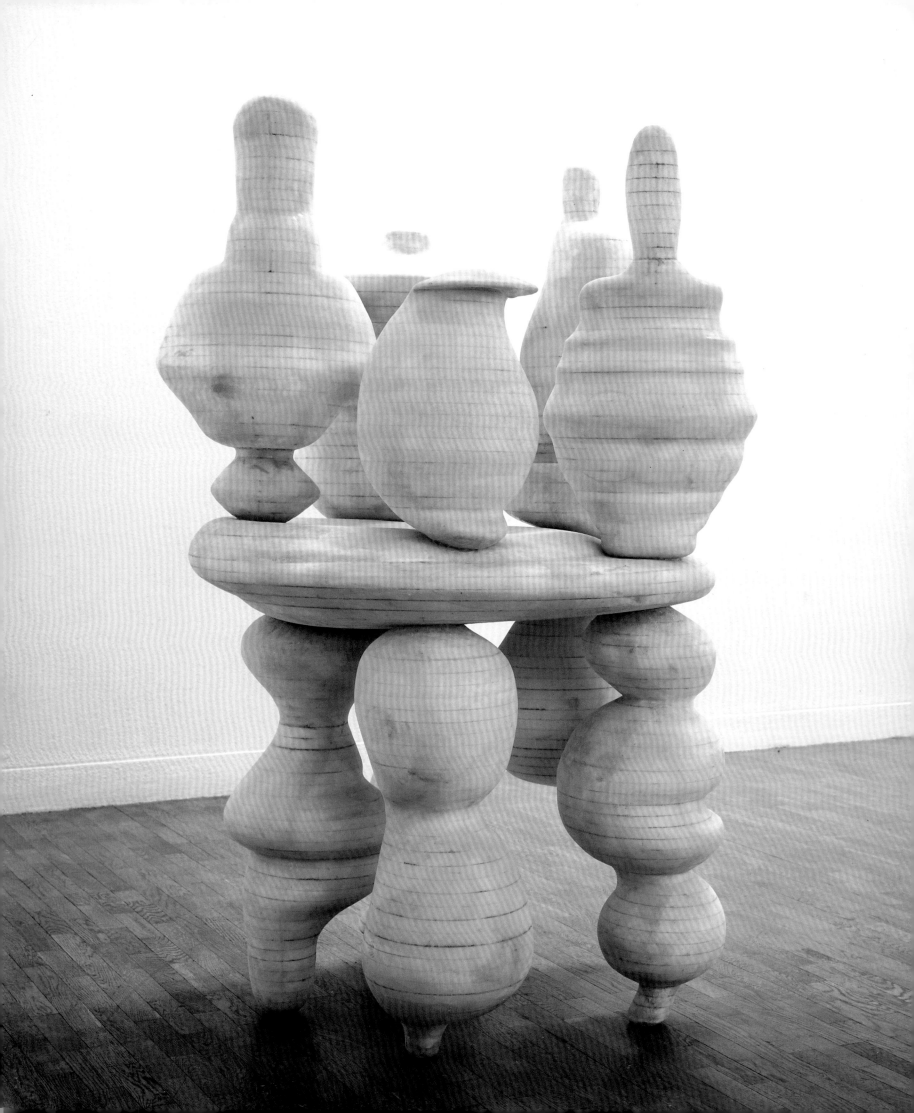

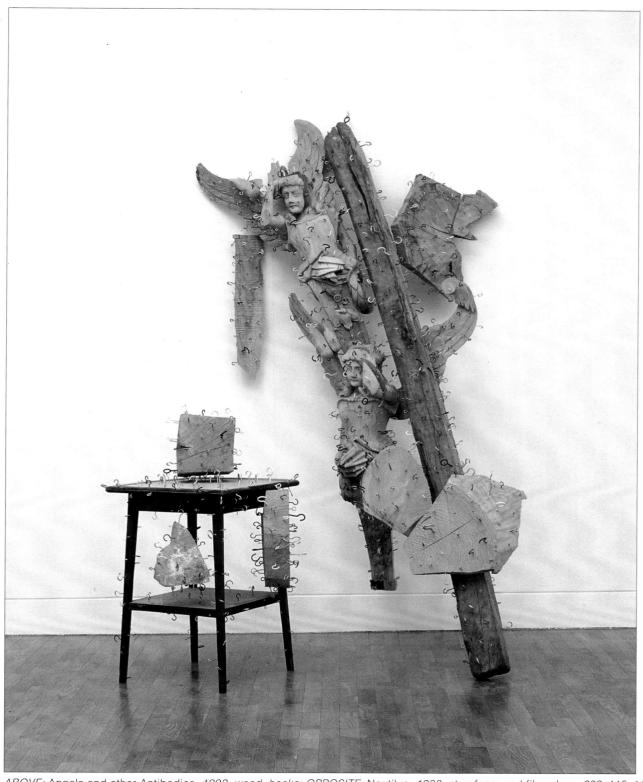

ABOVE: Angels and other Antibodies, *1992, wood, hooks; OPPOSITE:* Nautilus, *1996, styrofoam and fibreglass, 203x115x115 cm,*
photo Stephen White

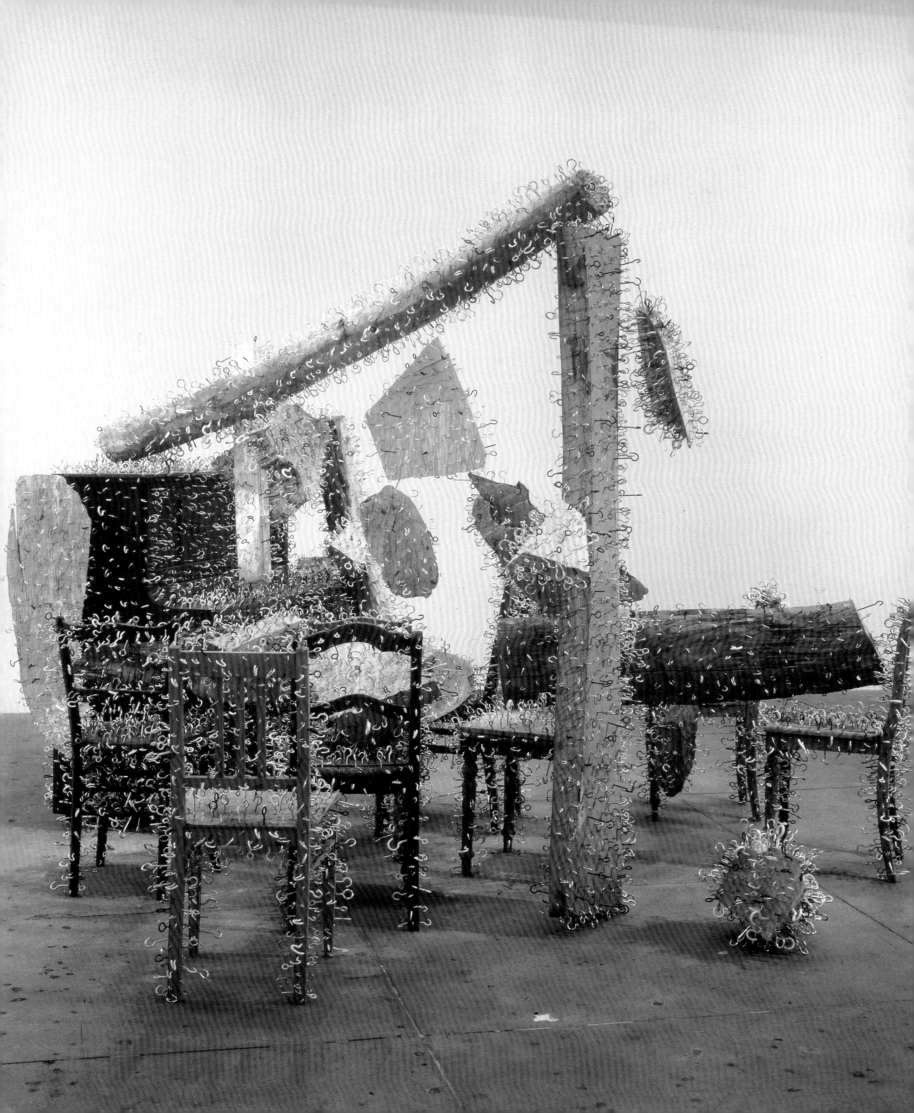

apprehended through the accumulation of near-sighted repetitions; the overall is never accessible to the subject but only to others in the form of the trace of his desperate gropings.

While *Secretions* and *Forminifera* extend the limits of the classical sculptural object through the exchanges brought about by the development of a simple order on a complex surface, the linked pair of *Untitled* (1993) and *Angels and other Antibodies* (1992) develops fields or atmospheres above the sculptural artifact. In a similar way to *Secretions* the passage from classical sculptural object to dematerialised materiality is acted out, both at the historical level, and simultaneously at the systemic one. The application – in both cases U hooks to a sculptural body – effects specific modes of transformation and reception. Here quantity effects more than qualitative change. In *Angels and other Antibodies*, an assemblage of wooden objects dominated by a cruciform figure, U hooks are strategically inserted about the figural tableau. The effect is immediately and strongly reminiscent of impaled bodies such as one might find in depictions of Saint Sebastian or voodoo fetishes. In this sense they belong firmly within the sculptural tradition.

In *Untitled*, an arrangement of wooden furniture is also pierced by U hooks, however with vastly different consequences. Rather than extending the figural potentials inherent in furniture, the sheer quantity and density of U hooks destitute the overt symbolism of the grouping and promote, instead, field effects. Paradoxically, what appears to be the ornamentalising of sculpture, when shifted to the systemic/architectural domain, produces a robust and intricate condition of order.

On an extended reading certain universal features are adducible to these processes. By universal, I do not mean to refer to any pre-existing or transcendent model in the platonic sense, but rather, as Manuel de Landa writes, to 'figures of destiny' which are not, prior to, or above the singularities that are manifest, but are incarnated under certain conditions and persist (and have the capacity to develop) for as long as those conditions exist. From the standpoint of the relationship between architecture and sculpture, commonalities may be abstracted along two dimensions, spatial and temporal. (1) Spatial. Regular geometries may cooperate with complex geometrical substrates in order to provoke novel irruptions (singularities) of order. These geometries are inherently independent of scale though scale-dependent in terms of their architectural effects. (2) Temporal. Two related yet distinct conditions become apparent. It is perfectly irrelevant whether or not the complex substrate is developed a priori as a result of rational systems. The complexity of the formation (latent in the substrate and the applied system) comes about precisely when the two systems are brought into relationship. And following from this, it is perfectly irrelevant whether authorial control in the form of rational construction of the substrate is originated by the author or, as it were, inherited. These are mere illusions of history, what is important is the resultant organisation and its potential effects. The collapse of the structure/ornament dialectic as exemplified by the work of Tony Cragg becomes interesting for architects because it points to techniques whereby sculpture in the classical sense may through certain procedures release novel architectural potentials.

Note

1 These works were shown together at the Whitechapel Art Gallery, London, at the exhibition 'Tony Cragg', 9th January – 9th March, 1997.

Untitled, *1993, piano, chairs, wood, hooks, 228x328x330 cm*

SITES OF TENSION

Serge Spitzer's work in the Kennedyplatz, Essen
ANDREW BENJAMIN

Here there are two sites of tension. Serge Spitzer's work in the central square of Essen works to redirect the urban encounter within that field. At the same time the work itself inscribes, as a constitutive part of its make up, an element that disrupts any conception of the smooth or the continuous.

Spitzer's work is positioned not in the centre but to one side. In addition, it interrupts the field of vision that, from one position, had hitherto allowed an unrestricted view of the Cathedral. The work is placed sufficiently near to the entrance of the underground car park that it will be an inevitable encounter for all citizens driving into the centre of Essen. What is important about the work as an element within the urban fabric is this positioning. However it is not positioning in itself. It is rather the positioning of an art work – a work which because of its height brings with it the problems of a complex monumentality – within the urban. The work is such that it resists an automatic absorption into its setting. As such it intensifies the setting. Its construction from steel necessarily gestures to what had been the industrial strength of the region. And yet the gesture is neither nostalgic nor cautionary. It merely reinforces

the work's specificity. It is the twofold movement of gesturing to the region's history and of forming an element of the urban while at the same time complicating both the gesture and its place that provides a fundamental aspect of the work's importance. It is also possible to argue that its strength as an art work lies precisely in its capacity to complicate. Neither autonomous nor mere vernacular, as a work within the urban setting of Essen, it will continue to demand. Demanding and intensity are, in this instance, interrelated.

There is another site of intensity. In this instance it occurs within the work itself and is thus only available when the work is encountered as a particular object. The particularity of the work is not given by its size. Nor is it given by the hoops of steel that have been placed on top of each other. If size and steel were central then the work would have simple weight. It would bear down upon the viewer. In bearing down it would be ignored. The mass object runs the risk of forgetting. Size does not guarantee endurance. The work's hold cannot just be found in its monumentality. Spitzer has introduced into this work – again not as an addition but as fundamental to the work – an

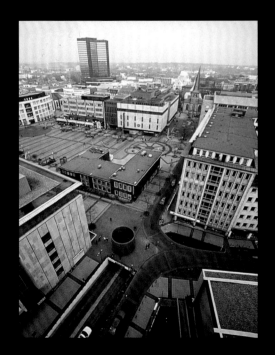

Untitled (Essen), *1995-96, permanent installation Kennedyplatz EuropaHaus, Essen, photos Wilfred Kruger*

element bearing and yielding intensity.

At a number of places within the work the continuity of the metal hoops are interrupted. The interruption occurs by the placing of folded steel between the hoops. The folding means that these elements not only disrupt the continuity, they look as though they hold and absorb the weight of that which has been placed above them. Their construction is such that they actually have held and absorbed the work of weight. Holding and absorbing are remarkable qualities. Simply to absorb would be to allow that which was absorbed to disappear; perhaps to disappear in the name of continuity. Mere holding would deny the effort of construction; activity, work, would be held back and thus held from view. In both cases there would be a sense of seamless continuity. Here, with this work, the discontinuity is introduced not because the continuity of the hooped metal has been disrupted but because holding and absorbing are dramatised. The elements between the hoops stage that activity. They refuse to the work a continuous flow precisely because the interruption brings with it a different sense of activity and intensity. It is as though the non-relation between the elements – a non-relation in terms of activity and intensity – is occasioned because of the relation of materials within the work. What this means is that the work brings with it a refusal of reconciliation. The work is not reconciled with itself because it announces and affirms the impossibility of reconciliation and thus of self-absorption. The dramatic consequence of this is that it is only the work's refusal of the structure of melancholia that allows it to have monumentality and thus to work within memory.

Internally and externally therefore the work brings with it a form of disruption that continues to position it. The two-fold movement of being positioned and the refusal of being positioned defines the work's work. Both as monument and as sculpture its place is to displace. And yet displacing is neither utopian nor destructive. Displacing can only be understood in relation to placing. They work together. Displacing and placing opens up the possibility of alterity by yielding the site of singularity. Being reconciled to the impossibility of reconciliation is to allow for the activity of intensity. Serge Spitzer's work in Essen can be understood in this light. His work provides sites of tension.

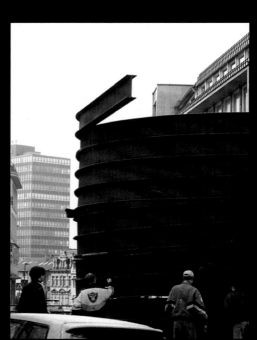

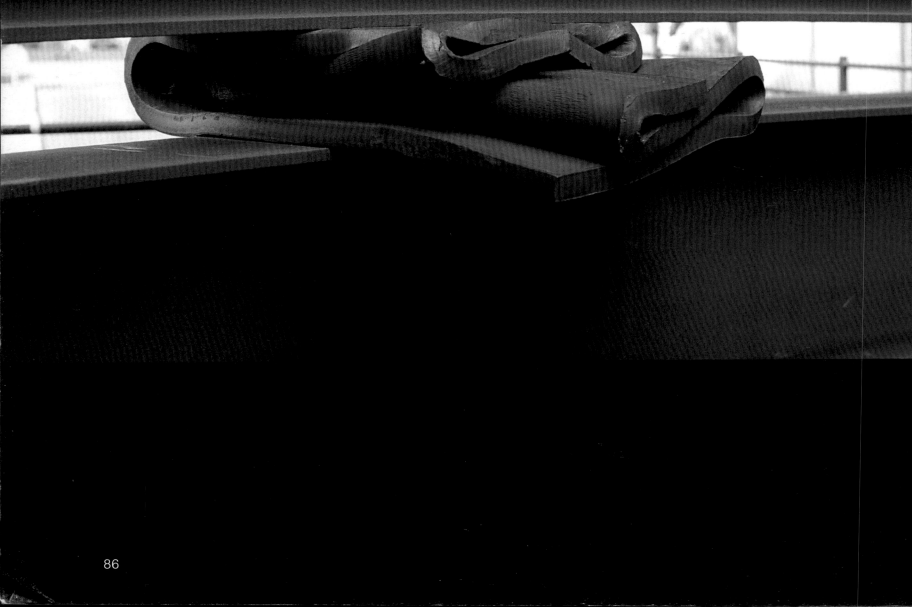

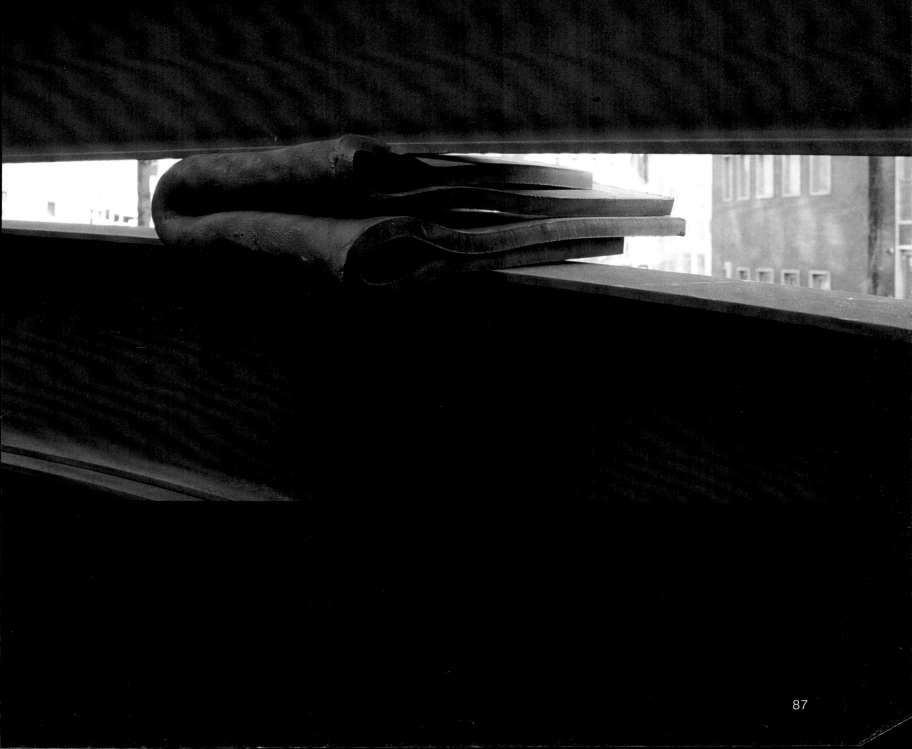

Sculpture

changes everything

SCULPTURE: *VENUS AUX TIROIRS*
(VENUS DE MILO WITH DRAWERS) PLASTER CAST OF 1936 ORIGINAL
©SALVADOR DALI MUSEUM, INC., ST. PETERSBURG, FLORIDA

SCULPTURE PHOTO: HANS KACZMAREK,
COURTESY OF SALVADOR DALI MUSEUM

FLORENCE PHOTO: GREGORY M. BORDYNOWSKI